C
th
jo
C
sti
br
in
Lc
Sc

J745

WHITFORD, F.

Bauhaus

Please return or renew this item by the last date shown.
You may renew items (unless they have been requested
by another customer) by telephoning, writing to or
calling in at the library. 100% recycled paper. BKS 1

30 Bloomsbury Street, London WC1B 3QP
In the United States please
THAMES AND
500 Fifth Avenue, New York

Printed in Singapore

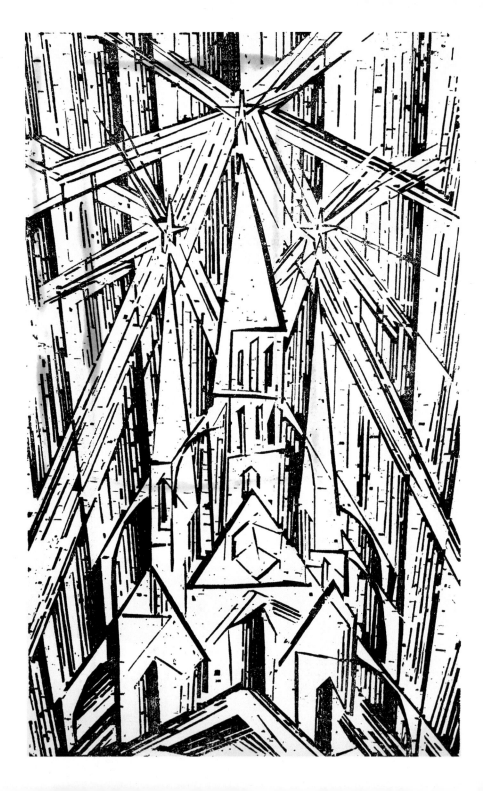

BAUHAUS

frank whitford

154 illustrations 16 in colour

 thames and hudson

for Ceci

Frontispiece

1 Cover illustration (*Cathedral*)
by Lyonel Feininger for the Manifesto
and Programme of the Weimar Bauhaus,
woodcut, 1919

© *1984 Thames and Hudson Ltd, London*
Reprinted 1994

ISBN 0-500-20193-5

Printed and bound in Singapore by C.S. Graphics

contents

preface

The Bauhaus began life in 1919. It was born into a world quite different from the one which we inhabit, yet its influence is still manifestly at work. The questions it raised – about how art and craft should be taught, about the nature of good design, about the effects buildings have on the people who live in them – are still being asked and with the same urgency, even after more than half a century and at a time of increasing conservatism in educational and architectural activity. The objects the Bauhaus produced continue to provide those who shape our environment with inspiration. And its approach to art education in general continues to affect the teaching in many art schools throughout the world.

Much has been written about the Bauhaus. Yet surprisingly, there has until now been no basic book which tells the story of the school, examines its aims and achievements and describes the personalities, both teachers and students, who were associated with it.

That I was able to undertake research in the former German Democratic Republic is due to the kindness of the British Council and the Cultural Ministry of the GDR whose representative in Berlin, Angelika Landmann, organized my programme, arranged access to archives and introductions to scholars and curators. Herr Günther Michel-Treller of the Thuringian State Archive and Frau Jutta Hörning of the Castle Museum gave me help in Weimar in various ways, as did Herr Eberhard Renno and Hermann and Ingeborg Sommer. Professor Christian Schädlich of the Hochschule für Bauwesen und Architektur in Weimar was especially helpful and gave me access to his school's collection of rare Bauhaus photographs. I am also grateful to Dr George Opitz who gave me the run of the splendidly restored Bauhaus and a tour of the other buildings associated with the Bauhaus in Dessau, and to Dr Ulla Jablonowski of the Dessau City Archive.

Considerable thanks are also due to the British Academy which provided me with a generous grant to work in the Bauhaus Archive in West Berlin, to the late Professor H. M. Wingler, the first director of that archive, for allowing me to use its admirable facilities, and to Frau Barbara Stolle for dealing with my requests and expediting orders for scores of photographs with patience and efficiency. Paul and Charlotte von Kodolitsch assisted me in ways too numerous to mention here.

Gratitude is due to Robert Edwards, editor of the *Sunday Mirror* and Professor Christopher Frayling of the Royal College of Art in London for their help and understanding during the writing of this book. More specific help was provided by Roy Wright and Carl Bruin.

I must also thank Iain Boyd-Whyte, Paul Joannides, Gillian Naylor and John Gage for reading the typescript and doing a great deal to improve it. Richard Hollis pointed out a number of errors in the first edition which are now corrected. I can only hope that no more remain.

Great Wilbraham, Cambridge, 1991 F. P. W.

I aim∫ and ambition∫

The Bauhaus, the most celebrated art school of modern times, was closed down by the Berlin police acting on the instructions of the new Nazi Government on 11 April 1933. It was the first tangible expression of the Party's cultural policy, of its determination to remove from Germany every trace of what it called 'decadent' and 'Bolshevistic' art.

Adolf Hitler's appointment as German Chancellor on 30 January 1933 signalled the end of the Weimar Constitution which had been drawn up in 1919. The life-span of the Bauhaus was precisely that of the Weimar Republic. The school had opened its doors while the National Constituent Assembly was deliberating the shape of the Constitution, and in the same city. The school's subsequent history was shaped by the pressures against which the new Republic also struggled to survive. As Oskar Schlemmer, one of the Bauhaus teachers, wrote in 1923: 'Four years of the Bauhaus reflect not only a period of art history, but a history of the times, too, because the disintegration of a nation and of an era is also reflected in it.'

The early months of the Bauhaus were marked both by a determination to reform art education and to create a new kind of society, and by a willingness to sacrifice a great deal in order to do so. Plagued like the young Republic itself by internal dissent, unreasonable external demands and crippling economic crises, the Bauhaus was quickly forced to redefine its aims, to temper idealism with realism. During the second phase of the school's life, therefore (which lasted from 1923 to the end of 1925), rational, quasi-scientific ideas gradually replaced Romantic notions of artistic self-expression and brought about important changes in the school's curriculum and teaching methods. This phase embraced the years in which the tottering German economy was stabilized and the nation's industry began to flourish. They were, however,

9

also the years in which political extremists of both the left and right gained strength. They, too, directly affected the Bauhaus.

The third phase of the school's history began in 1925 when the Bauhaus was forced to leave Weimar: the city's new nationalist government withdrew financial support. The German Republic itself now also suffered increasingly from the attacks of radicals and revolutionaries alike, and the polarization of politics was reflected at the Bauhaus, now located at Dessau. At the same time the national economy enjoyed a brief boom and the Bauhaus began to tailor its teaching to the demands of industry. The school's third phase ended early in 1928 when its founder and director Walter Gropius handed over the reins to Hannes Meyer, an avowed Marxist who regarded art and architecture exclusively in terms of measurable social benefit.

Political differences not only forced Meyer's resignation in 1930 and the appointment as director of Mies van der Rohe but also led to the removal of the Bauhaus from Dessau to Berlin in 1932. This was again the result of a nationalist victory in regional elections. Once the nationalists had achieved national power the Berlin Bauhaus was closed down finally and irrevocably and most of the artists and architects associated with it left Germany, taking Bauhaus ideas with them to those countries in which they sought refuge, especially the United States.

During its brief existence the Bauhaus – for better or worse – precipitated a revolution in art education whose influence is still felt today. Every student now pursuing a 'foundation course' at an art school has the Bauhaus to thank for it. Every art school which offers studies of materials, colour theory and three-dimensional design is indebted in some degree to the educational experiments carried out in Germany some six decades ago. Everyone sitting on a chair with a tubular steel frame, using an adjustable reading lamp or living in a house partly or entirely constructed from pre-fabricated elements is benefiting (or suffering) from a revolution in design largely brought about by the Bauhaus. In the words of Wolf von Eckardt, the Bauhaus 'created the patterns and set the standards of present-day industrial design; it helped to invent modern architecture; it altered the look of everything from the chair you are sitting in to the page you are reading now'.

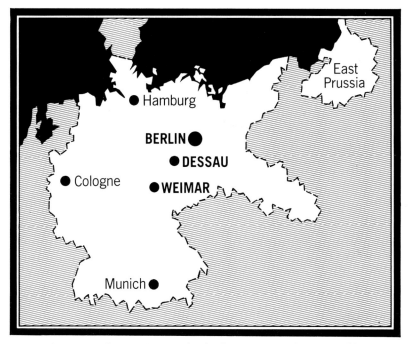

2 Map of Germany showing (in capitals) the three successive locations of the Bauhaus

Although the Bauhaus changed direction several times during its short life, it initially pursued three main aims, each of which is clearly defined in the Manifesto and the 'Programme of the State Bauhaus in Weimar' which accompanied it. Written by Walter Gropius, the school's founder and director, and illustrated with a full-page woodcut of a Gothic cathedral by Lyonel Feininger, the 1 Programme was published in April 1919.

The school's first aim was to rescue all the arts from the isolation in which each then (allegedly) found itself and to train the craftsmen, painters and sculptors of the future to embark on co-operative projects in which all their skills would be combined. These projects would be buildings for, in the ringing declaration with which the Manifesto begins, 'The ultimate aim of all creative activity is the building.'

The second aim was to elevate the status of the crafts to that which the 'fine arts' then enjoyed. 'There is no essential difference between the artist and the craftsman,' the Manifesto proclaims. 'The artist is an exalted craftsman . . . Let us then create a new guild of craftsmen without the class-distinctions that raise an arrogant barrier between craftsman and artist!'

The third aim, less clearly articulated in the Programme than the other two, but of increasing importance once the Bauhaus got under way, was to establish 'constant contact with the leaders of the crafts and industries of the country'. This was more than an article of faith; it was a matter of economic survival. The Bauhaus hoped gradually to free itself from dependence on public subsidy by selling its products and designs to the public and to industry. At the same time, contact with the outside world would ensure that the school did not become an ivory tower and that its students were fully prepared for life.

Several of the ideas expressed in the Manifesto and Programme were startlingly subversive, not least the claim that art cannot be taught. Craft, manual skills, can be taught, however, which is why the basis of the school was to be its workshops: 'The school is the servant of the workshop and will one day be absorbed by it.' This is why there were no 'teachers or pupils at the Bauhaus' but, following the example of the guilds, 'masters, journeymen and apprentices'. Students would therefore learn by doing, by actually making things in collaboration with or under the supervision of the more experienced.

As we shall see, it took some time before the intentions expressed by the Bauhaus Programme were even partially realized. We shall also see that the Bauhaus was not alone in its attempts to reform art and craft education. It was not even the first school to try to do so.

2 art, crafts, architecture and the academies

Although there had been no art school quite like the Bauhaus before, the ideas behind the 1919 Programme had a long and respectable pedigree. They reflected attitudes to art, architecture and craft which had been shaped by the forces of engineering and technology.

The Industrial Revolution brought forth machines and materials which usurped the traditional functions of the artist and craftsman. Cast iron was more versatile than brick or wood. Steam-driven machines could stamp, cut and fashion almost any substance faster and more regularly than the human hand. Mechanized production meant lower prices and higher profits.

The Great Exhibition staged in London's Hyde Park in 1851 dramatically demonstrated, to anyone who cared to think, how much the world had changed since the beginning of the nineteenth century. Joseph Paxton's vast exhibition hall constructed from prefabricated metal ribs and sheets of glass (the Crystal Palace) was the work not of an architect but of an inspired, self-taught engineer; and it housed not only traditional manufactures from almost every country in the world but also the new-fangled, steam-driven machines, the engines, hammers, lathes and looms 3 which had given Britain industrial and economic advantages enjoyed by no other country.

While ordinary mortals were thrilled and fascinated by the wonder of Paxton's creation, a small number of thoughtful people were horrified by what it contained. They believed that the machine announced (among other terrors) the imminent demise of both individuality and the craftsman.

The most articulate opponents of the machine in nineteenth-century Britain were John Ruskin and William Morris. The latter thought that it was dishonest for machine-goods to pretend to be hand-made, while the former was opposed to the use of the

13

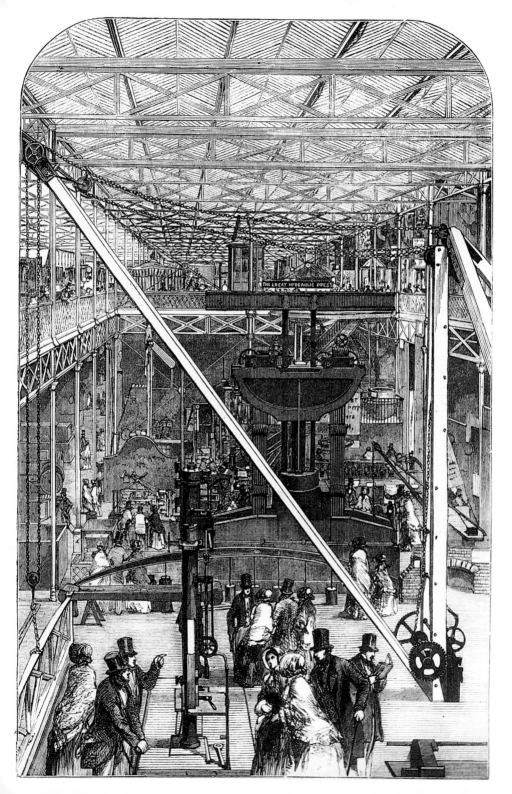

THE GREAT HYDRAULIC PRESS

THE SUSSEX RUSH-SEATED CHAIRS
MORRIS AND COMPANY
449 OXFORD STREET, LONDON, W.

"ROSSETTI" ARM-CHAIR.
IN BLACK, 16/6.

SUSSEX CORNER CHAIR.
IN BLACK, 10/6.

SUSSEX SINGLE CHAIR.
IN BLACK, 7/-.

SUSSEX ARM-CHAIR.
IN BLACK, 9/9.

ROUND-SEAT CHAIR.
IN BLACK, 10/6.

SUSSEX SETTEE, 4 FT. 6 IN. LONG.
IN BLACK, 35/-.

ROUND SEAT PIANO CHAIR.
IN BLACK, 10/6.

3–5 *Opposite* Great Exhibition, 1851.
The Machinery Court in the Crystal
Palace showing a crane in the fore-
ground and a hydraulic press at the
back. *Above* Page from a catalogue
issued by William Morris' company.
Right A time-piece shown at the Great
Exhibition and illustrated in the official
catalogue. The style of the decoration is
mock Gothic, the metal case is made to
look like oak

machine altogether, damning the introduction of any device in the crafts which did more than aid 'the muscular action of the human hand'. Both believed that the effects of industrial production were spiritually damaging to craftsman and customer alike: the machine had no soul; it would render mankind soulless. It robbed the craftsman of the joy in work well done and denied the public the life-enhancing pleasure of living in an environment that had been shaped with both skill and love.

4 The solution according to Morris was sponsorship aimed at the resuscitation of the traditional crafts. In 1861 he founded a firm which would produce the kind of work of which he approved and give employment to traditional craftsmen. Morris also hoped that the price of the firm's products would be within the reach of ordinary people, for they much more than the 'swinish rich' (his words) were in need of the spiritual benefits conferred by honestly and sensitively made artefacts.

Morris' ideas and efforts to stem the tide of industrialization were naive. They drew their strength from a fondly imagined rather than authentic Middle Ages in which mechanization was not even a dream, and the craftsman was a secure and contented member of a happy band of brothers singing and chiselling its way from one cathedral to the next.

Morris' ideas were also impractical. Although there was a market for the craftsman's products, these were inevitably more expensive than mass-produced goods, and could be afforded only by the 'swinish rich' who had least need for them. The inexorable progress of the machine would not be halted by anachronistic cottage-industries.

Another who was critical of most of what he saw at the Great Exhibition was the German architect Gottfried Semper (1803–79), for several years resident in England as a political refugee. Semper realized that technological progress was irreversible. Instead of devising ways of keeping traditional crafts alive he therefore proposed the education of a new kind of craftsman who would understand and exploit the machine's potential in an artistically sensitive fashion. In England the phrase 'Arts and Crafts' had been coined to describe the results of the various attempts to revive craftsmanship and reform design. Semper invented a German equivalent: *Kunstgewerbe*.

An Englishman who sympathized with Semper, had helped to organize the Great Exhibition but was critical of the goods on show there was Henry Cole (1808–82). Like Semper, Cole considered that the only lasting solution to the problems posed by industrialization was education in which craft museums would play as important a role as schools of arts and crafts. As director of the South Kensington Museum established in 1852 (now the Victoria and Albert) and of the school of design attached to it (now the Royal College of Art) Cole exerted a considerable influence, not only in Britain but also on the Continent, and especially in Germany and Austria.

Art and craft education was in urgent need of reform. Artists and craftsmen had continued to learn their trades as though the Industrial Revolution had never happened: artists were still instructed in the refined atmosphere of the academies, and craftsmen still acquired their skills within an apprenticeship system going back, virtually unchanged, to the epoch of the great cathedrals.

During the late nineteenth century the growth of craft museums and of schools of arts and crafts associated with them was considerable throughout Europe, but no matter where they were established, the schools failed to convince society at large that they were anything more than the poor relations of the fine art academies: they trained not artists but artisans. The academies, meanwhile, continued to give instruction based on the study of the Antique and the old masters, blind to the spectacular successes of the avant-garde, especially in France and in painting, and believing that they alone enshrined the ultimate artistic values. They also believed that it was possible to teach people to become artists. Clearly any reform in art education would have to begin with an attack on the élitist academies.

The Industrial Revolution also precipitated a crisis in architecture. It was not simply a question of whether architects might legitimately employ new building-materials and of the forms the use of such materials might demand. It was also one of devising solutions to the problems created by the stupendous and distressing growth of urban populations. How and where was the new urban proletariat to be housed?

The lack of answers to that urgent question resulted in badly lit, airless, damp and insanitary slums in every industrialized city from

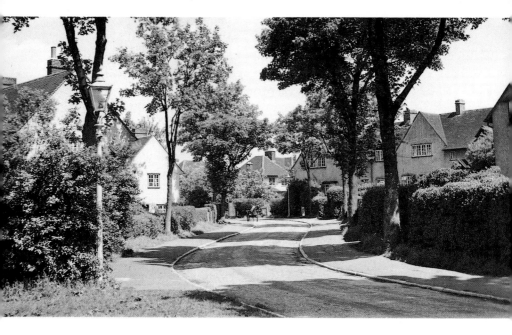

Paris to Budapest. The problem would not be solved by architects trained to imitate past styles or build piecemeal with conventional materials.

The first solutions to this problem were suggested in England where estates of dwellings for working families began to appear as early as the 1850s. During the rest of the century such estates, for the middle class as well as the proletariat, sprang up everywhere, some of them (like Port Sunlight and Bournville) built by large firms for their employees. The garden city movement was a step in the same direction. Its first expression was Letchworth (begun in 1904), a development planned from start to finish around the needs of the factory workers who were to be its inhabitants.

6

During the last two decades of the nineteenth century Britain came to be admired on the Continent for the quality of its industrial products, its crafts, its art and craft schools, its garden cities and its modest and solid domestic architecture. Such admiration was in part inspired by the desire quickly to match Britain's record as an industrial and mercantile power. Well-designed goods sold better than shoddy ones; healthy and contented workers produced more and better goods than infirm and discontented ones.

18

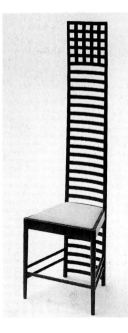

6 Rushby Mead, Letchworth, in 1914: a typical street of workers' houses

7 Signet for the Wiener Werkstätte designed by Josef Hoffmann, c.1905

8 Charles Rennie Mackintosh, chair for a bedroom in Hill House, 1902

The Austrians and Germans (the latter's economy booming after unification in 1871) were in the vanguard, and by 1910 had overtaken Britain in the originality of ideas and the quality of practical solutions to the problems of art education, craft, design and architecture.

The avant-garde artists' association, the Vienna Secession (founded in 1898), was as concerned with revitalizing architecture and the crafts as it was with freeing painting and sculpture from the shackles of historicism, and it was crucially influenced by the British Arts and Crafts movement, especially the work of Charles 8 Rennie Mackintosh. Secession members were instrumental in establishing the Wiener Werkstätte in 1903, crafts workshops 7 which produced furniture, household goods, textiles and even clothes for sale in its own shop, thus providing training and financial support for artists and craftsmen.

The Wiener Werkstätte soon became identified with a style that was relatively simple and essentially geometric. At the same time radical Viennese architects like Adolf Loos (1870–1933) began to design buildings which to most of their contemporaries seemed alarmingly anonymous and devoid of ornament. This lack of ornamentation – a major characteristic of all twentieth-century

design – had ideological as well as aesthetic justification. For Loos ornamentation was simply a waste of money, and in his essay 'Ornament and Crime' (1908) Loos argued that the greater the decoration on an object, the greater the exploitation of the craftsman employed to create it: 'If I pay as much for a smooth box as for a decorated one, the difference in labour time belongs to the worker.'

Meanwhile in 1896, the German government had created a special post at its London embassy so that the architect Hermann Muthesius (1861–1927) could study and report on British town-planning and housing policies. Muthesius remained in London for seven years after which he published an enormously influential book, *Das englische Haus* (1904).

Muthesius admired English domestic architecture for its sobriety and functionalism, qualities he also looked for in the crafts. He wanted objects that expressed the qualities of the materials in which they were made, were free from unnecessary ornament and could be afforded by the broad mass of the public. He believed that ornament and mechanized production were irreconcilable. 'What we expect from machine products', he wrote, 'is smooth form reduced to its essential function.'

After his return from London Muthesius was appointed superintendant of schools of arts and crafts by the Prussian Board of Trade. He persuaded architects and designers of the calibre of Peter Behrens, Hans Poelzig and Bruno Paul to head art schools in such important cities as Düsseldorf, Breslau and Berlin. Influenced by British educational reformers, Muthesius encouraged the establishment of training workshops in which students could learn by actually making things rather than designing them on paper.

Even more important than Muthesius' efforts in art education were his attempts to persuade German industrialists to encourage good design. In 1907 he succeeded in bringing together twelve artists and twelve industrialists to found an organization called the Werkbund. The Werkbund was to arrange for the employment of designers in industry and sustain a publicity campaign directed at the improvement of manufactured goods. Its aim was the reconciliation of art, craft, industry and trade, and a subsequent improvement in the quality of German products.

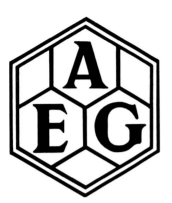

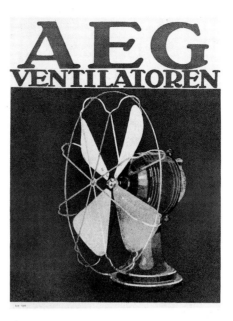

9, 10 Peter Behrens, trade mark for the AEG company, *c.*1908, and electric fan, 1908

In 1907 the AEG (the German general electricity company and one of the country's biggest concerns) appointed a founder-member of the Werkbund, Peter Behrens (1868–1940), as chief designer. Behrens not only designed the company's products (telephones, fans, kettles and street lamps), he also gave its printed material an unmistakable house style and created some of its factory buildings, the most celebrated of which was the AEG turbine-construction hall in Berlin.

Behrens' career well illustrates the way in which the concerns first aired by Morris found concrete expression in Germany around the turn of the century. At first a painter, Behrens soon turned his attention to design and then to architecture. He was a leading member of the artists' colony on the Mathildenhöhe in Darmstadt, founded in 1898 partly in emulation of the English Arts and Crafts movement. Behrens, working in close collaboration with the young Viennese architect (and member of the Secession) Josef-Maria Olbrich, designed his own house and everything in it, from the door-handles to the furniture and cutlery.

Leaving Darmstadt for Düsseldorf, in 1903 Behrens was appointed by Muthesius to the directorship of the arts and crafts

10

9

11

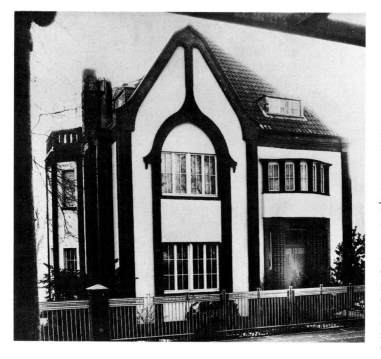

11 Peter Behrens, house designed for himself on the Mathildenhöhe, Darmstadt, 1901. A fine example of *Jugendstil*, the German version of Art Nouveau

12 Henry van de Velde at home in Weimar, *c*.1910. The house and its furnishings were designed by the Belgian. Even the cushion cover is a fabric of his own design

school there. Realizing the implications of industrialization and the potential of the machine, he reorganized the school's curriculum in an attempt to reconcile traditional craftsmanship and mechanized production. 'Whether and when it will be possible to transform the great technical achievements of our age into the expression of a mature, elevated art,' Behrens wrote, 'is a question of the greatest importance, of significance for the history of human culture.' The Düsseldorf school was one of the earliest German attempts to give art education a modern face. Significantly, Gropius' future partner, Adolf Meyer, was educated there.

Behrens then left Düsseldorf for Berlin where he joined the AEG. For a few months Charles Edouard Jeanneret, later to call himself Le Corbusier, worked as a junior in Behrens' private architectural practice. So, too, did two future directors of the Bauhaus: Walter Gropius and Ludwig Mies van der Rohe. Behrens' ideas and activities were therefore of some importance to the Bauhaus.

Gropius joined the Werkbund in 1912, taking an active part in its organization and policy-making. Another Werkbund member

22

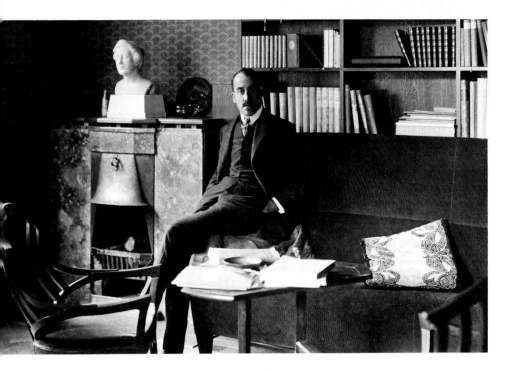

whose work and ideas were of importance for the Bauhaus was
Henry van de Velde (1863–1957), a Belgian who had begun, like 12
Behrens, as a painter (as one of the best of the second generation of
Neo-impressionists) but, believing that painting was not the best
medium in which to meet what he saw as his social responsibilities,
had then become a designer and architect. In 1901 he wrote: 'The
seeds that fertilized our spirit, evoked our activities, and originated
the complete renewal of ornamentation and form in the decorative
arts, were undoubtedly the work and the influence of John Ruskin
and William Morris.' Yet he designed objects which could be made
equally well by hand or the machine, and in 1897 declared his ideal
to be 'the thousandfold multiplication of my creations'.

In his essay 'Concept and Development of the State Bauhaus'
(published in 1924) Gropius acknowledges the school's debt to
'Ruskin and Morris in England, van de Velde in Belgium, Olbrich,
Behrens ... and others in Germany, and finally the German
Werkbund', all of whom 'consciously sought and found the first
ways to the reunification of the world of work with the creative
artists'.

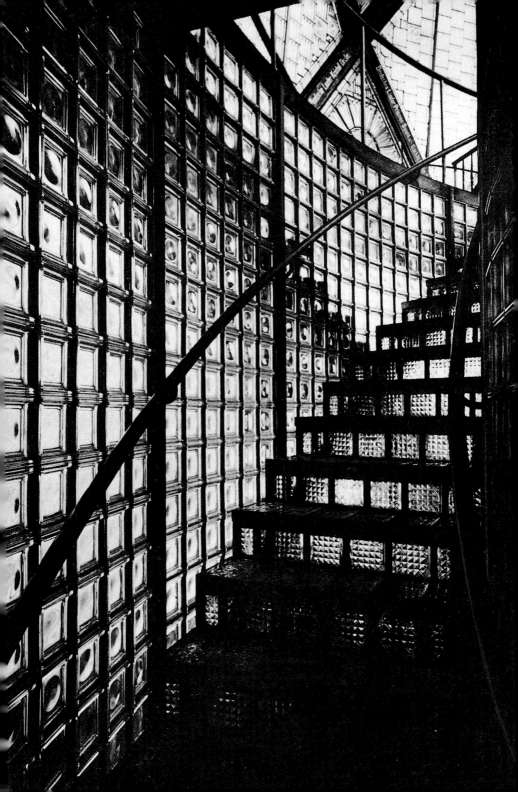

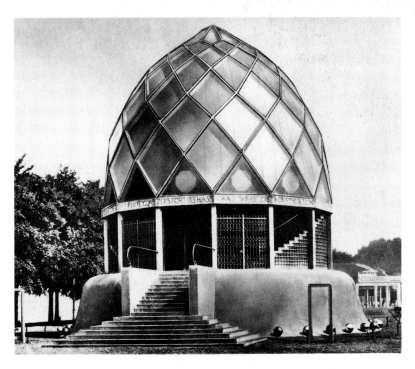

13, 14 Bruno Taut's Glass Pavilion at the Cologne Werkbund exhibition, 1914. Even the stairs (*left*) were constructed of translucent glass bricks. Like all the other buildings on the site, the pavilion was demolished after the exhibition

The Bauhaus' debt to van de Velde, at least in practical terms, was the largest debt of all. At the start the school was little more than the continuation in Weimar of the activities of van de Velde, who had been summoned to the city in 1902 'to provide artistic inspiration to craftsmen and industrialists by producing designs, models, examples and so forth'. This private 'Arts and Crafts Seminar' was 'an institute to support the work of craft and industry, more precisely a kind of laboratory where every craftsman or industrialist could be given free advice, have his products analysed and improved'. Van de Velde thus realized the dream of 'co-operation between artist, craftsman and industrialist . . . six years before the foundation of the Werkbund and twenty years before that of the Bauhaus'. His school became public in 1907. The Bauhaus began life in buildings designed by the Belgian; Gropius 24 was offered the directorship at van de Velde's suggestion; much of the curriculum attempted to keep alive van de Velde's ideas.

The tone of the 1919 Bauhaus Manifesto is vague, ecstatic and utopian. In this respect it draws upon neither Behrens nor van de Velde, but upon the Expressionism of the pre-war years. As though to advertise its provenance, it is illustrated with a woodcut (itself a preferred Expressionist medium) in the Expressionist splintered and dynamic style.

Expressionism urged social change and even revolution: these were to flow naturally out of a profound change in human consciousness. Art, the Expressionists fervently believed, could change the world.

At the exhibition organized by the Werkbund in Cologne in 1914 there had been buildings specially designed by van de Velde and Gropius, but also a curious structure with a dome made of panes of different coloured glass, the brainchild of Bruno Taut. Inspired by the writings of Paul Scheerbart, who was not an architect but an author specializing in the fantastic and bizarre, Taut used coloured light and dramatic shapes (made possible by modern materials) to create a highly imaginative building. Around the string-course of this 'Glass Pavilion' were inscribed a number of statements specially written by Scheerbart, such as 'Coloured glass destroys hatred'.

Taut was but one of several Werkbund members who designed buildings in a style that can be described, however loosely, as Expressionist, and he dreamed of fantastic utopian projects through which the architect might reshape the world and human consciousness. The ideas which the Bauhaus attempted to realize are related to Expressionist notions in several important ways. Gropius hoped that his school would become a source of social change through art: by stressing the importance of collaborative work it sought to mould the character of its students whilst training them to be craftsmen and artists.

Even the belief in the importance of creating a synthetic, 'total' work of art by combining a number of previously separate disciplines and media has parallels in Expressionism, and may explain why so many of the artists Gropius brought to Weimar to teach had strong Expressionist connections.

3 art education reformed

In 1914 the Weimar Kunstgewerbeschule was but one among eighty-one German institutions specializing in art education in one form or another, and of these no fewer than sixty-three included craft departments. Although many were little more than places where elementary skills were taught, their large number relative to the academies testifies to the efforts made in Germany since the late nineteenth century to bring the crafts and fine arts into close communion, and to find alternatives to the academic system.

The desire for educational reform led in Germany to two fundamental demands. The first was that all art education should be based on craft-training; the second that, since students were forbidden to specialize, the schools should embrace as many activities as possible. The fine arts were to find their place alongside the greatest possible variety of craft skills and, wherever possible, architecture and engineering as well. The term *Hochschule für Gestaltung* (best but imperfectly translated as Institute for Design) was coined to describe this novel kind of establishment long before Gropius applied it to the second incarnation of the Bauhaus at Dessau.

A further demand was for a solution to the vexed question of 'academic freedom', that pillar of German higher education which gives every student the right to study at his own pace and take the final examinations whenever he feels ready. This resulted in a large number of 'professional' students, some of whom were still at university or art school when approaching middle age. The reformers insisted that the discipline of a fixed period of study was long overdue and the course at the Bauhaus was rigidly structured and had to be completed at a fixed time.

Most of the reformers agreed that an essential part of the syllabus would be a general preliminary course during which the innate artistic talent of the student would be brought out, and he

27

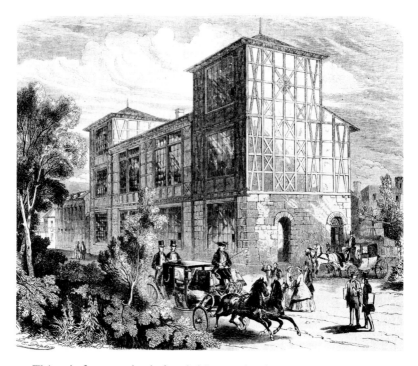

15 Weimar's first art school, founded in 1860 by the Grand Duke of Sachsen–
Weimar

would be given experience of as many media and techniques as
possible so that he would recognize where his true abilities lay.

Behrens' Düsseldorf school of arts and crafts and the Breslau
Academy under the architect Hans Poelzig were but two of the
institutions which combined the teaching of fine art, architec-
ture and craft, and discouraged specialization.

Before and during the war the belief grew in Germany that the
reform of art education was vital for economic reasons. Germany,
unlike America or Britain, was not especially rich in raw materials,
and therefore relied more heavily on the expertise of its skilled
labour force and the ability of its industry to export sophisticated
and high-quality goods. There was a growing need for designers,
which only a new kind of art education could meet.

This explains why even during the war, negotiations were
begun between Gropius and Weimar officials who wanted to
reopen the school of arts and crafts as soon as hostilities were over.

28

(Van de Velde who was an enemy alien had resigned and the school had been closed for the duration.) It also explains why the professors of the Weimar Academy of Fine Art, founded in 1860, 15 came to the startling conclusion that educational reform was in their interests, too. In the event, it was they and not the bureaucrats who proposed a merger of their institution and a re-opened school of arts and crafts, and it was they who selflessly concluded that the new establishment should be headed not by one of their own number (fine artists to a man) but by an architect.

Gropius was therefore appointed in 1919, not to found a new school, but to direct the amalgamated academy and Kunstgewer-beschule. Even though he was given permission to name the amalgam 'the State Bauhaus' soon after he became director, the school remained during the first academic year more like the former academy than any reformed institution. It inherited four professors from the academy and it inherited their students.

The choice of the name Bauhaus for the amalgamated school is revealing. Although the noun *Bau* literally means 'building', it evokes associations in German which Gropius clearly intended to exploit. In the Middle Ages the *Bauhütten* were the guilds of masons, builders and decorators, out of which, incidentally, the freemasons sprang. *Bauen* also means 'to grow a crop', and there can be little doubt that Gropius intended the name of his school to evoke the idea of sowing, nurturing and bringing to fruition. Craftsmen were to be trained to combine their skills on building-projects. Their collaboration was to be inspired by the example of the medieval guilds, and a community was to be formed at the school which would be as exclusive as freemasonry.

The professors from the former academy were probably un-aware of what they had let themselves in for. Max Thedy, acting director of the academy until Gropius arrived, was ageing, conservative and proficient in figure-painting. Richard Engelmann was a sculptor of equally academic bent and Walther Klemm a printmaker and draughtsman of marked but unadventurous talent. They continued to teach according to the conventional studio-method in which they themselves had been trained.

For Gropius the word 'professor' reeked of academicism and he did away with it, not only to proclaim to the outside world that the Bauhaus was proudly anti-academic, but also, by calling teachers

'masters' and students 'apprentices' and 'journeymen', to announce that his school was to be craft-based and a part of the real, working world.

Reality was also introduced in the form of a probationary period followed by a rigidly structured course. Four years was the maximum any student could remain at the Bauhaus. The days of students staying on indefinitely, enjoying their freedom and the facilities for as long as they saw fit were now over. Students who had enrolled at the Weimar Academy long before the war and were determined to remain firmly ensconced in the best studios were now summarily ejected by Gropius.

Workshops, not studios, were to provide the basis for Bauhaus teaching. Workshop training was already an important element in the courses offered by several 'reformed' schools of arts and crafts elsewhere in Germany, but what was to make the Bauhaus different from anything previously attempted was a tandem system of workshop-teaching. Apprentices were to be instructed not only by 'masters' of each particular craft but also by fine artists. The former would teach method and technique while the latter, working in close co-operation with the craftsmen, would intro-duce the students to the mysteries of creativity and help them achieve a formal language of their own. These artists were to be known as 'Masters of Form' while the craftsmen, theoretically their equals in every way, were called 'Workshop Masters'.

The nature of the preliminary course (*Vorkurs*) was also some-thing which distinguished the Bauhaus from all other 'reformed' schools in Germany. It seems that Gropius did not originally intend to introduce such a course, and that he was persuaded to do so by Johannes Itten, one of his first appointments to the staff. The *Vorkurs* appeared on an experimental basis in the autumn of 1919 and was made compulsory a year later. Once under way, however, the *Vorkurs* quickly became a crucial part of the Bauhaus cur-riculum. It was also regarded as a probationary period: if a student performed unsatisfactorily in the *Vorkurs* he was not allowed to proceed to workshop training.

Preliminary course and workshop training: these were the fundamentals of the Bauhaus Gropius hoped to create. In 1919, however, it must have seemed as though those hopes would never be realized.

4 the founder

When the Weimar Bauhaus opened its doors Walter Gropius was only thirty-six but already widely regarded as one of Germany's leading younger architects. Some measure of his reputation is provided by the fact that in 1915 Alma Mahler had agreed to marry him: the Viennese widow of the composer was one of the shrewdest, as well as one of the most celebrated beauties of the age. According to Frau Mahler, the Gropius she first met (after ending a stormy affair with the painter Oskar Kokoschka) 'would have been well cast as Walther von Stolzing in *Die Meistersinger*'.

The Gropius of the early Bauhaus was not entirely the same man as the Gropius of the pre-war years. He had seen action as a cavalry 16 officer and terrifying evidence of the destructive power of machines had led him to modify his once-optimistic view of the benefits of mechanization. Previously apolitical, he had come to sympathize with the Left and to share its belief that only radical social reform could cure Germany of its ills.

Gropius' changed beliefs help explain the character of the early Bauhaus: the emphasis on craftsmanship rather than machine-production, the attempt to establish an ideal community in miniature, the employment as staff of painters with utopian leanings, and the teaching programme which aimed to develop the student's personality as well as provide technical skills, were all aspects of a desire to reform not merely art education but society itself. Little of this seems to have been anticipated in Gropius' earlier activities.

Walter Gropius was born in Berlin on 18 May 1883 into a family with strong architectural and educational connections. A grandfather was a well-known painter and friend of the famous architect Schinkel; a great uncle had designed the Berlin Museum of Arts and Crafts and had been director of the school associated with it.

31

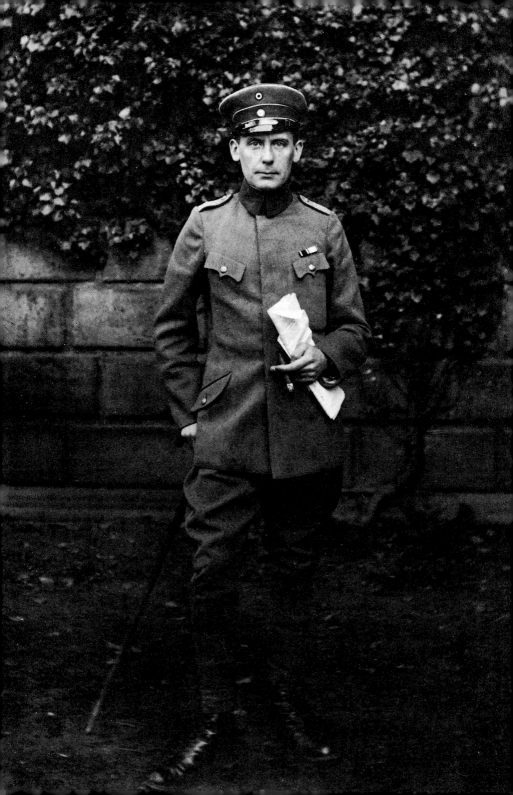

Gropius' father was also an architect. Walter Gropius studied architecture in Munich and Berlin. He qualified quickly – in only five semesters – interrupting his studies once, to spend a year as a volunteer with the fifteenth regiment of Hussars. Once qualified, he joined the Berlin practice of Peter Behrens in 1907, the year of Behrens' appointment as chief designer to the AEG.

Three years later Gropius left Behrens to open his own practice, and almost immediately received the commission which made his name: the Fagus factory for the manufacture of shoe-lasts at Alfeld on the River Leine, a small town near Hildesheim. The building 19 which Gropius designed with Adolf Meyer (his partner for many years to come) was startlingly ahead of its time, especially in its novel use of steel and glass as substitutes for conventional load-bearing walls.

This building was not the only evidence that Gropius was rethinking fundamental problems of design and construction. In 1910, some months before the Alfeld factory was finished, Gropius wrote to Walther Rathenau, the president of the AEG and an influential economist and politician, proposing the establishment of a company to construct dwellings for working families from prefabricated and standardized parts.

Further evidence of Gropius' determination to come to terms with fundamental problems and principles is provided by his involvement with the Werkbund, that loose organization of architects, designers and industrialists which was briefly described in Chapter 2. He left his mark on the Werkbund in several ways. Together with van de Velde he led the faction which opposed Muthesius' demands for standardization. Muthesius advocated the introduction of national norms – standard sizes for everything – and Gropius believed that Muthesius' policy would eliminate individual creativity by imposing a straitjacket on designers and architects alike.

In the Werkbund spirit Gropius tried his hand at designing furniture, wallpaper, a diesel locomotive and the fittings for a 17 railway carriage. Collaborating again with Adolf Meyer, he was 18 also responsible for a small model factory for the Werkbund 20 exhibition at Cologne in 1914. With its daring forms and use of a glass façade which revealed rather than concealed much of the building's internal workings, this factory was as original as the Alfeld project.

33

16 Walter Gropius as a cavalry officer during the First World War

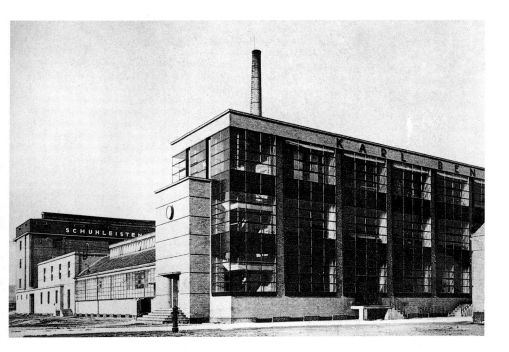

17–20 Pre-war designs by Walter Gropius *Opposite, above* Diesel railway locomotive 1912. *Opposite, below* Compartment in a Mitropa sleeping car, *c.*1914. *Above* (with Adolf Meyer) Fagus shoe-last factory at Alfeld-an-der-Leine, 1910–11: the main wing with workshops. *Right* (with Adolf Meyer) Office building at the Cologne Werkbund exhibition, 1914. This and Gropius' model factory beside it were demolished after the exhibition closed

Within weeks of the opening of the Werkbund exhibition war broke out. Not much is known about Gropius' war service other than that he saw combat on the Western Front (he was on the Somme in 1917), was badly wounded, was awarded the Iron Cross twice and was not demobilized until 18 November 1918. He had married in August 1915 and his wife gave birth to a daughter, Alma Manon, in the following year.

In 1915 Gropius' name was one of the three put forward by van de Velde as his possible successors as director of the Weimar Kunstgewerbeschule. Although he was plainly a modernist, a man with the kind of ideas foreign to such a conservative city, and devoid of teaching and administrative experience, Gropius was immediately sounded out by the authorities and invited to put in writing his view of the future of the school.

By January 1916, when Gropius delivered a paper to the Weimar authorities outlining his proposals, the school had already been closed, its buildings requisitioned as a reserve military hospital. The paper was nevertheless taken seriously. It was cleverly composed and based on close knowledge of local economic and social conditions. Economically the Grand Duchy of which Weimar was the capital was underdeveloped. Apart from the city of Jena, the location of the world-famous glass-manufacturer Schott and of the photographic and optical firm founded by Carl Zeiss, there was little modern industry within its borders, and the number of skilled craftsmen and small tradesmen was higher than in most other parts of Germany. The craftsmen had long since felt the draught of mechanization.

Gropius' paper therefore began with a general examination of the way mass production had caused the decline of traditional craftsmanship. It proposed the creation of a 'partnership between the artist, industrialist and technician who, organized in keeping with the spirit of the times, might perhaps eventually be in a position to replace all the factors of the old, individual work'.

The student, already a trained craftsman, would come with his design commissions to the school, would develop them artistically under his teacher's direction and would return to the factory or workshop to carry them out.

The Ministry of State in Weimar thought well enough of the proposals but no decision was taken about the future of the

Kunstgewerbeschule. More urgent problems supervened. Gropius, however, did not forget, and as soon as the war was over he wrote to the authorities reminding them of the earlier negotiations and stating that: 'I have immersed myself for a long time in the idea of giving Weimar a new kind of artistic life, and have very specific plans for doing so.' In February and March 1919 he travelled frequently to Weimar to discuss those plans with, among others, August Baudert, the head of the provisional republic of Thuringia. He also tried to enlist the support of locally influential people, among them Ernst Hardt, director of the Weimar theatre. On 1 April Gropius was appointed director of the Academy of Fine Art, and on 12 April he received permission to unite that institution with the re-opened school of arts and crafts.

Two days after that he wrote to Ernst Hardt outlining his long-term plans:

My idea of Weimar is not a small one ... I firmly believe that Weimar, precisely because it is world-famous, is the best place to lay the foundation stone of a republic of intellects ... I imagine Weimar building a huge estate around the Belvedere hill with a centre of public buildings, theatres, a concert hall and, as a final aim, a religious building; annually in the summer great popular festivals will be held there ...

Mentally and physically scarred by the war, Gropius seems to have arrived in Weimar with a firm political commitment. Like 'every thinking person', he had, as he put it, sensed 'the necessity for an intellectual change of front'. He had come to believe that 'capitalism and power-politics have made our species creatively dull and a broad mass of bourgeois philistines are suffocating living art. The intellectual bourgeois ... has demonstrated his inability to support a German culture.'

Gropius shared at least some of the aims of the left-wing revolutionaries. In a speech given in Leipzig in 1919 he condemned 'the dangerous worship of might and the machine which led us over the spiritual to the economic abyss'. He also joined, and early in 1919 became chairman of, the recently founded, left-wing association of architects, artists and intellectuals, the Arbeitsrat für 21 Kunst (Working Soviet for Art), whose aim was to involve creative people directly in the forging of a new social order. According to its manifesto (written by Bruno Taut), 'Art and the

37

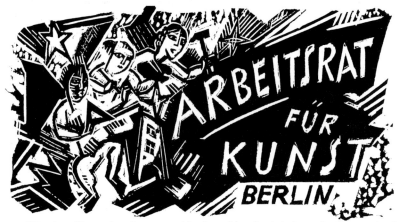

21 Woodcut illustration for a pamphlet issued by the Arbeitsrat für Kunst, April 1919. In the Expressionist style, it was probably executed by Max Pechstein

people must form a unity'; and, according to an essay written by Gropius for one of Arbeitsrat publications, 'the true task of the socialist state is to exterminate this evil demon of commercialism and to make the active spirit of construction bloom again among the people'.

Gropius was also a member of another left-wing artists' organization in Berlin after the war, the Novembergruppe, but if he ever was a socialist, then his socialism was of the utopian kind; and if he ever sympathized with the aims of any single party, then that sympathy soon gave way to abhorrence of all organized politics. In June 1920 he wrote to a friend: 'We must destroy parties. I want to found an unpolitical community here.'

The Bauhaus needed to be an 'unpolitical' community, lest its political opponents use its own beliefs against it. In March 1920, six days after a group of strikers had been shot dead in Weimar, their funeral was attended by hundreds of sympathizers including Bauhaus students who carried banners made on the school premises. 'The Bauhaus', according to Alma Mahler, 'was fully represented, and Walter Gropius . . . regretted that he allowed me to dissuade him from taking part himself. But I wished only that he should not engage in politics.' Gropius himself fervently wished that his students would not engage in politics, and on 24 March he

38

wrote to eight of them expressing the school's disapproval of their demonstration at the funeral. Not long after, however, a monument to the dead strikers designed by Gropius was erected in the Weimar cemetery.

This monument was commissioned by the local Trades Unions who chose Gropius' design from several submitted. It was made in concrete with the assistance of the stone-carving workshop at the Bauhaus, and has much in common with the fantastic Expressionist architectural projects of some of Gropius' fellow Werkbund members. A squat, angular column like a huge crystal projects up at an angle from a low, roughly circular enclosure. The monument not only betrays Gropius' political sympathies, it also demonstrates that his approach to building underwent a change in keeping with those sympathies. No-one could have imagined that the creator of the Fagus factory would design anything like this.

22

22 Walter Gropius' Monument to the March Dead in the main cemetery of Weimar, concrete, 1921. Badly damaged during the Nazi period, it has since been restored

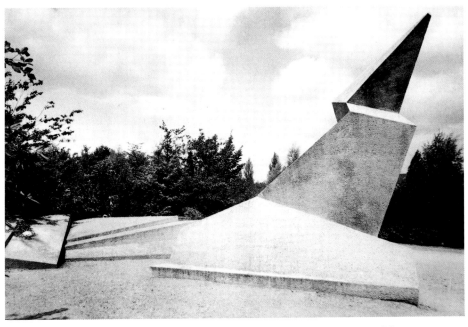

An essay Gropius wrote for the Arbeitsrat für Kunst to accompany an exhibition of utopian architecture held in Berlin in April 1919 reveals the way he was thinking at the time. It calls for 'the creative conception of the cathedral of the future, which will once more encompass everything in one form – architecture and sculpture and painting'. More surprisingly, it is disdainful of functionalism in design: 'Things shaped by utility and need cannot still the longing for a world of beauty built completely anew, for the rebirth of that spiritual unity which rose to the miracle of the Gothic cathedral . . .'

If Gropius' thinking at the period of the foundation of the Bauhaus is relatively easy to understand, his day-to-day involvement is less clear. He was extraordinarily busy with administration, securing funds, handling public relations, selecting staff and students, and with his architectural practice which continued to function. In addition to his responsibilities as director, he took charge of the cabinet-making workshop when it was started in 1921. Until 1920 his living arrangements were temporary; then he moved into an unfurnished flat where he lived alone. Alma Mahler stayed in Vienna where she had begun an affair with the writer Franz Werfel, something Gropius had known about since 1918. Until they were divorced in 1920, she travelled to Weimar occasionally on the rare occasions when Gropius wanted her to help him entertain important guests. Gropius remarried in 1923.

Gropius was a sound administrator, politically shrewd, and, when he needed to be, an adept manipulator of people and events. His correspondence shows that his directorship of the Bauhaus was not just another job but the centre of his life. While he was director, everything, including his private architectural practice, took second place. He was tireless in his defence of the school and of the interests of the students. Conflicts within the school were serious enough, but they were as nothing compared to the opposition to the Bauhaus which came from outside.

5 problems

The year 1919 was an inauspicious one for the foundation of anything in Germany, let alone an art school run along new lines. Following its defeat and the abdication of the Kaiser, the country was in chaos.

Weimar, although it remained relatively free from political unrest, was also an inauspicious location: with about forty thousand inhabitants, it was small and had almost no industry. As former capital of a Grand Duchy with a proud cultural past, it mistrusted the new-fangled. Its narrow streets, lath-and-plaster houses, pleasant squares, small castle and landscaped park gave it an idyllic air. Goethe and Schiller had lived and worked there; so too, had the two Cranachs, J. S. Bach, Wieland and, more recently, Liszt. Herder, that key figure of the German Enlightenment, had been a priest in Weimar for many years, and, no doubt trusting that there was something in the air conducive to the creation of great literature, scores of minor writers settled in the city during the nineteenth century. In 1900 Nietzsche died in Weimar. The legacy of Goethe and Schiller hung like an albatross around the city's neck.

In 1919 Weimar became the capital of a provisional federal state whose final form would depend on a new national constitution. The National Assembly which was elected on 19 January and first sat on 6 February 1919 to draw up the constitution, met, not in Berlin, but in the National Theatre in Weimar where, it was believed, it would not be troubled by the kind of guerilla warfare raging in the capital. Even so, a contingent of soldiers was sent to Weimar. On 5 April a large demonstration against the National Assembly took place, and a week later the unemployed of the city protested violently against – among other things – the unfair distribution of food. It was precisely during that troubled period – on 11 April – that Gropius arrived in Weimar to sign his contract.

23 Walter Gropius in 1920

24 Weimar Academy of Fine Art, built by Henry van de Velde between 1904 and 1911. After 1919 it housed the administration, classrooms and studios of the Bauhaus. The view is from the main entrance of van de Velde's school of arts and crafts which the Bauhaus also absorbed

In Weimar as elsewhere the provisional nature of the local government resulted at first in administrative chaos. There was scarcely any public money available for anything, and even if there had been, no-one would have known who had the right to apportion it.

It was fully a year after the Bauhaus had opened its doors that the new German Republic decreed the shape and administrative form of the country. Weimar became the capital of the federal state of Thuringia. The Bauhaus became the responsibility of the Thuringian Ministry of Education and Justice.

In view of such administrative chaos it was a miracle that the Bauhaus got under way at all. In view of the lack of money and proper facilities it was an even greater miracle that the school managed to survive. It was housed partly in the old school of arts 24 and crafts, partly in the former academy. These institutions were very close together (on opposite sides of a narrow and quiet street), but not all their rooms could be occupied immediately. Parts of the Kunstgewerbeschule used during the war as a military hospital and for storage had not yet been cleared. In 1919 some of the rooms were occupied by troops guarding the National Assembly. Most

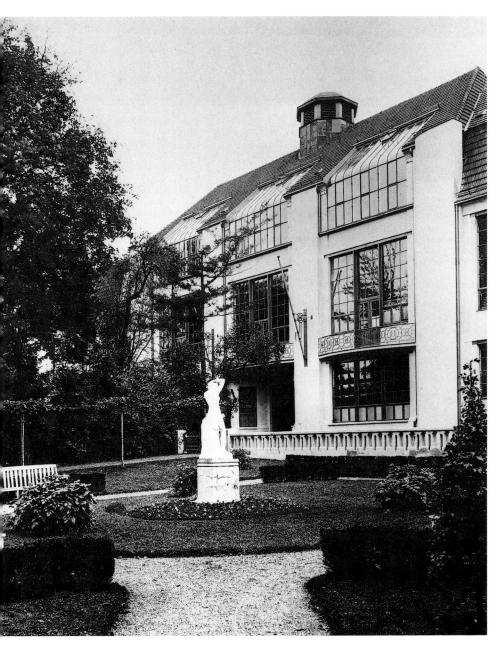

of the rooms had no artificial light, a few had gas-illumination. Fuel for heating was a problem for several years, partly solved (in 1919 at least) by a typical piece of directorial inspiration. Gropius made an arrangement to collect coal directly from a mine in hired trucks which were loaded by students in exchange for meal tickets.

Perhaps even more serious than the lack of space and adequate heating was the lack of essential tools and equipment for the few workshops in operation. As late as March 1920 Gropius was pleading with the authorities for immediate aid: 'We cannot work without materials and tools! If help does not speedily arrive I think the future existence of the Bauhaus is in doubt. Many must leave the school or want to leave it because they are unable to work.'

Such difficulties were compounded by opposition to the Bauhaus from several sections of the Weimar populace. Some of the most vocal came from small businessmen and craftsmen who believed that the school threatened their very existence. Other opposition came from nationalists who suspected the Bauhaus of Communist sympathies. As early as December 1919 a protest meeting was called in the city at which the Bauhaus was criticized by, among others, one of its own students, for not doing enough to develop an artistic consciousness that was thoroughly and obviously German. The criticisms were taken up in the local council and Gropius' reply to a council-member makes the nature of the objections plain. He assures her that the school's students are all German-speakers of German origin, and that 'only 17 students are of Jewish *extraction* of whom *none* has a grant and most have been baptised'. All the others, he writes, 'are Aryans'.

Further opposition came from another quarter which believed that the Bauhaus had not so much absorbed the former academy as smothered it. The staff of the older institution who remained at the Bauhaus to teach, quickly turned against Gropius and agitated for the reinstatement of the academy. In January 1920 Max Thedy wrote to Gropius accusing him of 'breeding an artistic proletariat ... I am convinced that after completing their training at the Bauhaus the young people will not be adequate as craftsmen let alone as painters'. Obliquely damning Gropius' view of the fine arts, Thedy added that 'the creations of Titian, Rubens, Velazquez and Rembrandt should not be described as "salon art" just because they were created as objects independent of any building. Painting

44

is an end in itself.' Thedy then withdrew his support for Gropius' plans for the school.

In September 1920 a split was authorized, and a school of painting was founded. Thedy and the other artists who had taught at the former academy now left the Bauhaus, taking twenty-eight students with them. In April 1921 the new institution became the State School of Fine Art: the revived academy by another name. Although Gropius must have been relieved to lose one source of opposition so quickly, he must also have been depressed to lose it in this way, for one of the pillars of his programme had now collapsed: the Bauhaus could no longer claim to unite the crafts and the fine arts under one roof. The new school still shared the buildings and facilities with the Bauhaus but there was much bickering about which institution was entitled to use what, to say nothing of who had the right to the lion's share of the budget.

Such controversies and the lack of facilities demoralized many students who had enrolled with high hopes. With great optimism to compensate for empty pockets they looked forward to a period of peace in which they might develop as artists. They found only what appeared to be insuperable difficulties. The school itself was in a shambles, and it was difficult to find anywhere to live. Most of the students put up at the youth hostel in the city while most of the staff found accommodation in guest-houses. A handful of lucky students were permitted not only to work in an adjacent building, but also to live there.

The only truly positive thing about the Bauhaus from the students' point of view was the canteen set up in the former military-hospital laundry. The canteen stayed open in the evening and provided staff and students with at least one nourishing meal a day. A limited number of students was able to eat for nothing after Gropius had persuaded several wealthy men in Weimar and elsewhere to donate 'free tables', and money for grants, in exchange for honours from the (socialist) Thuringian government. Even for those obliged to pay, a lunch or dinner in the canteen cost no more than ten pfennigs. Most of the vegetables were grown in the school's own garden, on some of the seven thousand square metres of land on the edge of the city leased to the school by the government. A full-time gardener was helped by students who were paid in food tokens. These were vital, since most of the

students were virtually penniless. The luckiest received money from home or perhaps earned two marks a night by acting as extras in the Weimar theatre. They were arriving for work at the Bauhaus already tired out by their extramural employment.

'Many of us spent the evenings at a factory which produced Thuringian peasant paintings,' a student remembered. 'We worked there for a few hours, mostly until midnight, and were paid immediately. As soon as the baker opened his shop in the morning we rushed there to buy bread. By mid-day the bread was already dearer: inflation was raging.'

The worst inflation Europe has ever known added considerably to Gropius' difficulties. Many students did indeed have absolutely nothing, and could not afford to buy shoes and clothing. Gropius found funds to acquire such things as shoes and trousers wholesale and they were distributed to the most needy.

The Bauhaus canteen quickly became the most important part of the school, the centre of its social life and the basis for what Gropius hoped would become a genuine community.

From the beginning Gropius was determined that the Bauhaus would become much more than a mere school. He hoped that the students would learn to live and work together in a miniature society which would serve as a model for society at large. For this reason he introduced what for the time was a startling degree of democracy: students were given two seats on the governing council of the Bauhaus and a student union was encouraged. Each workshop had an elected student-representative who was kept informed of all decisions, and the students generally organized many independent activities, among them lectures in art history and a regular Saturday hike.

Gropius knew that the kind of community he envisaged would only work if students and staff were able to live as well as work together. He therefore developed a plan to build a small estate on the plot of land leased to the Bauhaus by the state. The lack of money ensured that the plan came to nothing.

If most students shared Gropius' dream of an ideal community, not all of them understood or sympathized with his conception of an art education based on collaborative workshop-training. Most had enrolled in the hope that they would eventually become painters or sculptors, and were therefore dismayed not only by the

lack of space and materials but also by the minimal attention to fine art in the curriculum.

This dismay is understandable. Although Gropius' conception of a radically new kind of art education was made clear enough by his original Manifesto and although he seems to have had an aversion to easel painting, the men he employed to teach at the Bauhaus implied another approach entirely. Of the nine men he appointed as Masters of Form between 1919 and 1924 no fewer than eight were painters.

Initially, Gropius did not have a completely free hand. Since the Bauhaus emerged from an amalgamation of the former school of arts and crafts and the art academy it was obliged to honour the teaching contracts of the staff it inherited. The presence at the Bauhaus of former academy professors makes Gropius' decision to appoint yet more fine artists – however unorthodox they were – curious indeed. What did painters know of bookbinding, carpentry, metalwork or any of the other crafts which the school set out to teach?

Gropius' staffing policy may seem less eccentric if the personalities and special interests of the Masters of Form are borne in mind. The sculptor Marcks, Feininger, Itten, Muche, Schlemmer, Klee, Schreyer, Kandinsky and Moholy-Nagy, who arrived in Weimar at various times between 1919 and 1924, were all highly original and impressively articulate men. All were intrigued by theories about fundamental problems. Although all, with the major exception of Moholy-Nagy, were interested in ideas which might loosely be described as Expressionist, their work did not have much in common.

Important to Gropius' conception of the Bauhaus was the idea that the fine arts and the crafts were not fundamentally different activities but two varieties of the same thing. Painters, especially painters concerned with artistic theory and predisposed to embrace fresh ideas, were therefore better qualified in Gropius' eyes to teach craft apprentices than old-fashioned craftsmen with narrow horizons. Such painters could stress and explain the elements common to all artistic activities. They could give instruction in the effects and uses of colour, in form and composition, provide insights into the fundamentals of aesthetics. In short, they could use their experience as painters as an aid to the formulation of a new

47

grammar of design which in no way depended on historical examples. Their own painting was seen as a reservoir of creativity which would never run dry.

In any case these painters were not the only teachers at the Bauhaus. There were also the Workshop Masters, men skilled in their own particular craft. They were to equip students with manual skills and technical knowledge while the painters were to stimulate their minds and encourage creativity.

Although Gropius insisted that the head of each workshop should be a creative artist he set out to treat these and the Workshop Masters as equally as possible. To begin with he even paid them the same salaries.

Exciting though tandem-teaching might sound, it was not very successful. Most of the painters at the Weimar Bauhaus had little interest in the workshops and some were reluctant even to visit them. Several Workshop Masters failed to welcome the artistic direction offered by those Masters of Form prepared to provide it. Disputes were frequent in which the greater practical expertise of the craftsmen inevitably gave them the edge. This meant that the Workshop Masters became more important as teachers than Gropius intended. It also meant that the gulf between art and craft which the Bauhaus was pledged to bridge remained, at least at the beginning, almost as wide as ever.

The very existence of two types of Master perpetuated the cultural class system and the position of each within the Bauhaus hierarchy actually exacerbated it. For, in spite of all protestations to the contrary, the Masters of Form were generally treated better than their craftsmen colleagues. Although the vacations allowed each were theoretically the same (five working days annually at the start, four weeks later) the Masters of Form could, and always did, ask for permission to work outside Weimar for extended periods, an arrangement which usually took them to some watering place in the sun for most of the summer. Their teaching, unlike that of the Workshop Masters, officially ceased during the summer months and the absence of most of the painters from mid-July to the end of September was a foregone conclusion.

The painters also had more influence within the school than the Workshop Masters. All important decisions were taken by the 'Council of Masters' which consisted only of the Masters of Form

and student representatives and was not obliged even to consult the craftsmen before making up its mind.

Regular rumbles of discontent could be heard in the workshops. In May 1921 the Workshop Masters asked for an increase in salary. Unlike the Masters of Form, they argued, they were forbidden to earn extra money by selling their own work outside and they also wanted the kind of summer holidays enjoyed by the teachers at all other art schools.

In July 1923 the Workshop Masters were still complaining about the lack of equality and sent a paper to the director in which they criticized the Masters of Form for not taking enough interest in the workshops, for instructing students to carry out projects without the agreement of the Workshop Master and for an inadequate understanding of craftsmanship itself. They also drew Gropius' attention to the fact that in spite of their apparent equality the raging inflation combined with the intervals between salary-payments ensured they earned less than the Masters of Form. The salaries were poor in any case, much less than the craftsmen would have commanded outside the school. In 1920 the Union of Lithographic Printers complained to the Bauhaus that the Master in the printing workshop was earning less than the minimum Union wage.

The wide divergence at many points between Gropius' declared aims and what he did in practice cannot always be seen as the regrettable but necessary result of the compromises enforced by the lack of funds and facilities. The school claimed to be modern and forward-looking, yet its efforts to revive traditional crafts-manship smack of romantic medievalism. It was dedicated to breaking down the barriers between the fine arts and the crafts, yet it employed as teachers painters who were unable to throw a pot or make a dovetail joint and joiners and bookbinders who could neither paint nor sculpt. It proudly announced that the ultimate aim of all artistic activity was the building, yet had no proper department of architecture. As Schlemmer, who from the beginning perceived and criticized the school's major weaknesses, wrote in 1921: 'There are no architectural classes at the Bauhaus; none of the apprentices seeks to become an architect, or at least he cannot for that reason. At the same time the Bauhaus still stands for the idea of architecture's pre-eminence.'

Although there were no architecture classes as such, there were courses in building techniques and architectural drawing. Adolf Meyer, Gropius' partner in his private practice, became a part-time member of the Bauhaus staff as soon as the school opened, and although his appointment was clearly more in the interests of the firm than the school, Meyer did give regular instruction in technical subjects. Gropius also speedily made contact with Paul Klopfer, the director of the Weimar Baugewerkschule, the local, publicly funded building-trades school which trained masons, plumbers and carpenters and provided instruction in basic building and engineering theory and practice.

They agreed that Bauhaus and Baugewerkschule students could attend courses at the other institution. Teachers from the Baugewerkschule also gave regular lectures at the Bauhaus. In 1919 six Bauhaus students took part in the scheme and Klopfer lectured at the Bauhaus for four hours every week.

When Klopfer left the Baugewerkschule for a higher appointment in 1922 Gropius wrote to the Ministry urging that both institutions should continue to co-operate closely, and implying that an amalgamation would be in the interests of both. Nothing came of this and it seems that architectural studies at the Bauhaus were restricted after Klopfer's departure to a few regular lectures on theory. Meyer stopped teaching technical drawing in 1922.

This aspect of Bauhaus activities – like so many others – remains confused. It would clearly be wrong to maintain, however, that building had no place in the early curriculum and that Gropius intended it to have no place.

In view of the school's financial straits, the small number of workshops in operation and the presence until 1921 of an academic faction, it is surprising that anything was achieved at all. The difficulties go far to explain why theory loomed large at the Weimar Bauhaus: theory requires fewer facilities than practice.

6 the first appointments

Of the first three men Gropius appointed as Masters of Form once his own directorship was confirmed, two were painters and one was a sculptor with an interest in ceramics and print-making. The painters were Johannes Itten and Lyonel Feininger, the sculptor was Gerhard Marcks. All had connections with the Berlin gallery Der Sturm, which before the war had become the German centre of the international avant-garde and the focal point of Expressionism.

Of greatest importance for the school, although surely not as an artist, was the painter Johannes Itten (1888–1967), a man of strange 26
beliefs, a teacher of unconventional brilliance and a perplexing mixture of saint and charlatan. According to Lothar Schreyer, a future colleague, Itten 'knew with certainty that his insight was an event of global significance in the teaching of art'.

Itten was Swiss. Originally an elementary-school teacher trained in the Froebel method, he decided to become a painter relatively late and studied at the Stuttgart Academy where Adolf Hoelzel, one of the pioneers of abstraction, was teaching at the time.

When Gropius invited Itten to become a Master of Form, he was running his own private school in Vienna and developing an unconventional method of art teaching based partly on the techniques of Pestalozzi, Montessori and Franz Čizek. He was in contact with the circle around Arnold Schoenberg and with Adolf Loos who organized an Itten exhibition in the Austrian capital in 1919. Gropius may have known Itten's painting from exhibitions at Der Sturm; he probably knew little of his unconventional teaching and appointed him entirely on the recommendation of Alma Mahler. Itten was not even Gropius' first choice. The director had asked the Berlin Expressionist painter and stage-designer César Klein to come to the Bauhaus in April 1919. Klein had accepted, but failed to turn up.

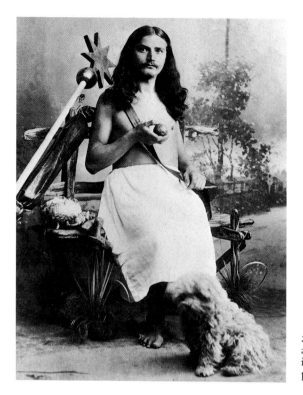

25 The wandering
apostle gustav nagel
in a Weimar
photographic studio

Itten's personality, behaviour and beliefs were little short of bizarre, so much so that they are often allowed unfairly to overshadow his considerable achievements as a teacher. Yet his beliefs and teaching methods are difficult to separate.

Itten was a mystic, an opponent of every materialist interpretation of the world and a disciple of one of the many new faiths and pseudo-religions that proved so popular in Central Europe before and after the war. Some of them infiltrated the Bauhaus. Adolf Meyer was a theosophist. Kandinsky, who joined the staff in 1922, had been influenced by Rudolf Steiner and anthroposophy. Several peripatetic preachers, prophets of arcane and extraordinary religions, appeared at the Bauhaus, among them gustav nagel who spelled his name thus because he urged, among other things and in anticipation of Bauhaus typography, that capital letters should be banned. Another wandering self-styled prophet was Rudolf Häusser who managed to convert a few Bauhaus students, taking them off with him on his pilgrimage.

25

52

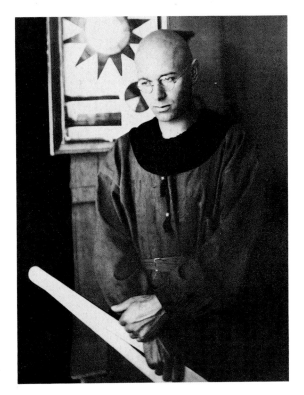

26 Johannes Itten in
the robe he designed
for himself

The faith that Itten followed was as strange as any. Called
Mazdaznan, it was derived from ancient Zoroastrianism, was
distantly related to the beliefs of the Indian Parsees and was the
creation of a German-American typographer who had given
himself the name Dr O. Z. (for Zarathustra) A. Ha'nish.
Mazdaznan saw the world as a battlefield on which evil
continuously challenges good for supremacy. (Good is represented
by the spirit Ahura Mazda of whom Zarathustra spake.) Mazdaz-
nan also held that what is commonly construed as reality is no
more than a veil obscuring a higher and more authentic existence.
In order to make the mind and body receptive to the true reality,
Mazdaznan prescribed a programme of physical and mental
exercises, a rigorous vegetarian diet and regular purification of the
system by means of fasting and enemas.

Itten followed the prescription to the letter and, as the outward
signs of his inner convictions, shaved his head and wore a long,
loose-fitting robe. Everything Itten did was informed by Mazdaz-

53

nan. As a teacher he believed that everyone was innately creative and that Mazdaznan could provide the key to unlock their natural artistic talent.

With Itten Mazdaznan virtually took over the Bauhaus for a time, for the Swiss was far and away the most important teacher there for more than two years. He was, to begin with, on the premises more than any of his colleagues and lived close to the school. Gropius made him Master of Form in more workshops than any other teacher, and soon after the Bauhaus opened, Gropius accepted Itten's proposal that every student should attend a preliminary course for six months before being allowed to proceed to any kind of workshop training. Itten was in sole charge of this preliminary course, was largely responsible for selecting students to attend it and therefore the Bauhaus itself. As a former student recalled:

After we had an interview with Gropius we still had to be passed by a kind of one-man Student Council. I remember my trepidation as I was led into the room, whitewashed and totally bare, except for a huge wooden cross on one wall. On a simple iron bedstead sat a haggard young man in a monk's habit. His cheeks were hollow, his eyes burned feverishly. He was one of Itten's most trusted pupils. 'Really a saint,' my companion whispered. The young man looked me over while my companion stood in respectful silence, then he said something in an ecstatic singing voice and nodded. He had seen none of my drawings and barely heard me utter a word but I had passed the test and was accepted. 'The master has complete trust in his intuitive judgement,' my companion explained after we had left the room.

It is a measure of the magnetism of Itten's personality that he persuaded about twenty of his students to adopt his habits of dress and behaviour and managed to establish so many practices at the Bauhaus that were clearly foreign to Gropius' thinking. He even persuaded the Bauhaus canteen to abandon conventional cooking and go over entirely to Mazdaznan macrobiotic recipes. Its staple fare was a garlic-flavoured mush which prompted Alma Mahler to remark that the most characteristic thing about the Bauhaus style was 'garlic on the breath'.

One of the students temporarily converted by Itten, Paul Citroen, wrote that the diet might have been excellent in more affluent times, but in impoverished post-war Germany his skin

looked grey or green because of it. The purifications prescribed included puncturing the skin all over the body which was then anointed with oil so that the tiny wounds began to suppurate and the system allegedly rid itself of its impurities.

But what of Itten's teaching? Since his methods have become familiar at many art schools throughout the world they might now seem less original and imaginative than they were at the time. His main achievement was the design and introduction of the Bauhaus preliminary course (*Vorkurs*).

Its critics have seen the *Vorkurs* as a kind of brain-washing in which everything students had previously learned was drummed out of them and they were made receptive to new ideas and methods. Its apologists prefer to see the primary aim of the preliminary course as the liberation of the creative potential dormant within each student.

Two of Itten's exercises were especially important. The first required students to play with various textures, forms, colours and tones in both two and three dimensions. The second demanded the analysis of works of art in terms of rhythmic lines which were meant to capture the spirit, the expressive content of the original. Before attempting such exercises the students were asked to limber up their bodies and minds by physical jerks, controlled breathing and meditation.

27–9

30–2

Alfred Arndt remembered attending Itten's *Vorkurs* on his first day at the school. Itten made the students repeat their 'Good morning' to him but 'thought that we were still sleepy, cramped. "Please stand up. You must loosen up, get really loose, otherwise you can't work! Turn your head! So! Still further! Your neck's still asleep . . ."'

The play-type of exercise owed something to the Dadaist habit of making collages and assemblages from every imaginable kind of material, something to Hoelzel, and even more to Froebel's ideas about education through play. According to Itten all perception takes place in terms of contrasts: nothing can be seen on its own, independent from something else of different quality. This is why so many of the tasks he set the students consisted of arranging in unison contrasting marks, tones, colours and materials.

The analytic type of exercise, although reminiscent of art historical compositional analysis, in fact had little to do with it.

27–29 Exercises from Itten's preliminary course *Right* V. Weber, study of materials, 1920–1. *Below left* W. Dieckmann, study of materials, 1920–1. Sticks, wire, bricks and other materials employed to extend the sense of touch and a feeling for the arrangement of textures. *Below right* K. Auböck, study of materials in three dimensions to produce a representational object

△ abc ist das Pythagoräische △
ac : ab : bc =

3 : 4 : 5

ad = b = Höhe d. △

$AC = \frac{4}{3} h$
$AB = \frac{3}{2} h$

Schnittpunkt AD ad = s = Centrum
der Gloriole deren Radius
$\frac{Dh}{4}$

30–2 Itten's analysis of Meister Francke's *Adoration of the Magi* (published in *Utopia*, Weimar, 1921).
Above left The original painting. *Above right* Rhythmical analysis with notes on the significance of the colours. *Left* Constructive analysis

57

It was concerned not so much with the way a painting was formally constructed as with how underlying structure actually contributes to a painting's meaning.

Itten also made his students observe and interpret the real world. He asked them to draw natural objects – stones, plants and so forth – not as an end in itself but to sharpen up their visual sense. Whereas the aim here was accuracy, Itten's life-drawing classes had a different purpose: not anatomical precision but the discovery and interpretation of what Itten believed to be the characteristic expression of each pose. As an aid to that interpretation music was played throughout each session. None of the exercises designed by Itten was seen as an end in itself. Each was simply a preparation, a stage on the road towards independent creativity.

At first Itten was also in charge of the workshops for carving, metal, stained glass and mural-painting. Although his influence in each was less than that of the craftsmen – the Workshop Masters – his preference for strikingly individual form over the requirements

33 M. Willers, 'dark-light study' from Itten's preliminary course, charcoal and pencil, 1921

34 M. Jahn, rhythmical study from Itten's preliminary course, charcoal and pencil, 1921.

Both drawings are results of Itten's insistence that his students should emphasize particular aspects of each given motif

of function is obvious in most of the work produced. Not much work was produced in any of the workshops at this time, however. The preliminary course dominated everything and encouraged more talk than action.

Itten's influence at the Bauhaus soon became a cause for concern, not only for Gropius who saw his position as director undermined and his original conception of the school subverted, but also for an increasing number of students who found Mazdaznan adherence tiresome. They also noticed that Itten frequently got things wrong. Judging the results of an exercise which required the students to draw 'war', Itten praised the work of someone who had not been called up as being the obvious expression of personal involvement, and condemned that of someone who had been wounded as romantic and fantastic. As we shall see, the debate about Itten within the Bauhaus soon resulted in a change of course.

The second most important of the first staff appointments at Weimar was that of Gerhard Marcks (1889–1981), widely known

35 Gerhard Marcks, *The Owl*, woodcut, 1921

36 Gerhard Marcks, *c.*1921

for his long, lean, elegant and faintly Gothic figure-sculptures and for his woodcuts, more medievalizing than Expressionist. Marcks 35 was a member of the Werkbund (in which capacity Gropius had come to know him) and had made ceramic decorations in the restaurant designed by Gropius and Meyer for the Cologne exhibition. He had also produced the models for a series of china animals manufactured by the Schwarzburg porcelain factory.

Unlike any other staff member at the Bauhaus (apart from Gropius himself) Marcks therefore had first-hand experience, however limited, of collaborating with industry, and was well-suited to the pottery workshop where he was appointed Master of Form.

The success of the pottery workshop after 1920 was encouraged by its relocation twenty-five kilometres away from the main school. Its organization and products will be described in a later chapter dealing with the tangible early achievements of the Weimar Bauhaus.

Marcks also contributed to Bauhaus production as a printmaker. Scores of his woodcuts were printed in the school's printing workshop.

The Master of Form in that workshop was Lyonel Feininger 36 (1871–1956). He was the third of the first trio of teachers to be appointed to the Bauhaus and was, in terms of practical, measurable results, the least important. Feininger was a German-American painter who had made the woodcut on the cover of the Bauhaus Manifesto. He was to remain with the school far longer 1 than anyone else, the only person, indeed, to be there from start to finish; but he did very little teaching, and none at all for more than half the years he was there.

When Gropius appointed him, Feininger was forty-eight and had been painting seriously only for twelve years. Before that he had been a highly successful cartoonist, producing beautiful comic strips for American newspapers and political drawings for German 37 magazines.

Feininger's angular graphic style anticipates the sharp linearity of his paintings, which became even more geometric under the influence of Cubism and – more important – of Robert Delaunay. Unlike the Cubists, however, Feininger was interested in painting landscapes and architectural motifs, and he was fascinated by

39 colour. The result was a series of pictures of medieval towns and villages in which the existing geometry of the subject is exaggerated and used as a key for subtle shifts of colour and tone. Many of these paintings are of places in the vicinity of Weimar where Feininger had a studio for some years before the war.

It may have been the architectonic character of Feininger's work which attracted Gropius, yet it is not clear what Gropius thought the painter could contribute to the Bauhaus teaching. Feininger himself later said that his 'mission at the Bauhaus' was 'to create atmosphere', but since he saw students on only one day each week (when he taught life-drawing) and used the print-making workshop almost entirely for the production of his own work, that atmosphere is difficult to define.

Itten, Marcks and Feininger remained the only full-time Masters of Form directly appointed by Gropius before the end of the school's first year. There was one other, part-time, member of staff who should be mentioned here, however. Gertrud Grunow seems to have given Itten support by instructing students individually in methods of meditation and relaxation, an activity officially described as 'harmonization' but characterized by Wingler as 'more like a psychological counselling service for the students'.

What of the Workshop Masters, whose responsibilities were scarcely less great than those of the Masters of Form?

Gropius experienced great difficulty in finding suitable people for posts which were unique in the world of art education. The Workshop Masters had to be gifted craftsmen, good teachers, sympathetic to the school's aims and able to work with the Masters of Form who inevitably possessed powerful personalities. As late as March 1921 Gropius was writing to fellow architects and art teachers urgently asking for the names of possible Workshop Masters. Advertising these posts in the usual way, he said, had proved fruitless and several of the men already appointed were obviously unsuitable.

In some of the workshops Gropius had been given no choice, however, since the technical equipment (and sometimes even the premises) belonged not to the Bauhaus but to independent craftsmen who leased them and their own services to the school. Otto Dorfner owned the bookbinding equipment, Helene Börner the weaving looms and Leo Emmerich the small factory for

37 Lyonel Feininger, *The Kinder-Kid's Relief-Expedition*, colour title-page for the comic section of *The Chicago Sunday Tribune*, 1906. The sharp angularities of the cartoons continued into Feininger's paintings

38–9 Feininger, *c.*1920, and (*far right*) his *Gelmeroda IX*, oil on canvas, 43 × 31½ in (109 × 80 cm), 1926

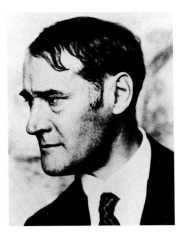

40 The cabinet-making workshop at the Weimar Bauhaus

making tiled stoves where the Bauhaus pottery was first situated. These three craftsmen inevitably became Workshop Masters. So, too, did Max Krehan who owned the pottery to which the Bauhaus workshop moved in 1920.

Most of the other appointments were of men who had already worked either for van de Velde at the Kunstgewerbeschule or for the art academy. They did not stay long at the Bauhaus. Thus Hans Kämpfe of the wood-carving workshop was replaced by Josef Hartwig in 1921, who in the same year also took over the workshop for sculpture which had already been led by two other craftsmen. Hartwig, by trade a stone-mason, was one of the few early successes. Another was Carl Zaubitzer. In charge of the printing workshop, he was a teacher the Bauhaus had inherited from the Kunstgewerbeschule. He adapted well to the new circumstances and remained with the school until it moved to Dessau.

41 The weaving workshop at the Weimar Bauhaus

Staff changes in the workshops founded after 1919 were also frequent. Christian Dell, who did much to modernize the products of the metal workshop, replaced Alfred Kopka in 1922; Reinhold Weidensee took over from Josef Zachmann in the cabinet-making workshop in the same year; two craftsmen preceded Carl Schlemmer (Oskar's brother) in the mural-painting workshop. Schlemmer himself handed over to Heinrich Beberniss in 1922 after leading an acrimonious and slanderous campaign against Gropius' directorship. The stained-glass workshop, the Cinderella of the Bauhaus, had no Workshop Master until Josef Albers was appointed in 1923.

The lack of information about the Workshop Masters both as men and teachers is frustrating. It is also revealing. In spite of Gropius' determination to elevate the status of the crafts, it was the fine artists who were the stars of the school.

7 the students

Those who first came to study at the Weimar Bauhaus had little in common. There were men, already mature and hardened by military service, some of them shell-shocked or maimed. There were boys who had begun to paint and sculpt at the academy or to learn a craft at the school of arts and crafts who simply remained with their teachers when the two institutions were amalgamated; there were the followers of Itten who came with him from Vienna; there were people already qualified as artists and teachers who were excited by the prospect of an entirely different kind of education. There were many women, most of whom were determined to take up weaving. There were so many women, indeed, that Gropius found it necessary to restrict the number admitted by raising the standard of competence demanded of them.

According to the Bauhaus prospectus of 1921 those applying to become students had to provide examples of their own work, a curriculum vitae, a statement of their financial situation, a medical certificate, details of any previous apprentice work and the written assurance of their local police force that nothing was known against them.

Applications were usually considered by Gropius and three or four Masters, of whom Itten carried the most weight, by some accounts. Fortunate students were accepted initially only for a trial period of six months and then became full members of the school only if their work in the preliminary course had been satisfactory. They could then choose the craft in which they wished to specialize. 43

Bauhaus students had to enroll formally as apprentices with the Weimar Chamber of Trade as soon as their trial period was over. Their freedom was more restricted than that of students in the fine art academies. Regular attendance in the workshop and in classes given by the Masters of Form was compulsory, and their holidays

42 Students in front of the workshop building in 1920. They had daubed the statue in the background with bright colours and, after protests, had just removed them

were short. More important still was the obligation to complete each stage of the course within a fixed period.

The sense of living in the real world was enhanced by the demand that students should do their best to produce work for sale. Materials were provided gratis by the school, and anything a student made was the property of the Bauhaus. If it was sold the student received some of the proceeds.

Bauhaus students were either apprentices or, if they had passed the first examination set by the local guilds, journeymen. Journeymen could prepare themselves for the final master's test. Some journeymen were employed by the workshops and were paid a small salary. Gropius believed their presence provided a vital link between the school and the world of work outside. Other than the outside examinations there were no tests at the Bauhaus and no grades were given. Work was reviewed from time to time by the Masters of Form and the Workshop Masters.

In the beginning, as we have seen, several students were bitterly disappointed by the school. Heinrich Basedow left the school in 1921 having 'been greatly stimulated but not having learned much'. According to Basedow: 'Gropius himself wallowed in his well-meaning, utopian ideas but the entire Bauhaus, apart from making propaganda, never actually *did* anything at all.' Basedow continues: 'Since no-one could be commanded to be an architect or craftsman either, everything stayed the same and even the most famous members of the Bauhaus remained nothing more than the usual, even though modernistic, rootless painters.'

Basedow was not the only student to leave, and almost all the students at the Weimar Bauhaus continued to paint, mostly in secret. Citroen (the Itten disciple) even specialized in portraiture, a genre regarded as even more moribund than landscape.

Bauhaus students, like art students everywhere before and since, were regarded by the townspeople as dirty, lazy, promiscuous and having too high an opinion of themselves. Defacement of public statuary and nude sunbathing provoked angry complaints.

Student life in Weimar was austere but must have been great fun. It is a tribute to Gropius and his staff that their students considered themselves an élite and would have done almost anything to defend the name of the school. They were conscious of participating in an experiment that was making history.

68

That consciousness did not prevent them from finding fault, and Gropius encouraged and frequently acted upon their criticisms and recommendations. One of the most frequent complaints was that the Masters of Form did not take part in school life sufficiently and were reluctant to show their own work to the students. On 1 February 1923 Ludwig Hirschfeld, a student representative, wrote an open letter to the Masters asking them to take part in as many social activities as possible. At present, he claimed, there was no personal contact at all between staff and students, and if the teachers remained 'so hopelessly cold and uninterested, then all the administrative attempts to "make" a Bauhaus, the best teaching and lectures, will have been in vain . . .'. Hirschfeld reminded the Masters that the next student dance would be held at The Swan in Upper Weimar at eight p.m. two days later.

The students knew that Gropius could be relied upon for moral and financial support and the director was consequently very popular. Something of the students' feeling for him as well as of the atmosphere at the early Bauhaus emerges from a letter about the 1919 Christmas party from one student (Lis Abegs) to another (Gunta Stölzl).

Christmas was indescribably beautiful, something quite new, a 'Festival of Love' in every particular. A beautiful tree . . . beneath the tree every-thing white, on it countless presents. Gropius read the Christmas story, Emmy Heim sang. Gropius gave us all presents . . . then a big meal . . . Gropius served each person in turn. Like the washing of the feet.

It was never easy to get into the Bauhaus. There were few places (the total student enlistment was only 1,250, and on average only about one hundred students were at the school at any one time). Rejections after the six-month trial period were numerous.

Students whom the school suited, like Josef Albers, Joost Schmidt, Marcel Breuer, Theo Bogler and Gunta Stölzl, were successful from the moment when they first entered, and soon availed themselves of the opportunities of earning money by making things for sale. What distinguished them from the mal-contents was above all their willingness to acquire craft skills and to collaborate with others. Most of them were older than average.

Gropius' private practice frequently sub-contracted to the work-shops the furniture and fittings of houses that the director had

been commissioned to design. Schmidt, for example, worked on
49, 52 the Sommerfeld villa in Berlin, and Gropius ensured that he was
properly remunerated. Breuer, Albers and the other apprentices
108 and journeymen responsible for the interiors of the 'Haus am
Horn', built in 1923, were also paid current rates. In general,
138–9 however, it was the weavers who earned most from their
workshop.

The most striking characteristic of the moderately successful as
well as the subsequently famous Bauhaus students is their extra-
ordinary versatility. It would not be an exaggeration to say that
most of them had turned their hands to everything before leaving
the school and continued to develop an expertise in a wide variety
of areas afterwards. They could paint, take photographs, design
furniture, throw pots and sculpt. Herbert Bayer and Marcel Breuer
could design buildings as well. Franz Singer, one of the students
who followed Itten from Vienna, was interested only in painting
when he arrived in Weimar. At the Bauhaus he learned to master
several crafts, and after he had qualified he became an architect and
interior decorator, working much later as a consultant in London
for the John Lewis Partnership. Marianne Brandt, who joined the
Bauhaus in 1924 and became renowned for her adjustable metal
lamps, was also a talented painter, and made photomontages that
are witty, imaginative and clever. Such versatility testified to the
efficacy of the courses the students had followed and to the ability
of the Masters who had taught them.

43 Interview form for Luise Molzahn who was seen by Gropius, Itten, Muche,
Schlemmer and Feininger on 18 April 1921. All agree to accept her for a trial
period, i.e. on the preliminary course. Miss Molzahn, who lived in Weimar and
was the sister of Johannes Molzahn, a well-known Expressionist painter, failed the
course six months later and was therefore prevented from proceeding to an
apprenticeship in the weaving workshop

Zirkular.

Um Aufnahme ~~Wiederaufnahme~~ in die Großh. Sächs. Hochschule für bildende Kunst

in die Frauenabteilung ersucht

Luise Molzahn, Weimar

Das Lehrerkollegium wird gebeten, über das Gesuch abzustimmen. Die eingereichten Arbeiten und Papiere folgen anbei.

Bemerkungen:

26 Jahr alt. Ärztliches Zeugnis fehlt

Weimar, den _18. April_ 19_21_

Satzungsgemäß (§ 5, Abs. 8) zur Probearbeit in

Abstimmung laut § 5, Abs. 9

44 Max Krehan (seated in the centre) and apprentices in the pottery workshop, Dornburg, *c.*1924

45 Beaker by Theo Bogler with two portraits by Gerhard Marcks, 1922. The portrait facing is of Otto Lindig, a journeyman in the pottery workshop. Marcks made few pots himself, preferring to decorate the work of others before the final firing

8 achievements

In July 1919 when the first (internal and private) exhibition of
students' work was staged at the Bauhaus, the speech Gropius
made at the opening made it clear that he was bitterly disappointed
by what he saw. 'We live in dreadfully chaotic times,' he said, 'and
this small exhibition is their mirror-image.' The work was bad
and, worse, it was dilettante. Gropius reminded the students 'that a
whole group of you will unfortunately soon be forced by necessity
to take up jobs to earn money, and the only ones who will remain
faithful to art *will be those prepared to go hungry for it.*'

There was a dilettante atmosphere at the Bauhaus for some
considerable time. As we have seen, some students preferred to
paint and sculpt rather than spend time in the workshops which
lacked fundamental equipment in any case. In most of the
workshops, moreover, the school's aim of gaining financial
autonomy through sales of Bauhaus products seemed like a wild
dream. There were two exceptions to this, however: the weaving
and pottery workshops, both of which soon managed to sell their 44
wares and win outside commissions.

There were no facilities for pottery in the Bauhaus buildings and
no money was available to install them. After an arrangement with
a factory which produced tiled stoves in the city proved impracti-
cal and ceased in the spring of 1920, a pottery workshop was set up
in the stables of a small Rococo castle at Dornburg, a town 25
kilometres distant from Weimar and not easy to reach by road or
rail. At the start five women and two men studied there.

The lack of adequate premises in Weimar paradoxically resulted
in the creation at Dornburg of a Bauhaus outpost which quickly
realized many of the school's original aims while the headquarters
were still floundering. The distance from Weimar ensured that
Marcks (the Master of Form), Max Krehan (a potter who owned 45
the pottery and was necessarily appointed Workshop Master) and

46–8 Products of the pot-
tery workshop. *Right* Max
Krehan, *Poron*, c. 1923.
Centre Gerhard Marcks and
Theo Bogler, tall double
pot, 1921. *Far right* Otto
Lindig, pot with lid, 1924

their team remained largely immune from the controversies and
clashes of personality which threatened the main Bauhaus, while
the tiny scale of the pottery workshop helped the rapid growth of a
close community and genuinely democratic working environ-
ment. More important still, in terms of what Gropius hoped for
the entire Bauhaus, was the way in which the pottery workshop
operated in close co-operation with the local community in which
it found itself. It made pots for the community and the town of
Dornburg leased the workshop a plot of land which the students
used for vegetables and on which, it was hoped, they would build.
Gropius was pleased to note that 'the boarding-school character' of
Dornburg 'comes closest to Bauhaus intentions'.

In Dornburg, theory was largely irrelevant since pottery had to
meet real and obvious needs. Krehan was unaware of the current
debates about art and society and the relative merits of artists and

craftsmen, and the students were obliged to get on with the tasks they were given. Designs for industry – prototypes for the manufacture of pots – were produced there several years before any of the other Bauhaus workshops were in a position to do anything similar. Marcks' activities as a Master of Form were close to Gropius' intentions. He applied his own formal sense as a sculptor to the design of ceramics, the shapes of which became more varied without losing any of their utility.

In spite of the lack of real achievement that characterized the first years of the Bauhaus, one early project proved that sections of the Weimar school could work together in accordance with Gropius' aims. This was the villa in Berlin commissioned by the timber-merchant Adolf Sommerfeld and completed in 1921 (later destroyed). It was designed by Gropius and Adolf Meyer with the collaboration of the Bauhaus workshops.

Those familiar with Gropius' earlier and later work, with his rational use of new materials, his insistence on simplicity and lack of decoration, find photographs of the Sommerfeld house startling. It was, for a start, constructed entirely in wood, and the beams were employed in a way which recalls relatively primitive 49 structures like Alpine huts or the shacks of homesteaders in the Wild West. It also betrays the influence of the American architect Frank Lloyd Wright.

Some have been tempted to describe the Sommerfeld house as Expressionist; the invitations to the topping-out ceremony are 51 certainly reminiscent of some Expressionist woodcuts. Yet the choice of heavy teak beams was effectively forced on Gropius and Meyer. Materials of every kind were scarce in 1920, and Sommerfeld had acquired large amounts of a salvaged ship's timbers.

The reliefs carved by the Bauhaus apprentice Joost Schmidt 52 create the very different mood of the interior. They are abstract, geometric, and far from Expressionist in the sense of balance and order they convey. Some of the furniture was made by Marcel 50 Breuer as part of his journeyman's examination, and the lamps, door-handles and other fittings were designed by other students.

Successful though the Sommerfeld house was as a co-operative project, it illustrates the weakness of the Bauhaus in several areas. It celebrated craftmanship in the old-fashioned sense: there was nothing suggesting industrial design anywhere in it. It was commissioned not by a local Weimar patron but by someone living in Berlin. This suggested that the kind of enlightened patronage vital to the success of the school could be found not in the provinces but only in the capital. It was, moreover, commissioned not from the Bauhaus directly but from Gropius' private practice.

There was one problem which had nothing to do with any shortcoming of the Bauhaus. Gropius attempted to protect the school from the effects of roaring inflation, and in this case demanded that his client should pay more at each fall in the value of the mark. Sommerfeld was unhappy with Gropius' persistent demands, and sarcastically asked the director whether Weimar was some kind of enclave within Germany where the only legal tender was dollars or gold. Similar accounting problems arose with the few other private patrons for whom Gropius' practice carried out

77

49 Sommerfeld house, Berlin, 1921, designed by Walter Gropius and Adolf Meyer. View from terrace at rear. The carvings on the beams were probably by Joost Schmidt

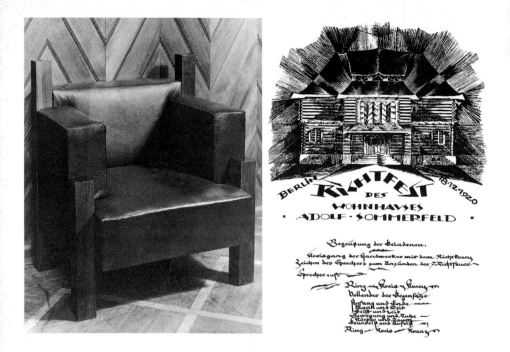

50–1 *Left* Marcel Breuer's chair for the entrance hall of the Sommerfeld house, 1921. *Right* Programme of the topping-out ceremony, December 1920

work in collaboration with the Bauhaus workshops at about the same time.

The Berlin villa of Dr Otte, designed by Gropius, was decorated and furnished by the school in 1922. Herr Cargher, also of Berlin, commissioned the mural-painting workshop to carry out a decorative scheme in one of his houses in the same year. They and the Sommerfeld house seemed to point the way forward.

Yet the Masters of Form appointed by Gropius in 1920 and 1921 were three painters: Schlemmer, Muche and Klee. Schlemmer noted that 'the construction and architecture class or workshop, which should be the core of the Bauhaus, does not exist officially, but only in Gropius' private office. . . . It is an architectural bureau, its aims directly opposed to the schooling function of the workshops.' Then, simultaneously putting his finger on the major weaknesses of the Weimar Bauhaus and expressing the confusion of many of his colleagues and their students, he added: 'If only the Bauhaus would admit to being a modern art school!'

78

52 Joost Schmidt's door and surround in the entrance hall of the Sommerfeld house, 1921. The house and contents were later destroyed

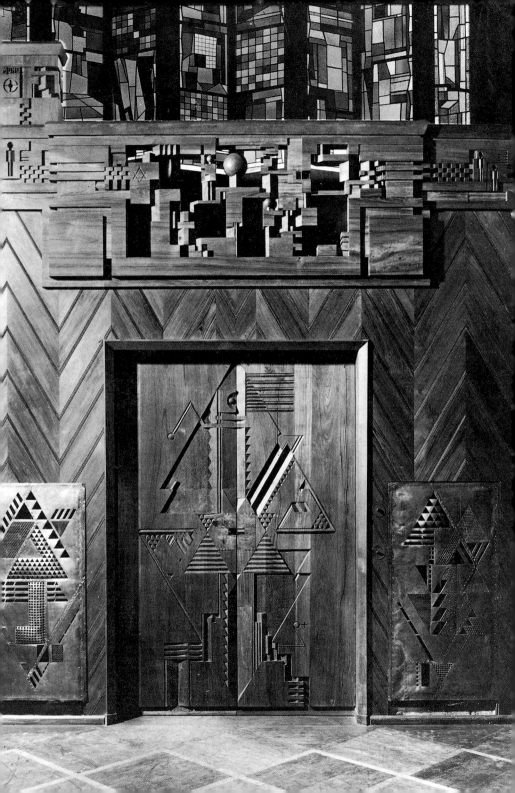

9 new arrivals

Between 1920 and 1922, as funds became available or existing posts were vacated by the former academy professors, Gropius appointed five more Masters of Form. They were all painters, and two of them, Klee and Kandinsky, had established formidable reputations before they arrived. The first two of these new appointments were of Oskar Schlemmer and Georg Muche.

53 Schlemmer (1888–1943) was at first asked to contribute to Bauhaus teaching without a formal appointment. He had come to Weimar in the summer of 1920 to discuss the publication of some of his graphics in *Utopia*, a bibliophilic publication co-edited by Itten. Gropius was aware of Schlemmer's connection with the Werkbund. In 1914, together with two other artists, Schlemmer had made three murals in the main building of the Cologne exhibition.

In December 1920 Schlemmer accepted the offer of a Master's post with some reluctance. His first impressions of the place had not been good. As he wrote at the time: 'They want to do much but can do nothing for lack of funds. So they play about . . . It is incredible, for example, that the excellent workshop-fittings were sold during the war, so that now there is scarcely a planing-bench, and that in an institution based on the crafts.'

Like most of his colleagues Schlemmer did not move permanently to Weimar for some time. Since he was sometimes employed as a designer by the Stuttgart theatre he commuted to the Bauhaus where he put up in a guest-house before finding a small flat.

Schlemmer was born in Stuttgart and, like Itten, was a graduate of the Stuttgart art academy and a pupil of Adolf Hoelzel. Although trained as a painter (he early assimilated the influences of both Cézanne and Picasso), Schlemmer quickly became interested in the theatre, and before the First World War had worked on

80

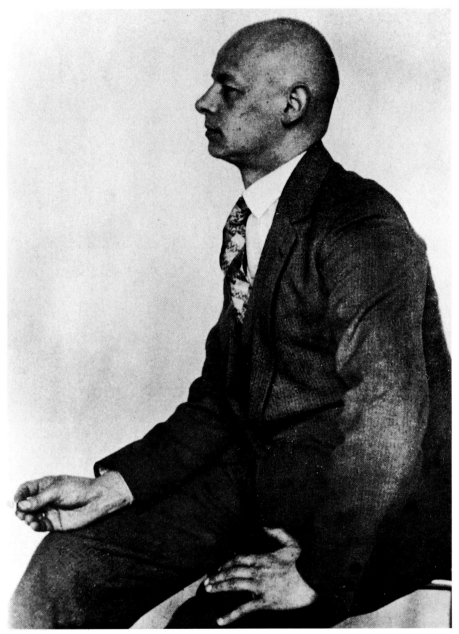

53 Oskar Schlemmer *(photo by Hugo Erfurth)*

54 Oskar Schlemmer, *Female Dancer*, oil and tempera on canvas 78½ × 51 in (199 × 130 cm), 1922–3

55 The sculpture workshop, Weimar, 1923, with sculptures by Schlemmer and his students

several productions of avant-garde, especially Expressionist plays.

Schlemmer continued to paint, however, and by the time he arrived in Weimar was on the point of stylistic maturity, working in a way unlike that of any of his contemporaries either inside or outside the Bauhaus. His single subject was the human figure, which he treated in a tight, disciplined manner and conceived in terms of a restricted geometric language. His figures look like puppets, or the statuary of some society on the fringes of the Classical world.

54

Schlemmer's practice of setting his figures in a shallow space, and of combining them in groups that are seemingly determined by simple arithmetical formulae, give his paintings an architectural air and make them especially suitable as wall-decorations. Gropius therefore asked him to take over part of Itten's responsibility for the mural-painting workshop. The main task Gropius gave Schlemmer was as Master of Form in the sculpture workshop, however. He taught life-drawing, too, and from 1923 onwards was given charge of the Bauhaus theatre workshop, a job which suited his interests and abilities best of all.

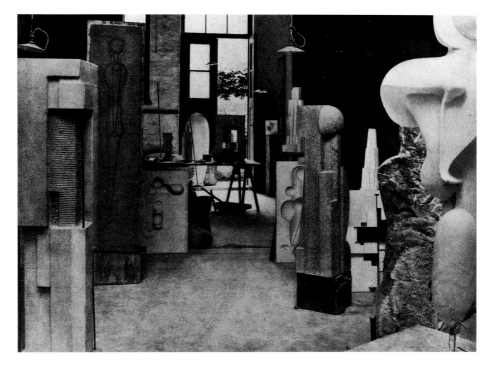

Evidence of Schlemmer's activities in both the mural-painting and sculpture workshops is somewhat thin. We know much more about him as Master of Form in the theatre workshop, an appointment made in 1923 after the previous incumbent, Lothar Schreyer, had resigned.

At first sight the inclusion of a theatre course in the Bauhaus curriculum may seem strange. How could stage-design and production have been relevant in a school primarily concerned with craft and design?

The existence of the theatre workshop seems less peculiar, however, given the school's concern for art that was primarily public. Theatre is perhaps the most public art of all. It is, moreover, an art form in which several media are combined and thus provides a parallel to architecture. A stage performance, like a building, demands the close co-operation of a number of different artists and craftsmen working as a team. The Bauhaus stage was therefore more than a fringe activity; it was a vital part of the school, providing instruction in movement, costume- and set-design and direction.

Der Spielgang enthält :

Wortreihe : Worte und Laute in Takte eingeteilt
Tonreihe : Rhythmus/Tonhöhe/Tonstärke in Takte eingeteilt
Bewegungsreihe : Bewegung der Farbformen in Takte eingeteilt
Taktrhythmus Vierviertel Takt = Schwarze Zackenlinie

Gleichzeitig gespielte Takte stehen untereinander/Gleichzeitig gespielte Wort-Reihen sind durch senkrechte Balken zusammengefasst/ Das Zeichen der Farbform bezeichnet jeden Beginn ihres Spiels/Tongebung Klangsprechen

Bedeutung der Zeichen

SEHR HOCH	HOCH	MITTE	GERÄUSCHTON	TIEF	SEHR TIEF
LEISE BIS SEHR LEISE	GANZ LEISE	MITTELSTARK RHYTHMUS GEBROCHEN	STARK	SEHR STARK	STARK
				HALBE PAUSE	
VOLLE PAUSE	MANN BEWEGUNG	MANN BEWEGUNG WIE TAKT VORHER	MUTTER BEWEGUNG	VOLLE PAUSE	GELIEBTE BEWEGUNG

XIII

56–8 Lothar Schreyer, and (*opposite*) two pages from his performance-notation for his play *Crucifixion*, 1920. Schreyer's idiosyncratic system of performance-notation provides precise instructions for the quality, pitch, volume and rhythm of the actor's voice, and for the movements which accompany the spoken passages

Lothar Schreyer (1886–1966), the first Master, had trained as a lawyer, and was another Expressionist painter with close connections with Sturm. Schreyer was appointed to begin and run the Bauhaus theatre workshop in 1921 after Gropius had been impressed by his work at an avant-garde theatre in Hamburg. Even Itten's beliefs seem less strange when compared to Schreyer's. They were highly mystical and esoteric, expressed in a conception of theatre that was primitivistic and pseudo-religious.

Schreyer remained in Weimar but briefly. He left in 1923 after colleagues found a production of his own 'Moonplay' (*Mondspiel*), which he was rehearsing for the Bauhaus exhibition later that year, incomprehensible.

Schlemmer who succeeded him was interested neither in the classical theatre nor in the conventional, contemporary stage. He aimed for nothing less than a complete renewal of the medium, which he thought might best be achieved through a kind of

57

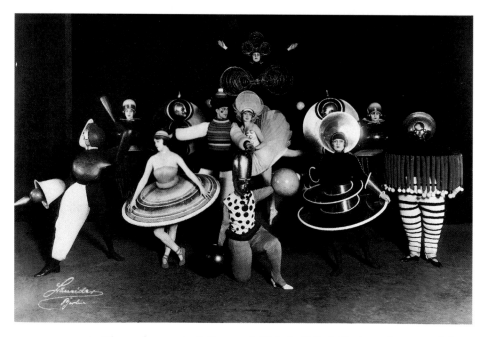

59 The performers in Schlemmer's 'Triadic Ballet', Bauhaus theatre workshop, Dessau, 1926–7

ritualistic performance, essentially ballet, which stressed its apartness from the real world but emphasized through stylized movement and costume the relationship between one human figure and another, and the space around them.

The most celebrated of Schlemmer's productions was the 'Triadic Ballet' which was first performed, not at the Bauhaus, but in the Stuttgart theatre in September 1922. It employed three figures, one female and two male, dressed in curious, puppet-like costumes. In an elaborately choreographed routine these figures explored various permutations of dancing together, in twos and threes against a series of backgrounds whose colours stressed the triple nature of the entire spectacle. The productions Schlemmer later staged at the Bauhaus developed from the 'Triadic Ballet'.

59–61

Schlemmer's theatre was a kind of puppet show and relates to the theories of one of his favourite authors, Heinrich von Kleist, whose essay 'Concerning the Marionette Theatre' (1798) employs the lifeless, idealized figure controlled by strings as a metaphor for the perfect, innocent human being.

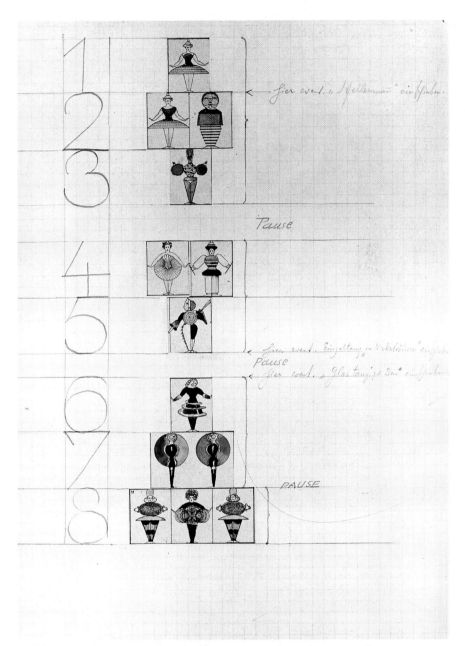

60 Diagrammatic representation of Schlemmer's 'Triadic Ballet', 1927. There are eight scenes and three intervals, with each set of scenes given a dominant colour

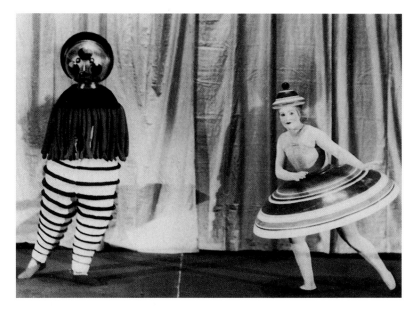

61 The second scene from the 'Triadic Ballet', 1926–7

62 Theatre workshop, Weimar. Figures from Schlemmer's 'Mechanical Ballet'. That there are people inside these brightly coloured geometric costumes can be ascertained from the shoes at the bottom. The ballet was first performed during the Bauhaus exhibition of 1923

63 Georg Muche, Master of Form in the weaving workshop, Itten's assistant on the preliminary course, and an Expressionist painter who developed, unusually, from abstraction to figuration

Schlemmer quickly became one of the most important teachers at the Bauhaus, the activities of the theatre workshop one of the school's most visible aspects. Schlemmer's diaries and letters also provide important insights into the ideas behind the Bauhaus, the personalities of its teachers and the controversies with which it was plagued.

In a letter of June 1921 he revealed that whenever he thought of himself as a Bauhaus teacher the title of a story by Adalbert Stifter came to mind – 'The Castle of Fools'. When it came to the aims of the Bauhaus, Schlemmer was indeed as confused as most. On the one hand he demanded that 'we can and may want only what is most real . . . Instead of a cathedral the machine for living in'. On the other hand he was only too aware of the dangers of taking the machine as a model for anything: 'I am unable to desire what industry can do better already and anything that the engineers can do better. What has to remain is the metaphysical: art!'

Schlemmer had arrived at the Bauhaus at about the same time as Georg Muche (born 1895), whose main tasks were to assist Itten

with the preliminary course and to teach basic design to apprentices already in the workshops. Muche, only twenty-five in 1920, was the youngest teacher and was given an enormous responsibility when he arrived. He replaced Itten on the *Vorkurs* while the older man spent several months in retreat learning the most arcane secrets of Mazdaznan at the cult's Herrliberg headquarters.

Muche was also Master of Form in the weaving workshop from 1921 to 1927. Like all his painter-colleagues Muche had exhibited at the Sturm gallery in Berlin. Indeed, he had taught at the Sturm art school in the capital until his move to Weimar. As we might expect, therefore, he worked in an Expressionist style. Like Itten, he had definite mystic leanings, and came to the Bauhaus in the hope of finding the germ of an artistic community more like a cloister than an outpost of bohemia.

Muche remained at the Bauhaus for six years and changed his ideas quite radically during that time. He was even briefly converted to the technological approach to art which Gropius was later to advocate and, demonstrating that versatility was not confined to the school's students, became interested in architecture, designing two experimental houses.

106,147

The most important of the second wave of appointments were 64–5 those of Paul Klee (1879–1940) and Wassily Kandinsky (1866–1944). Klee's work is other-worldly, fantastic, whimsical and witty; but there was nothing other-worldly about his reaction to Gropius' invitation to join the Bauhaus, which reached him in 1920 when on vacation.

Klee had not taught before and welcomed the offer of a Master's post chiefly because of the financial security it promised. Before accepting it he went to Weimar not so much to inspect the school as to compare the prices of groceries in the shops there with those in Munich where he was then living with his wife and son.

Klee had matured late and felt brave enough to handle colour boldly only in 1914 after travelling briefly to North Africa and falling under the spell of the powerful Tunisian sunlight. He was already forty-one in 1920 when the first monograph on his work was published and the first important exhibition was held.

Gropius knew enough about him to sense that he would make an inspiring teacher. Klee was fascinated by theoretical problems, was highly articulate and widely read. He took his teaching

seriously and was careful to be undogmatic in his pronounce-
ments, a habit which endeared him to the students who had their
fill of dogma from other quarters. Klee's thinking had, moreover,
begun to move in a Bauhaus direction and he was considering art
in both its political and sociological context. After the collapse of
the Munich Soviet Republic in 1919 he wrote to an artist-colleague
saying that an 'individualistic art is . . . capitalistic luxury' and that
a new kind of art 'could enter the crafts and produce great results.
For there would no longer be academies, only art schools for
craftsmen.'

Weimar prices compared favourably with prices in Munich so
Klee came to the Bauhaus, leaving his family behind until he found
somewhere for them to live. For more than a year Klee lived in a
Weimar guest-house, returning to Munich by train every other
fortnight. Only in the autumn of 1921 did he find a suitable flat.

At first Klee's appointment was not welcomed by all his
colleagues. Schlemmer recorded that Klee's work 'appears to
inspire the greatest shaking of heads, as a kind of *l'art pour l'art*,
removed from every practical purpose'.

Klee took over the bookbinding workshop from Muche, and on
the rare occasions he was seen there, almost invariably spent more
time arguing with the Workshop Master, Otto Dorfner, than
doing any work. When bookbinding ceased to be taught at the
Bauhaus in 1922 (not only Klee had problems with Dorfner), Klee
took over responsibility for the stained-glass workshop. That
arrangement was little more than nominal. The workshop with
which Klee had most contact, and that only later, was the one for
weaving, where he gave special classes on formal composition. It
was in the basic design course that he was most influential, and in
which he sought to persuade his students to develop a critical
approach to fundamental problems of image-making.

This course produced benefits not only for the Bauhaus but also
for Klee himself. Teaching forced him to consider his own work
on an intellectual level for the first time: 'When I came to teach I
was obliged to make precisely clear to myself what I did for the
most part unconsciously.' Klee's theories emerged from his
practice and not the other way about.

Klee's teaching was centred on a consideration of the elemental
forms from which, he believed, all natural things derive. Art

64–5 Paul Klee, *Self-portrait*, pen and wash, 1910. *Opposite* Klee's *Young Lady's Adventure*, watercolour, 17.2 × 12.5 in (43.8 × 31.8 cm), 1922, an example of his 'glazing' technique by which the picture is built up from layer after layer of watercolour wash

should disclose these forms, not by the superficial imitation of things found in nature, but by attempting to follow the very processes which make them grow. Nature should be 'reborn in the picture' which, while separate from the natural world, must obey the same laws within its own discrete, autonomous environment.

The idea, as difficult to grasp as most of Klee's thinking, is made clearer by an extract from the artist's *Pedagogical Sketchbook* which was itself the result of Klee's Bauhaus teaching, and was published as a 'Bauhaus book' in 1925. The student, Klee wrote (and told his classes), should attempt to become as rich and as various as nature itself:

Follow the ways of natural creation, the becoming, the functioning of forms. That is the best school. Then, perhaps, starting from nature, you will achieve formations of your own, and one day you may even become like nature yourself and start creating.

The crucial difference between mere imitation and true creation is explained in a vivid metaphor in the same book. 'When I say, form a figure of "Rest", it is probably very tempting to draw a man asleep in bed. But it should be formed as a picture in layers. Something like a vault burial: layer upon layer . . .'

Klee persuaded his students to experiment with techniques as well as with colour, form and imagery. He often employed a variety of glazing in his own watercolours and gave his classes an exercise which derived from them:

> We divide a long strip of white into seven parts and cover six of them (leaving out the seventh area) with a thin, pure, red watercolour wash. When this red area is dry we cover the parts of the strip (leaving out the first area) with a thin, pure, green watercolour wash . . .

As a teacher and painter Klee was invariably conscientious, painstaking and well-prepared. During the early years he wrote down everything he had to say in each class in a series of blue-covered books, and then followed his text precisely, quickly covering the blackboard with diagrams drawn with different coloured chalks held up in each hand (he was ambidextrous). He employed a traditional, not to say old-fashioned teaching method which consisted of lectures about theory followed by exercises in which the theory was tested. The first of these exercises, at least at the Weimar Bauhaus, was 'practical drawing from natural leaves, observing the articulating energies of the ribs of the leaf'.

Although painting and drawing as ends in themselves were officially discouraged at the Bauhaus, and although Klee did not intend to turn his pupils into draughtsmen and painters, he did require them to draw and paint since he believed that only practice would help them grasp the essential theoretical principles that he aimed to impart. He often stressed the affinities between building and picture-construction. A painting, he said, 'is built up piece by piece, no different from a house', and the painter, like the architect, has to ensure that his constructions are stable and 'load-bearing'.

Early in 1922 Klee was joined at the Bauhaus by a man of similar artistic stature but with quite different personality and approach to teaching. This was Wassily Kandinsky, who was middle-aged and in mid-career when he arrived in Weimar. Kandinsky was a Russian who had studied art in Munich around the turn of the century. He remained in Germany until the outbreak of war when, as an enemy alien, he was obliged to leave, returning to Russia via Scandinavia. After the Revolution he was actively engaged in the cultural politics of the young Soviet Union, reforming established art schools and founding new ones.

94

During that period Kandinsky was in correspondence with Gropius, whom he had met before the war and whom he now kept informed of his activities in the educational sphere. Kandinsky was almost certainly inspired by Gropius' Bauhaus Manifesto when writing the programme for the Moscow Institute of Art and Culture (INKhUK) in 1920. He appears to have known a great deal about the Bauhaus and its aims from the beginning. In an article of 1919 he refers to the 'synthetic association of architecture, painting and sculpture' which 'has, as far as I know, been accomplished at Weimar'.

When Kandinsky returned to Germany in 1921, driven there by fears of a reaction against experimental art in the Soviet Union and by disillusionment with the revolution, he must have hoped that it would be possible for him to teach at the Bauhaus. Indeed, Gropius contacted him soon after his arrival in Berlin: here was a man who had already contributed to educational reform against a background of great social upheaval. Gropius was at first circum-spect, however, asking his colleagues to keep Kandinsky's ap-pointment secret for a space, 'since difficulties can yet arise from Kandinsky's Russian affiliations'.

There were other reasons for Gropius' invitation to Kandinsky to join the Bauhaus. Although his work was scarcely popular, rejected even by some sections of the avant-garde which found Kandinsky's transcendentalist theories dubious, the Russian was, quite simply, one of the most celebrated abstract painters alive. He was credited with having created the first non-figurative composi-tion in the history of art, and his long essay 'Concerning the Spiritual in Art' (1911) was regarded as a key theoretical pro-nouncement even by many who could not understand it.

Kandinsky also believed that the art form of the future would bring together and transcend all the individual media, creating a glorious synthesis. This was the virtually untranslatable *Gesamt-kunstwerk* (roughly: 'total work of art'), a word coined by the German Romantics and employed by Richard Wagner who aimed for such a synthesis in his music dramas.

Kandinsky offered a tentative example of a *Gesamtkunstwerk* in a playlet published in 1912 in the *Blue Rider Almanac*: 'The Yellow Sound' in which speech, song, movement, shapes and colours were loosely combined.

95

66 L. Lang, analytical drawing from Kandinsky's course, 1926–7. This is the first stage of a series of drawings in which the student was expected to reduce a still-life set up in the studio to an abstract, geometric configuration. The motif's underlying structure is suggested by the sketch at top left

It was nothing like the *Gesamtkunstwerk* Gropius had in mind: that would have to be a building in which many talents and skills were bent to a common artistic purpose. Nevertheless the aims of both Kandinsky and Gropius were closely related.

Another aspect of Kandinsky's work made Gropius believe that Kandinsky would make a good Bauhaus teacher. He was a tireless theoretician, bringing to his analysis of fundamental artistic problems a wide knowledge of fields as diverse as jurisprudence and physics. For all the metaphysics of 'Concerning the Spiritual in Art', he was attempting to formulate objective laws for the expression of subjective experience.

Kandinsky had married for the second time before returning to Germany. His new wife, Nina, was considerably younger than he, and, to judge from her memoirs, a woman of more powerful physical attraction than intellect. She recalled that Kandinsky first took her to Weimar at the beginning of June 1922. They were very poor, overwhelmed even by what little the German shops had to offer since it was still considerably more than had been obtainable in the Soviet Union.

67 Wassily Kandinsky

Kandinsky replaced Schlemmer as the Master of Form in the mural-painting workshop and also developed a basic design course which he taught in tandem with Klee, working at the Bauhaus almost daily in the mornings and again in the late afternoons after taking a nap.

Kandinsky's mature years, his reserved, aloof appearance, his stately manner and his preference for dogmatic assertion gave his teaching an air of infallibility. Determined to propagate the notion of objectivity in artistic matters, he spoke as though he were revealing absolute truths and, appropriately enough for a former university lecturer in law, gave the impression of a legislator who would brook no dissent. Students found him cool and not easy to approach.

The basic design course which Kandinsky developed was primarily concerned with colour and he gave a seminar on colour which all students were obliged to attend. He also designed and taught a course of analytical drawing.

An amusing anecdote told by one of Kandinsky's students reveals that not everyone took what the teacher said seriously.

97

Kandinsky wrote and spoke often of the 'inner necessity' which drives every true artist to create. One day an American student, George Adams, painted the sun. He based it on the Japanese flag and showed it rising, at noon, in the afternoon, and sinking. 'What were you intending to do here?' Kandinsky asked. 'I was thinking about Japan.' 'But you're not Japanese.' 'No, but I can get inside the soul of a Japanese quite easily.' Kandinsky reacted very sharply to that – That was imitation and not inner necessity.

Another student told Lothar Schreyer that, believing abstract painting to be complete nonsense, he produced for Kandinsky a painting that consisted of nothing but a white area. 'Master Kandinsky,' he said politely, 'I have finally succeeded in painting an absolute picture of absolutely nothing.'

Kandinsky took my picture completely seriously. He set it up right in front of us and said: 'The dimensions of the picture are right. You are aiming for earthliness. The earthly colour is red. Why did you choose white?' I replied: 'Because the white plane represents nothingness.' 'Nothingness is a great deal,' Kandinsky said, 'God created the world from nothingness. So now we want ... to create a little world from nothingness.' He took brush and paint, set down on the white plane a red, a yellow and a blue spot and glazed on a bright green shadow by the side. Suddenly a picture was there, a proper picture, a magnificent picture.

That student's scepticism became conviction and he was not alone in being won over to the Russian's difficult ideas. It cannot have been easy to take part in Kandinsky's classes, however. There was no room for opinions divergent from his own, no sympathy for responses to forms and colours at variance with those experienced by the master himself.

To judge from photographs, Kandinsky's work in the mural-painting workshop consisted largely of translating the forms and colours of his own easel paintings on to a monumental scale. One of his students, Herbert Bayer who later became a Bauhaus teacher himself, provides information on Kandinsky's workshop classes:

The instruction was based on exercises for murals for interior and exterior spaces. They were intended to develop a feeling for colour integrated with architecture. The practical work was amplified by discussions about the nature of colour and its relationship to form. Each flowed into the other: theory and practice. Theoretical experiences were tested in murals with

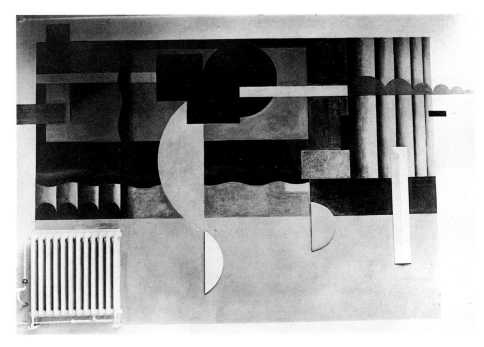

68 J. Maltan and A. Arndt, mural in the workshop building, 1923 (since destroyed). This fresco with relief elements was carried out as Maltan's journeyman's and Arndt's apprentice examination

the most varied materials and techniques. Kandinsky's ideas about the psychology of colours and their relationship to space provoked especially animated discussions.

Other accounts of Kandinsky's classes allow us to follow his methods in detail. This description is of an exercise from an analytical drawing class:

Kandinsky's lessons lasted for two hours. For drawing-practice Kandinsky alone or with the help of students assembled a still-life from planks, 66 laths, strips of wood, rulers, etc. We were not allowed to copy the still-life; Kandinsky rather demanded and expected the students to translate it into lines of tension or structure, recorded heavy or light characteristics, from bottom to top.

The same student described another exercise:

Kandinsky taught the process of seeing, not practical painting. The course was designed to give the pupils exercises at first. Like this: 'For next Friday please do the following: take a piece of black paper and place

99

squares of different colours on it. Then place these squares of the same colours on a white sheet of paper. Then take the coloured squares and place on them in turn a white and then a black square. That is your task for the next class. Good day.

Another student recalled a task Kandinsky set his class for the vacation:

An area 30 cm by 10 cm is to be divided into rectangles 5 cm by 10. The colours that must be used are: 3 primaries, 3 secondaries and 3 non-colours (black, white, grey); the arrangement of the coloured rectangles is left entirely up to you but they may only be horizontal and vertical, not put at an angle. How often you use each single colour is left up to you but each colour must appear at least once. The exercise itself is as follows:

1. Emphasise the centre.
2. Balance top and bottom.

The student continued:

He didn't say much new in the last lesson, only something more about the tensions in the square. I didn't understand it at all and I think it isn't all that important . . .

In spite of such occasional scepticism Kandinsky's basic design course seems to have been one of the most useful aspects of the curriculum at the Weimar Bauhaus. In submitting colour, form and line to rigorous, quasi-scientific analysis he opened his students' eyes to the possibilities afforded by an art that was intellectually controlled as well as emotionally expressive. His own painting, moreover, demonstrated the seemingly unlimited potential of an apparently limited abstract language: Kandinsky's subtle use of geometric shapes had an enormous influence on Bauhaus design, especially after 1925.

69 Kandinsky's 'free, wavelike line, with emphasis on the horizontal', and *right*, 'with the accompaniment of the geometric'

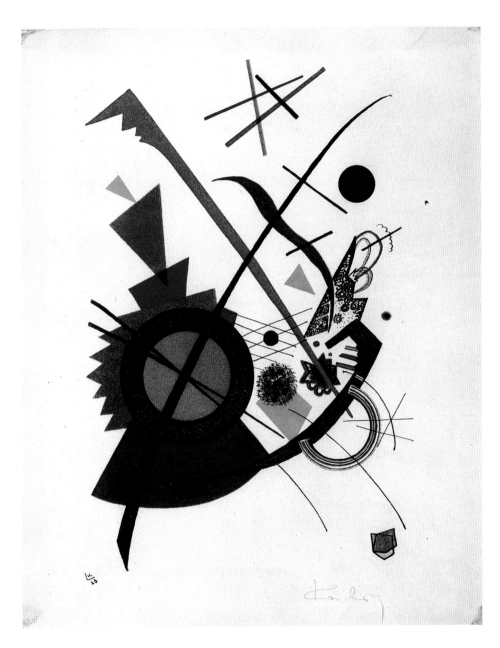

70 Wassily Kandinsky, *Violet*, colour lithograph, 1923

STUNDENPLAN FÜR VORLEHRE

VORMITTAG

	MONTAG	DIENSTAG	MITWOCH	DONNERSTAG	FREITAG	SAMSTAG
8-9						
9-10	GESTALTUNGS-STUDIEN		WERKARBEIT			GESTALTUNGS-STUDIEN
10-11			ALBERS			
11-12	MOHOLY	GESTALTUNGSLEHRE			GESTALTUNGSLEHRE	MOHOLY
12-1	REITHAUS	FORM·KLEE·AKTSAAL	REITHAUS		FARBE·KANDINSKY	REITHAUS
2-3			WERKZEICHNEN			
3-4			GROPIUS·LANGE·MEYER RAUM 39			
4-5	WISSENSCHAFTL. FÄCHER.·MATH·	ZEICHNEN KLEE	Werkzeichnen *Liebersohn v. 3-6 Uhr*	Baukonstruktionslehre *Donnerstags v. 3-5 Uhr*	ANALYTHISCH ZEICHNEN—	
5-6	PHYS.·AKTSAAL	RAUM 39	Raum 39	Raum 39	KANDINSKY.R39	VERSCHIEDENE
6-7			4-6 *Statik (Volk)*			VORTRÄGE.
7-8		ABENDAKT·KLEE OBLIGATORISCH FÜR VORKURS			ABENDAKT	
8-9						

AN DEN GELB UMRANDETEN UNTERRICHTSSTUNDEN KÖNNEN ALLE
GESELLEN UND LEHRLINGE TEILNEHMEN.

10 the basic course: colour and form

Writing about his preliminary course in 1963, Itten denied that there was anything unusual about its contents or that it involved new teaching methods: it was designed simply to measure and liberate the creative potential of those who followed it.

The ideas behind the *Vorkurs* at the Bauhaus were indeed not new, and some other schools in Germany had already insisted on a probationary period for all students during which their suitability for final admission could be tested. What made the Bauhaus preliminary course – both before and after Itten's departure – unique was the amount and quality of its theoretical teaching, the intellectual rigour with which it examined the essentials of visual experience and artistic creativity.

Something has already been said about the experiments with materials and the analyses of old master paintings undertaken in Itten's classes, and the investigations of the properties of colour and form undertaken by Itten, Klee and Kandinsky as part of the theoretical syllabus. For most of the life of the preliminary course, basic theory was taught by Klee and Kandinsky. Each gave compulsory classes in colour and form, Klee until 1931, Kandinsky until 1933 when the school was closed. Both recorded what they said in class or at least published books based on their teaching. Kandinsky's *Point and Line to Plane* and Klee's *Pedagogical Sketchbook* appeared in the series already mentioned called Bauhaus books.

Itten also taught some theory, and it is with the founder of the preliminary course that we should begin.

As a painter Itten regarded himself pre-eminently as a gifted colourist. In correspondence he frequently appended the words 'Master of the art of colour' to his signature. Itten also believed that it was as a colour-theorist that he had made his greatest contribution to art education.

103

71 Timetable of the preliminary course, Weimar, *c.* 1924

72 F. Dicker, 'dark-light study' from Itten's preliminary course, charcoal, c. 1920

73–4 *Left* Peter Keler, cradle, 1922. The object is painted in the primary colours. *Right* Eugen Batz, ordering of colours and forms, from Kandinsky's colour seminar, 1929–30. The colours appropriate to the 'primary' geometric shapes are mixed so as to match the 'secondary' shapes in the centre vertical row

Itten studied at the Stuttgart Academy while Adolf Hoelzel was teaching there. Hoelzel was one of several German artists since Goethe to have made original contributions to colour theory and, like Goethe, was more concerned with the emotional and spiritual properties of colour than with its scientific aspects. Itten's theories are in turn indebted to Hoelzel.

Itten thought it impossible to consider colour apart from form, and vice versa, since one cannot exist without the other. A short essay which he wrote in 1916 gives the essence of his theory of colour and form.

The clear geometric form is the one most easily comprehended and its basic elements are the circle, the square and the triangle. Every possible form lies dormant in these formal elements. They are visible to him who sees, invisible to him who does not.

Form is also colour. Without colour there is no form. Form and colour are one. The colours of the spectrum are those most easily comprehended. Every possible colour lies dormant in them. Visible to him who sees – invisible to him who does not . . .

Geometric forms and the colours of the spectrum are the simplest, most sensitive forms and colours and therefore the most precise means of expression in a work of art.

Itten's students therefore had to begin their studies of colour and form by restricting themselves to the basic shapes and hues.

Form could not exist without colour and neither could exist independent of some context: some point of comparison was always necessary. Central to Itten's theories, therefore, was the notion of contrast and tension.

Following Hoelzel, Itten took as his foundation seven distinct types of colour contrast: a simple contrast between one colour and another, a contrast between a colour of a light and a colour of a dark tone, between a warm colour and a cold, and between complementary colours.

There were also simultaneous contrasts and contrasts of quality and quantity. Each of them was designed to bring out the essential qualities of the colours concerned and employed them to the greatest effect.

Itten's thoughts about colour led him to design, not a colour wheel, but a colour sphere which he described as 'the most useful shape for the presentation of the order of colours'. It also 'permits

the presentation of the law of complementarity and the illustration of all basic relationships to each other as well as their relation to black and white'. Moving from red to violet around the 'equator' and from white to black from 'pole' to 'pole', Itten's sphere introduces four intermediate hues in addition to those of the spectrum and illustrates how complementaries relate to primaries, to secondaries and to each other at each point on a tonal scale.

For Itten the qualities of colour were by no means only optical. Itten the mystic believed that generalized emotional states were communicated by colour – and also by form. In his investigation of the three basic geometric forms he saw analogies with specific colours.

These analogies were emotional and spiritual. The square, for example, signified peace, death, black, dark, red while the triangle was vehemence, life, white, yellow and the circle was 'uniformity, infinite, peaceful'. The circle was also blue.

Each form therefore had what Itten called its local colour: that emotionally most suited to it, and if a painter wished to achieve balance and harmony he had to pay attention to the natural affinities between the square and red, the triangle and yellow and the circle and blue.

Kandinsky, not to join the Bauhaus until 1922, believed the same, and there can be little doubt that Itten was already influenced by the colour-theories of his future colleague which were published in 1912 as 'Concerning the Spiritual in Art'. Kandinsky's contribution to the *Vorkurs* therefore fitted neatly into what Itten had already told his students.

Itten believed that his students would better comprehend what forms were capable of expressing if they experienced them physically. They were therefore encouraged to move their bodies in, for example, circular or triangular fashion in order to 'feel' and 'live' the shapes before putting anything on paper.

Students were also asked to make compositions which exhibited the character of a circle, square or triangle or combinations of all three. In this way Itten hoped that his students would become sensitive to the 'inner meaning' of forms and colours and better equipped to communicate their feelings visually, in three dimensions as well as two.

75 Fritz Tschaschnig, ordering of colours and forms, from Kandinsky's colour seminar, 1931

76 Fritz Tschaschnig, ordering of colours in terms of angles, from Kandinsky's colour seminar, 1931. Angles, like colours, were deemed to have a 'temperature'

Itten's theories not only influenced the way students thought about their painting and sculpture. It also affected what was made in the Bauhaus workshops. The dangerous-looking cradle which Peter Keler made in the cabinet-making workshop in 1922 not only employs the triangle, the circle and an arrangement of squares but also the colours which, according to Itten, were most appropriate to them. It is also, incidentally, safer than it looks.

Itten's theories were an uneven mixture of objective observation and subjective assertion. In that, they were similar to the much more elaborate and detailed theories of Kandinsky which were also concerned with the formulation of an elementary visual language.

Kandinsky knew from an early age that he possessed the gift of synthaesthesia: when one of his senses was stimulated another reacted. In his case he usually heard something when looking at a scene or even a single colour, or saw a colour or scene when listening to music. What he heard or saw was quite specific: a particular note played on a particular instrument for example.

Colours and sounds also evoked quite specific feelings, and although such emotional experiences were inevitably highly subjective, Kandinsky attempted to discover and define universal laws which explained them.

Kandinsky's contribution to the preliminary course was in two parts: analytical drawing – described in the previous chapter – and the theoretical consideration of colour and form. This was undertaken in a carefully structured, almost scientific way. Colour and form were examined at first in isolation, then in relation to each other and finally in relation to the 'ground' – the flat plane on which all two-dimensional images appear.

Kandinsky's colour theory, derived from Goethe via the anthroposophist Rudolf Steiner, employed as fundamental distinctions the 'temperature' of colours – their apparent warmth or coldness – and their tone – their lightness or darkness.

What Kandinsky synthaesthetically defined as 'four major sounds' thus appeared: warm and bright; warm and dark; cold and bright; cold and dark.

What determines temperature is the tendency of any colour towards yellow (absolute warmth) or blue (absolute coldness). Each colour not only has a temperature, however; it also has a meaning. 'Yellow is the typical earthly colour' while 'blue is the

typically heavenly colour', qualities which give rise to many others. Yellow advances, exceeds limits, is aggressive, active, volatile; blue on the other hand retreats, remains within limits, is shy and passive. Yellow is hard and sharp; blue soft and yielding. Yellow is sharp to the taste while blue evokes the taste of fresh figs. Trumpets are yellow, organs blue.

Kandinsky made a further list of qualities for 'the second great contrast' – that between white and black – and for the third – that between red and green.

Since green is made by mixing the total opposites yellow and blue it creates the feeling of perfect balance and harmony, is passive and self-sufficient. The lengths to which Kandinsky was prepared to go when describing the qualities of colours is illustrated by this gloss on the meaning of green: 'Absolute green occupies the place that the so-called bourgeoisie occupies in the human world: it is an immovable element, content with itself, limited in every direction.'

Red on the other hand is vital, restless and powerful. When red is mixed with yellow the result is orange. Orange and violet (the result of mixing red with blue) form the last of Kandinsky's 'great contrasts'. What is true of yellow and blue is also true of orange and violet, albeit to a lesser degree. Red therefore bridges the gap between yellow and blue.

It can be seen even from this highly abridged summary of the essentials of Kandinsky's colour course that he was moving towards a visual language which, he believed, would eventually communicate feelings more clearly than could a verbal language. Since, like Itten, he believed that colour cannot exist independent of form, his theory of form was a vital part of that language.

Kandinsky's investigation of form began with the smallest irreducible element, the point which, when set in motion, produced the line. The nature of the point is relative to the size of the ground on which it appears, however: a relatively large point becomes a disc, for example.

The kind of line produced by a point depends on the kind of force exerted on the point. A single, regular force produces a straight line, two or more forces produce angular or wavy lines.

Each kind of line possesses qualities directly analogous to those possessed by each type of colour. Verticals, for example, are

warm, horizontals cold while diagonals tend towards one or the other depending on their position and direction.

Precise correspondences between colours and forms were the aim of many of the exercises given by Kandinsky in his classes. If, as Kandinsky claimed, the appropriate primary colours for the elementary shapes were yellow for the triangle, red for the square and blue for the circle, mixtures of colour would need to follow the mixtures of form. A pentagon mixes a square and triangles: it must therefore be orange. Lines both angular and curved also had their appropriate colours. The effects of these, too, were explored in exercises which, even though they do not demonstrate the truth of Kandinsky's assertions, are frequently very attractive to look at.

74

75–6

Kandinsky developed a system not only for the alleged relationships between colours and lines but for entire compositions. He began with the type of format employed. A horizontal format was cold, a vertical one warm. Compositions which force the eye upwards are free and light, those which force the eye down, heavy and depressive. Movements towards the left are adventurous, liberating; their opposite are familiar and reassuring. Such 'rules' led to the creation of visual harmonies, dissonances, and compositions through which subtle feelings might be expressed.

Where Kandinsky was prescriptive and dogmatic Klee was tentative and hesitant. Kandinsky's rules seemed to have descended with Moses from the mountain; Klee's were empirical, derived from ordinary experience.

Like Kandinsky and Itten, Klee identified numerous parallels between painting and music and exploited them in his theories. Unlike Itten and Kandinsky, Klee was an accomplished musician himself, a virtuoso violinist who had played with the Berne symphony orchestra at the age of twelve. Klee had strong mystical leanings, and believed that the highest kind of artistic expression was an inexplicable mystery. What could be explained and taught, however, were the preliminary stages of that expression, and Klee developed a theory of colour and form as elaborate and subtle and as reliant on scientific models as Kandinsky's. His theoretical classes preceded those he gave on nature study as a source for creative form.

Like Kandinsky Klee began his classes on form with a discussion of the point and of the line which he defined as a point in motion.

77 Margaret Leischner, exercise from Klee's preliminary course, c.1929

He discerned three basic types of line: the active, the passive and the 'medial'. An active line was free, constantly moving, whether to a specific destination or not. A line became medial when it described a coherent form. If that form is coloured then the line becomes passive for the colour serves as the active element.

Instead of magisterially stating the qualities of each kind of line Klee would describe them metaphorically. A drawing, for example, is 'a line going for a walk' and the line changes character in keeping with what happens on the way: whether the going is easy or tough, whether progress is impeded entirely.

The medial line describes two basic types of form: structural and individual. Structure is achieved if the same visual element can be repeated infinitely, whereas an individual form cannot have anything added or subtracted without changing its character. A fish is an individual form. Its scales are structural forms.

Klee then moved on to consider the way each type of form can be related to others and he would give his students exercises which asked them to use the same form in a variety of ways and positions: reversed, turned through ninety degrees, upside down and so on. In this way the students became accustomed to the potential of a simple image.

For Klee the aim of each work of art was the creation of visual harmony, a balance between the 'elemental male' and 'elemental female' principles of mind and matter. A key image was therefore a scales on which line was balanced against colour, form against tone and so on.

Klee made it clear that in this as in everything else relativity was the most important factor.

78 Paul Klee, diagram showing the relationship between an image created from an active line and a passive plane (left), and its opposite (right). In the centre is the area in which the 'medial line' comes into play

79 Structural form and individual form (the fish) in a sketch by Klee

The assumption that black is heavier than white is only true for as long as we are dealing with a white ground . . . In physics one talks of specific gravity relative to water, in our field there is a variety of specific gravities, relative to white, to black or to the average (and to each tone in between). Yet more relationships are thrown up by the world of colour. Colours on a red ground . . . colours on a violet ground . . .

Klee's colour-theory, like those of Kandinsky and Itten, has its roots in Goethe, and also draws heavily on the theories of Runge, Delacroix, Kandinsky himself, and Delaunay whose essay on light Klee had translated into German in 1912. Like Itten, Klee began with the colours of the spectrum which he rendered as a circle – more conventional than Itten's sphere. Colour is the richest aspect of optical experience for, whereas line is only measurement, tone measurement and weight, colour adds a third factor: quality.

Students were therefore asked to deal with colour only after they had mastered line and tone. Using the metaphorical scales, Klee would ask them to weigh one colour against another (red was heavier than blue, for example) and to consider various colour progressions: from violet to red was one of them. In all of this Klee was concerned not to lay down the law, but to provide his students with material from which they might draw their own conclusions.

The theoretical aspects of the preliminary course did, perhaps surprisingly, have an effect on what was produced in the craft workshops. The celebrated cradle was not the only object made from the primary geometric forms painted in the primary colours. The artistic guidance and formal inspiration which the individual Masters of Form were meant to provide came, in most cases, not from them but from the preliminary course.

77

115

11 going dutch

An article inspired by the Dutch artist Theo van Doesburg but written by Vilmos Huszar appeared in the September 1922 issue of *De Stijl* condemning the Bauhaus for its unproductivity, which made it guilty of 'crimes against the state and civilization':

Where is there any attempt to unify several disciplines, at the unified combination of space, form and colour? Pictures, nothing but pictures . . . graphics and individual pieces of sculpture. What Feininger exhibits was done better in France ten years ago (Cubism of 1912). . . . Klee . . . scribbles sickly dreams. . . . Itten's emptily pompous daubing aims only for superficial effect. Schlemmer's works are experiments familiar to us from the work of other sculptors. . . . In the Weimar cemetery stands an Expressionist monument by director Gropius: the result of a cheap literary idea, it cannot compete even with Schlemmer's sculptures. . . . In order to reach the goals aimed for by the Bauhaus in its manifestoes other masters are required, masters who know what the creation of a unified work of art entails and can demonstrate their ability to create such a work . . .

Clearly, one of those 'other masters' should have been Dutch.

Huszar's article and van Doesburg's presence in Weimar were in part responsible for a change of course at the Bauhaus. Theo van Doesburg, artist, architect, theoretician and founder of De Stijl first turned up in Weimar in 1921 and began to publish his *De Stijl* magazine from there. He gave public lectures praising Gropius' basic conception of educational reform, but bitterly criticizing the direction Bauhaus teaching had taken.

Feininger carefully considered the advantages of offering van Doesburg a teaching appointment, an idea first mooted by Gropius himself. He would probably have been 'valuable because he would represent the opposite pole to much of the exaggerated Romanticism which haunts us here'. But Feininger saw dangers, too. 'He

would probably be unable, however, to keep himself within bounds and would soon, like Itten ... want to take over everything.'

Feininger saw Itten and van Doesburg as being like two sides of the same coin and so, in one sense, they were: they were both dogmatic. Everything else about them was different, however. While Itten floated about Weimar in his monkish robes, van Doesburg strode through the town wearing a monocle, a black shirt and white tie. Itten, who knew an enemy when he saw one, remarked bitterly that 'a man who wears a black shirt also has a black soul'.

Van Doesburg's criticisms were not easy to brush aside. He was a celebrated and respected member of the international avant-garde, the engine of a group which had once included Rietveld and Mondrian, had already left an indelible mark on the artistic landscape of Europe and was responsible for an architectural style which Gropius, for one, greatly admired. He was also, especially in his accusations that the Bauhaus had become hopelessly Romantic and was not producing very much in the way of concrete results, largely justified.

Van Doesburg himself had reached a turning point. Now deserted by all other founder-members of De Stijl, he was attempting to make an even bigger name for himself internationally, and he hoped that Gropius might offer him an appointment at the Bauhaus. In April 1921 he travelled to Weimar. Adolf Meyer found him a flat and a Bauhaus student offered him his studio as teaching premises.

Although van Doesburg's criticisms were clear and comprehensible enough, the positive side of his message was less obvious. The 'Constructivist and Dadaist Congress' which he 80 organized in Weimar in 1922 suggested that he was supporting cerebral, engineer-inspired art, certainly, but also the kind of anarchic performances in which those artists specialized who, for political or other reasons, belonged to a self-declared idiot fringe. A girl studying at the Bauhaus at the time provides a vivid account of one aspect of van Doesburg's activities in Weimar:

Van Doesburg attacked the issues and people with drums and trumpets. And he screamed. The louder he screamed the more he believed his ideas would penetrate the minds of the people. He made all Weimar and the

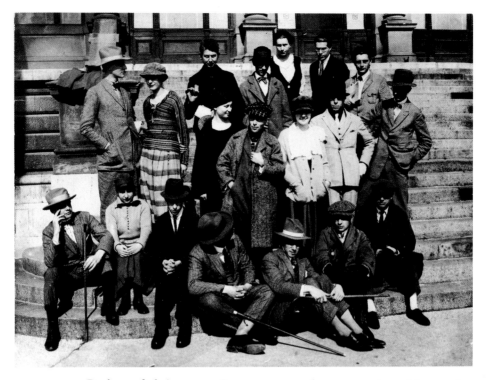

Bauhaus feel insecure. I was among those present at his evening performances in which he spoke and shouted about Constructivism. His tirade was interrupted here and there by passages of Constructivist music which his wife Nelly manfully played on the piano. She struck the keyboard forcefully and produced disharmonies. We enjoyed it enormously. Van Doesburg even managed to convert four students to his ideas. This troop abused the other Bauhäuslers: 'You're all Romantics.'

The tune Nelly van Doesburg played was almost certainly her own composition, the 'March of the Ants and Elephants'.

One of the students whom van Doesburg seduced away from the Bauhaus was Werner Graeff who helped organize the De Stijl course which van Doesburg gave in Weimar from 1921 to 1923, and which consisted of illustrated lectures and, for Bauhaus students, free instruction in composition. The result was a small Weimar branch of De Stijl consisting almost entirely of Bauhaus students. One of the most important of them was Karl Peter Röhl whose work was published in De Stijl in 1922. Röhl had designed the quasi-Expressionist seal which the school had used until 1921.

80 *Opposite* Constructivist and Dadaist Congress, Weimar, 1922. Nelly and Theo van Doesburg are second and third from right in the second row; above them are Moholy-Nagy and his wife; El Lissitsky is in the check cap; left is the Bauhaus student Werner Graeff; bottom row from the right are Tristan Tzara, Hans Arp and Hans Richter

81–3 *Above* The two official Bauhaus seals. The seal at top, by Karl Peter Röhl, was replaced by Schlemmer's, below, which owes an obvious debt to De Stijl: see (*right*) Theo van Doesburg's *Rhythm of a Russian Dance*, oil on canvas, 53½ × 24¼ in (135.8 × 61.5 cm), 1918

By that date Röhl was firmly under the influence of De Stijl and was using only straight lines and primary colours in his work.

Van Doesburg's presence in Weimar, and its effect on more Bauhaus students than those who decided to leave the school, forced Gropius to realize that the Bauhaus had moved so far in one direction that it would soon be too late to change. Gropius had originally envisaged a school that would happily accommodate many different points of view, would create harmony out of diversity. This had not happened. Itten's influence had grown so great that it dominated everything and the emphasis on the crafts now increasingly seemed anachronistic.

It has been argued that the first clear sign of a change in Gropius'
81 thinking was the adoption of a new official seal. Röhl's seal was
82 replaced by one which, designed by Oskar Schlemmer in the
autumn of 1921, is a model of clarity and economy. It loudly
announces the image which the Bauhaus was to strive to cultivate
especially after 1923. It was also unmistakably influenced by the
83 formal language of De Stijl.

There is much evidence to suggest that van Doesburg's presence
in Weimar merely confirmed Gropius in views he had held for
some time, brought out the Gropius of the Fagus works who had
been repressed since the beginning of the war. At the Bauhaus, the
signs of a major change of mind began to multiply. On 3 February
1922, for example, Gropius circulated a memorandum among the
Masters of Form which read in part:

Master Itten recently demanded that one must decide *either* to produce
work as an individual in complete opposition to the economic world
outside *or* to search for an understanding with industry. . . . I look for
unity in the *combination* not the division of these forms of life. How is it
that we can approve as much of the form of a well-built aeroplane,
automobile, machine, as of that of a single work of art made by the
creative hand? We are not the kind of people to reject one or the other, but
we are obviously considering two entirely separate creative processes
which advance side by side. One is not outdated and the other modern;
both will develop further and, as it seems, will gradually move together.
Whenever the question is raised about which forms created by recent
generations may later be seen to be characteristic of our times, the work of
the architects, academicians and artist-craftsmen disappear from view. On
the other hand . . . the world of forms which emerged from and in
company with the machine asserts itself: the new means of travel (steam-
engine, aeroplane), factories, American silos and things which we use
daily that were produced by machines.

Gropius went on to say that the Bauhaus was in danger of isolating
itself from the real world. If that were to happen, he added:

the only way out is the romantic island. Some Bauhäuslers worship a
misunderstood 'return to nature' *à la* Rousseau; they want to shoot with
bow and arrow rather than with a rifle. But then why not throw stones
and go about naked? . . . All the architecture and 'art and craft' of the last
generations . . . is, apart from very few examples, a lie. In all these
creations is the cramped intention of 'making art'.

The pre-war Gropius, his mind cleared of utopian socialism and romantic medievalism, had struck back.

The change in direction now urged by Gropius, and actually taken during the following eighteen months, was but one symptom of a general shift of taste in all the arts which occurred in Germany at about the same time. In painting, the theatre, cinema, poetry, prose and music, Expressionism was declared dead and swiftly buried. It had been replaced by a style which was disciplined, sober and even conventional, and for which the phrase *Neue Sachlichkeit* was coined. Usually translated as 'New Objectivity', the German term also conveys the sense of practicality, matter-of-factness and directness.

Gropius realized that there was one change on which all the others depended: Itten's influence had to be weakened; better still, Itten had to go. After a series of shrewd political manœuvres Gropius persuaded Itten to resign during October 1922. He finally left at Easter the following year, having done little teaching for two semesters. He went off to the Mazdaznan 'School of Life' at Herrliberg near Zürich to meditate in retreat. He was replaced, significantly, by an artist close to van Doesburg: László Moholy-Nagy.

84 Itten's letter of resignation to Gropius

85 László Moholy-Nagy (*photo courtesy Lucia Moholy*)

12 towards a new unity: moholy-nagy and albers

The man appointed to take over Itten's preliminary course in 1923, László Moholy-Nagy (1895–1946), was a Hungarian who had been enthusiastic about Bela Kun's Hungarian Soviet. He had arrived in Berlin in January 1921 after working his way across Germany as a letterer and sign-painter. Moholy had been introduced to Gropius by Adolf Behne, and Gropius' decision to appoint the Hungarian to the staff of the Bauhaus had crucial – and entirely foreseen – consequences for the school.

After Itten's resignation Moholy's appointment was the first result of Gropius' change of policy. After all, Moholy belonged to the camp of Theo van Doesburg: in 1922 he had participated in the Dada and Constructivist Conference which the Dutchman had organized in Weimar.

Even Moholy's appearance proclaimed his artistic sympathies. Itten had worn something like a monk's habit and had kept his head immaculately shaved with the intention of creating an aura of spirituality and communion with the transcendental. Moholy sported the kind of overall worn by workers in modern industry. His nickel-rimmed spectacles contributed further to an image of sobriety and calculation belonging to a man mistrustful of the emotions, more at home among machines than human beings. His dress stamped him as a Constructivist, as a follower of Vladimir Tatlin and El Lissitzky, who rejected all subjective definitions of art and were scornful of the idea of the artist as the inspired maker of unique objects indelibly stamped by his personality. Tatlin's model artist was a maker, a kind of engineer who creates by assembly, convinced that the idea behind a work of art is more important than the manner of its execution.

Self-taught, Moholy was innovative and proudly versatile. Having begun to paint while convalescing from a war-wound in

86 László Moholy-Nagy's 1925 cover for the prospectus advertising the 'Bauhaus books', 14 of which appeared between 1925 and 1930. The series included Gropius's study of international architecture, Klee's 'Pedagogical Sketchbook' and Moholy's own 'Painting, Photography and Film'. Moholy's typographic style is characterized by a judicious use of colour, a single, sans-serif type-face in various weights and a few heavy rules which provide dominant compositional elements

1917, he could now turn his hand to almost anything. He made
86 constructions and collages, was a typographer and designer. He
88 considered anyone who knew nothing about photography was a kind of visual illiterate, and that an artist who restricted himself to any single medium should not be taken seriously. One of his specialities was the photogram, a kind of photography without a camera in which both opaque and transparent objects are placed on light-sensitive paper and then exposed. The only thing Moholy could not do well was speak German, and his heavy accent provided a limitless source of jokes at the Bauhaus – as did the punning mispronunciation of his name: Holy Mahogany was a favourite example.

Moholy's paintings are uncompromisingly abstract, entirely Constructivist in their calculated use of a small number of simple geometric elements. Their surfaces are bland, anonymous, and their titles are pseudo-scientific, consisting only of letters and numbers. In Berlin just before he left for the Bauhaus Moholy had even ordered a series of three paintings by telephone, giving a factory that made enamel signs precise verbal instructions and leaving the manufacture up to them. The pictures are now in the Museum of Modern Art, New York.

87 László Moholy-Nagy, *Z IV*, oil on canvas, 37¾ × 30¾ in (95.8 × 78 cm), 1923

88 Lázsló Moholy-Nagy, the Berlin Funkturm (radio tower), photograph, 1925

Moholy's compositions might even be described as 'anti-paintings'. In May 1919 Moholy wrote in his diary:

During the war I became conscious of my responsibility to society and I now feel it even more strongly. My conscience asks unceasingly: is it right to become a painter at a time of social upheaval? Can I assume the privilege of becoming an artist for myself when everybody is needed to solve the problems of simply managing to survive? During the last hundred years art and life have had nothing in common. The personal indulgence of creating art has contributed nothing to the happiness of the masses.

It can be imagined that a man holding such views was not entirely popular with his colleagues, all of whom were committed to the kind of art which Moholy regarded as mere personal indulgence.

Moholy was a brilliant teacher, and his abilities may have caused resentment among those colleagues whose relationship with the students was less than easy. What put up the backs of most of the other Bauhaus teachers, however, was Moholy's rejection of everything irrational, convinced as they all were to some degree by the notion of art as spiritual revelation: in Klee's phrase they all thought that art's purpose was 'to render the invisible visible'. Moholy's ideas were quite different. As he is reported to have said to Schreyer: 'You surely don't believe the old fairy-story about the human soul? What is known as the soul is nothing but a function of the human body.'

Although the student-representatives supported Moholy's appointment, not all the students welcomed it. One of them, Paul Citroen, later claimed that 'none of us who had suggested Moholy liked his Constructivism. This "Russian" trend created outside the Bauhaus, with its exact, simulatively technical forms, was disgusting to us who were devoted to the extremes of German Expressionism.'

Citroen remembered Moholy as 'bursting into the Bauhaus circle like a strong, eager dog . . . sniffing out with unfailing scent the still unsolved, tradition-bound problems in order to attack them. The most conspicuous difference between him and the older teachers was a lack of the typically German dignity and remoteness prevalent among the older Masters.'

Another witness described Moholy's arrival at the school as like that 'of a pike in a pond full of goldfish'. Whatever the simile, the effect of the Hungarian's arrival in Weimar can be imagined. If the other teachers failed to argue emotionally they made dogmatic assertions: Moholy was invariably clear-headed and rational.

Another major difference between Moholy and his colleagues was in their attitudes to the machine. Transcendentalists like Kandinsky wanted nothing to do with it. For Moholy it was a kind of fetish. As he wrote in an essay called 'Constructivism and the Proletariat' (May 1922):

The reality of our century is technology: the invention, construction and maintenance of machines. To be a user of machines is to be of the spirit of this century. It has replaced the transcendental spiritualism of past eras.

Stressing the political dimension of his argument, Moholy went on:

Everyone is equal before the machine. I can use it, so can you. It can crush me; the same can happen to you. There is no tradition in technology, no class-consciousness. Everyone can be the machine's master or its slave.'

Moholy took over full responsibility for the preliminary course only after Itten finally left Weimar. Before that he became Master of Form in the metal workshop which Itten had also run until then. Once the path was clear Moholy changed the preliminary course drastically. All the metaphysics, meditation, breathing exercises, intuition, emotional apprehension of forms and colours, were blown out of the window. His classes introduced students to basic techniques and materials and to their rational use. Whereas Itten's teaching scarcely went beyond the possibilities of the easel painting or the individual piece of sculpture, Moholy tried to open his students' minds to new techniques and new media.

Moholy's influence in the metal workshop, augmented by that of Christian Dell, the Workshop Master, was equally sober. According to one student it had previously turned out 'spiritual samovars and intellectual doorknobs'; now it coped with the entirely real problems of designing electric-light fixtures. Previously students had made things like candelabra. Now, employing glass as well as metal, they made what may well have been the first globe lamps anywhere. Instead of the 'spiritual samovars' they turned their attention to simply shaped tea-pots and infusers.

89 Joost Schmidt, cover for the special Bauhaus number of the magazine *Offset*, 1926

130

90–4 Products of the metal workshop in Weimar. *Top left* Anonymous, three pots, *c.* 1921–2. The 'hand-crafted' look and occasional eccentricities of these objects, produced during Itten's control of the workshop, contrast sharply with the clean lines and functional appearance of the other objects illustrated, made after Moholy had taken charge. *Centre left* W. Tümpel, J. Knau and C. Dell, tea infusers, *c.* 1924. *Bottom left* Marianne Brandt, coffee and tea service, *c.* 1924. *Top right* J. Jucker and W. Wagenfeld, table lamp, 1923–4. *Bottom right* W. Wagenfeld, sauce jug and saucer, 1924

Students were also discouraged from using expensive materials like silver. Moholy told them to use steel sheeting instead.

Moholy's appointment provided clear evidence that Gropius had changed his mind about the kind of institution the Bauhaus ought to be. Gropius spelled this out in a public lecture he gave during the Bauhaus exhibition of 1923. It was on the theme 'Art and Technology, a new unity'. If the early years had seen emphasis placed on the investigation of properties common to all the arts and on the revival of craftsmanship, it had now irrevocably shifted towards the education of a new breed of designer capable of conceiving artefacts to be made by machine. William Morris would probably have felt at home in the early Bauhaus. He would now not have recognized the school as his progeny.

Most of Moholy's colleagues felt threatened by his presence among them, and were dismayed by the change of direction it signalled. Some of them took every opportunity in class and outside to compare the engineer unfavourably with the artist, the machine with art. 'The machine's way of functioning is not bad,' Klee admitted to his students, 'but life's way is something more. Life engenders and bears. When will a run-down machine have babies?'

If painters had seemed unpromising recruits to teach even the kind of craft-based course first approved by Gropius, they now looked virtually irrelevant to the 'new' Bauhaus, especially as there were now also increased pressures on Gropius to achieve a measure of financial independence from his local paymasters. This could only be done by co-operating with industry, by selling designs and patents rather than by producing unique, hand-crafted objects for a small number of wealthy patrons.

There had always been a clear understanding that the Bauhaus would do its best to earn enough money to support itself, but no real progress had been made. The entire staff was clear that without such progress the future of the school was in doubt. As Feininger wrote in 1923, anticipating the big Bauhaus exhibition held later that year:

One thing is certain: if we are not able to show 'deeds' to those on the outside and to win over the industrialists, the future hopes for the survival of the Bauhaus are slim. We must aim at earnings – strive for sales, reproduction! And that goes against the grain of all of us. It is difficult to

anticipate this evolution . . . but Gropi has an eye for realities and the rest of us haven't . . .

Moholy did not teach the new preliminary course single-handed. He was ably assisted by a former student whom Gropius had asked to remain after taking his Master's examination and who, in 1923, was not only made Workshop Master in the stained-glass workshop but also ran a self-sufficient course as part of the *Vorkurs*. This was Josef Albers (1888–1976). Like several of his 95 contemporaries Albers had come to study at the Bauhaus after qualifying elsewhere and having begun to work, in his case as an elementary school teacher specializing in art. Albers began his studies again at the Bauhaus in 1920 at the relatively advanced age of thirty-one.

When Albers enrolled in Itten's preliminary course he was exactly the same age as his teacher, and Albers' imaginative use of materials both under Itten and later in several of the craft workshops made it clear that he was one of the most gifted students of his generation. Gropius therefore asked Albers to remain in Weimar as a junior member of staff, to teach the use of materials in the preliminary course. Albers was given his own premises away from the main school, in the *Reithaus*, some converted stables in the park on the banks of the River Ilm. After the Bauhaus moved to Dessau in 1925 Albers was formally appointed a 'Young Master', and after Moholy's resignation three years later, he assumed responsiblity for the entire preliminary course. At the same time he became head of what had become the furniture workshop.

Albers was fascinated by the properties of materials and their potential when shaped. Paper, for example, is a fragile substance; 96–7 but if cut and folded in certain ways can become remarkably strong and rigid. Insights gained from experimentation with sheets of paper, metal and other materials are of obvious relevance to every kind of artistic and design activity and such experimentation was an important addition to the preliminary course.

There is something appealing and immediately intelligible about Albers' methods and intentions. The simplest and least likely materials could be used to teach important lessons about the nature of construction that were of relevance to engineering as well as to art. T. Lux Feininger, the painter's son who became a student at

95 Josef Albers

96–7 *Opposite* Modern reconstructions of exercises in cutting paper devised in 1927–8 as part of Albers' preliminary course

the Bauhaus, remembered a 'most impressive structure' made during one of Albers' classes, 'composed of nothing but used safety-razor blades (which are slotted and punched by the manufacturer) and spent wooden matches'. He also remembered Albers 'leading us through a cardboard-box factory, a depressing place to me (I confess), and pointing out manufacturing particulars, both good and bad (i.e. capable of improvement), with the kind of religious concentration one would expect from a lecturer in the Louvre'.

Hannes Beckmann, another student, recalled that Albers had arrived on the first day of the preliminary course with a heap of newspapers, saying that the group could afford to waste neither materials nor time.

Economy of form depends on the materials we are working with. Notice that often you will have more by doing less. Our studies should lead to constructive thinking. All right? I want you now to take the newspapers . . and try to make something out of them that is more than you have now. I

want you to respect the materials and use it in any way that makes sense –
preserve its inherent characteristics. If you can do without tools . . . and
without glue, so much the better. Good luck.

According to Beckmann, Albers then 'left the room, leaving us
quite flabbergasted'.

There were other tasks Albers regularly gave his students, one of
the most challenging of which was the making of a usable camera-
bellows from a single sheet of paper or card. Albers' preliminary
course also touched on typography. He asked the students to
arrange areas of light and dark on the paper, without using any
letters, so that the layouts were well-balanced and forced the
'reader' to move from one part of the page to the next.

Albers proved to be the perfect complement to Moholy-Nagy.
Together they assisted Gropius in steering the Bauhaus on a new
course. What the Bauhaus was to become was announced by the
important exhibition of the school's activities staged in Weimar
in 1923.

13 the public face

Public relations are vital to every educational establishment, but especially to those supported by municipal or national funds. To the Bauhaus, threatened in Weimar by the craft guilds, the supporters of the academy, nationalist politicians and the general public, they were especially important.

Efforts had constantly to be made to explain what the school was doing and what it hoped to achieve. With this in mind it seems strange that the first full-scale exhibition of Bauhaus work should have taken place as late as 1923, fully four years after the school's foundation.

Private, informal exhibitions had been staged before then, however. The first in June 1919 offered Expressionist and Dada-inspired paintings and constructions. By common consent it was so disastrous that Gropius was reluctant ever to present students' work to the public.

In March and June 1921 and again in 1922 further private exhibitions were organized, mainly of work by Itten's students following the preliminary course. In the summer of 1922 the 'First Thuringian Art Exhibition' was staged at the Weimar Landesmuseum. Both the now-separated Academy teachers and Bauhaus Masters showed there, and the divergence of approach was stressed by their physical separation on opposite sides of the museum. Convention confronted experimentation, and convention won hands down. As the critic of the *Rheinisch-Westfälische-Zeitung* commented, the various styles had been cleverly separated 'so that the art-lover, having made too great demands on his brain by earnestly attempting to find his way into the circle – or rather the cube – of those at the State Bauhaus, is in a position to revive his painful optic nerves ... among the artists of the Weimar Academy'.

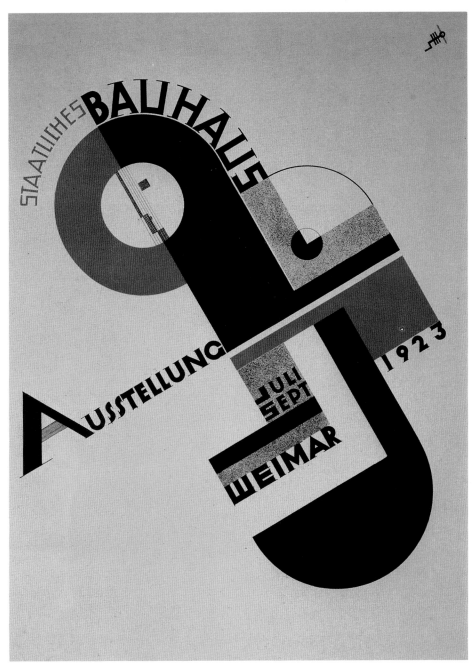

98 Joost Schmidt, poster for the Bauhaus exhibition of 1923

This exhibition damaged the Bauhaus, and Gropius was too wise to write off the adverse criticism as the irrelevant complaints of a philistine public. The school changed direction during 1923, a fact made plain, not only by the appointment of Moholy-Nagy, but also by Gropius' proposal at the same time to introduce classes in mathematics, physics and chemistry. It was made even plainer 100–4 by the exhibition held at the Bauhaus in the summer of 1923, and by the week of special activities organized in conjunction with it.

Gropius approached the event with trepidation. Even if it were to help the students to sell work and the school to find new patrons, what spoke against it was 'the lack of co-operation between the workshops, the lack of projects of any size which would make the idea of the Bauhaus clear to the public, and the small number of usable products made by some of the workshops'.

The Thuringian government demanded evidence of the school's progress, however, and Gropius was in no position to refuse. Further impetus was provided by the annual conference of the Werkbund, planned to take place in Weimar at the same time: at least the Bauhaus could be sure of a few sympathetic visitors to its exhibition.

In the event, the exhibition was a triumph in public relations, attracting visitors not only from the Werkbund conference but from all over Germany and further afield. No fewer than fifteen thousand people came to Weimar, filling the hotels, enriching the tradespeople and lifting the school's morale. The opening was graced by the presence of such international celebrities as Stravin-99 sky, Busoni and the Dutch architect J.J.P. Oud.

That Gropius was able to persuade them to come was in part due to the scale and energy of his advertising campaign. Throughout the six months before the opening Gropius had approached editors, critics and other specialist writers for reviews, articles, and stories about the Bauhaus. The school even took advertisements in magazines and cinemas.

The exhibition ran from 15 August to 30 September 1923, and was held in the entrances, halls and stairways of the main workshop-building as well as in the city museum. In addition, an experimental house was built alongside the school's vegetable plot.

The exhibition's climax arrived between 15 and 19 August, four days designated the 'Bauhaus Week'. Lectures were given by

138

99 From left to right: Kandinsky, Gropius and the Dutch architect J. J. P. Oud at the opening of the Bauhaus exhibition, 1923

Gropius, Kandinsky and Oud. Schlemmer's 'Triadic Ballet' and 'Mechanical Ballet' were performed and there were premières of 62 works by Stravinsky, Busoni and Hindemith. Shows of scientific films which exploited slow-motion effects (then decidedly novel) were also arranged.

Gropius' lecture, which he called 'Art and Technology: a New Unity', marked the public emergence of a man purged of craft-romanticism and utopian dreams.

There are parallels to be found between Gropius' change of heart and external economic and social factors. When Gropius gave his lecture the German economy was threatening to collapse completely under the weight of inflation. In November 1923, however, there was a currency reform, and it and the Dawes Plan of early 1924 stabilized German industry, attracted foreign investment and brought a few years of prosperity until the Wall Street Crash of October 1929. Precisely during those prosperous years, the Bauhaus moved over to the idea of industrial design and the mass-production of cheap, quality products.

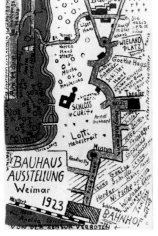

100–4 The 1923 Bauhaus exhibition. *Opposite, above* Products on show: ceramics, textiles and Keler's cradle can be seen. *Opposite, below* Products for sale. A series of postcards included Lyonel Feininger's advertisement and Kurt Schmidt's map of Weimar (*left*). The typography of the leaflet for the exhibition (*above*) is in typical Bauhaus style. Note the simplified diagram showing train connections between Weimar and the major cities

Interestingly enough, it was also in 1923 that Henry Ford's autobiography was first published in Germany and immediately became a best-seller. Ford's company was demonstrating that some aspects of Utopia can become reality. His production-line automobiles realized the dream of large numbers of people to have freedom of movement at low cost, and at the same time improved the pay and living-standards of the men who worked for him. In 1924 the Ford company of Germany produced its first assembly-line car at its Cologne plant, and German automobile manufacturers quickly followed.

With Ford and other Americans like F. W. Taylor (the prophet of scientific management) America became the model not only of technological reason but also of an ideal society in which all people were both rich and equal. In the minds of many Germans, a capitalist Utopia based on the profits from ever-increasing production had replaced a vaguely socialist utopia in which the machine was the enemy of the common man.

105 Still from Fritz Lang's film *Metropolis*, 1925–6

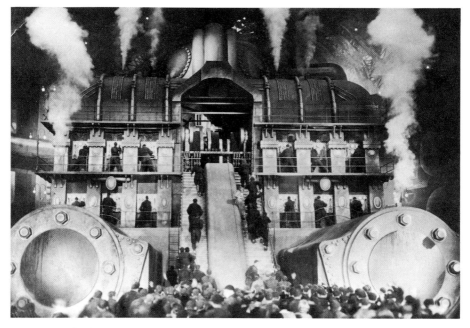

Technology became a popular subject. Several technical books written for the layman (with titles like *Beauty of Technology* and *Peace with Machines*) became best-sellers during the late 1920s. Perhaps the most dramatic evidence for the fascination of the machine and its social impact is Fritz Lang's film *Metropolis*. 105

The presence of J. J. P. Oud at the Bauhaus celebrations marked the reconciliation of the school with De Stijl, and from then on the influence of the Dutch group on the Bauhaus grew in strength. What the Germans found so exciting about De Stijl was its achievement in creating a collaborative, not to say collectivist, style in which variations introduced by individuals were reduced to a minimum. At the same time the Dutch began to have more respect for the Bauhaus: in May 1928 Vantongerloo wrote from Paris asking for a teaching position.

The exhibition demonstrated what the school was capable of achieving, and most clearly, perhaps, in the experimental house, named after the street on which it was built, 'am Horn'. It was not just an exercise in collaboration like earlier projects, but a prototype of cheap, mass-produced construction using the latest materials. It was designed, not by Gropius, Meyer or even Moholy, but by a teacher previously opposed even to handicrafts and dedicated to easel painting: Georg Muche. The painter's lack of technical knowledge was compensated for by the technical advice of Adolf Meyer, however.

The Haus am Horn was a simple cubic construction made of a 106 steel frame with a concrete infill. At the centre of the house was a large living-room, twenty feet square, which was taller by the height of a window than the rooms surrounding it. These rooms accommodated every need. Those for the children, for example, had walls covered with a material that served as a blackboard.

In a letter of March 1923 to the writer Alfred Döblin, asking if he would be prepared to publish an article about the forthcoming exhibition, Gropius stated that the aim of the house was to achieve 'the greatest comfort with the greatest economy by the application of the best craftsmanship and the best distribution of space in form, size and articulation'. Gropius went on: 'In each room function is important, e.g. the kitchen is the most practical and simple of kitchens – but it is not possible to use it as a dining room as well. Each room has its own definite character which suits its purpose.'

143

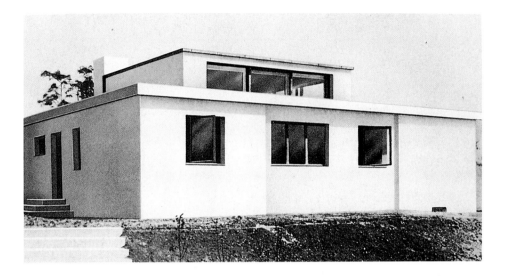

106–8 Muche's experimental Haus am Horn, 1923. *Above* Exterior from the street. The house was built at some distance from the main school on the plot of land which the Bauhaus used as a vegetable garden, and on which it was hoped that an entire 'Bauhaus estate' would appear. *Right* Marcel Breuer's dressing table with movable mirrors. Its construction recalls De Stijl designs. *Far right* Marcel Breuer's kitchen

The equipment of the house was as innovative as the basic design, and it was carried out entirely by Bauhaus workshops. There were specially designed carpets, radiators and tiles. The lights were designed by Moholy and made in the metal workshop. Much of the furniture throughout was designed by a student, 108 Marcel Breuer, who also conceived a kitchen which was startlingly functional. 'Who remembers', asked one of Breuer's student-colleagues, 'that it was the first kitchen in Germany with separated lower cupboards, suspended cupboards attached to the walls, a continuous work surface between them, and the main work space in front of the window (there was no table in the middle of the kitchen)?' Ceramic containers for foodstuffs such as flour and sugar had been designed in the pottery workshop, and significantly were already being mass-produced by an outside company.

Gropius had tried to persuade industry to provide the necessary materials free. In the event, the house was financed by Sommer-

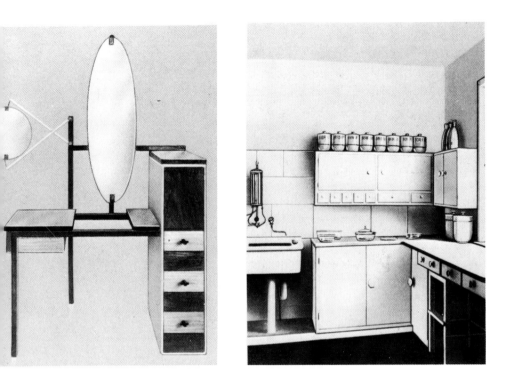

feld, the Berlin timber-merchant for whom Gropius had designed a villa in 1920. Indeed, the financing of the entire exhibition was a serious problem. In January 1923 Gropius had invested much time and effort in composing a long letter (translated by Feininger), which he sent to a number of what he called 'Dollar Kings', Henry Ford among them, asking for support. There were only two replies, both of them standard rejections. In the event there were not even enough funds to employ extra cleaners for the exhibition, so the teachers' wives busied themselves as temporary charwomen. The Haus am Horn itself had to be sold to a private individual as early as 1924 because of the school's financial straits.

The rest of the exhibition provided an idea of other Bauhaus activities. Gropius himself exhibited designs, plans, photographs and models to illustrate the theme 'modern architecture', and to demonstrate that a modernist style had emerged at the same time throughout Europe. Van de Velde's entrance-hall to the school had

109 Mural by Oskar Schlemmer in the right-hand section of the entrance hall of the workshop building of the Weimar Bauhaus, produced for the 1923 exhibition and later destroyed

110 Herbert Bayer's million mark banknote, issued by the State Bank of Thuringia

109 been reshaped to accommodate decorative schemes by Schlemmer, Joost Schmidt and Herbert Bayer, and the city museum showed work produced by students outside the curriculum.

The exhibition attracted much attention from the press, most of which was positive and optimistic. Adolf Behne, the leading radical critic of architecture in Germany at the time, wrote of 'a new and bold experiment which has been maintained here for four years under the greatest difficulties. With the exception of Russia I do not know where a second experiment of this kind might have been undertaken in Europe.'

One review was delightfully satirical. Writing for the *Kunstblatt*, the art magazine he edited, Paul Westheim concluded that: 'Three days in Weimar and one can never look at a square again. Malevich invented the square way back in 1913. How fortunate he didn't have his invention patented.' Westheim added that he had missed 'one of the idols of Cubism in the kitchen: the bouillon cube'.

Westheim published a more serious criticism of the exhibition and of the Bauhaus elsewhere. In an article written for the twentieth issue of the French periodical *L'Esprit Nouveau*, he said that the school, under the influence of Constructivist ideas, was taking as its model,

industry and industrial art. With that one slips immediately into a bad

146

Engineer-Romanticism which makes the positive mind uneasy. . . . The error of these tendencies is doubtless this: many believe they have achieved the essential by creating a new repertoire of forms – squares, triangles, circles, cubes and other geometric shapes. But these elementary forms have a point only when they lie at the heart of creation.

Such criticisms were in the minority, however, and the exhibition did wonders for the school's morale. The following term was the most successful there had ever been at the Bauhaus. The endless theorizing, the talk without action, ceased, and all the workshops began to produce things. A few commissions were even received from the outside, the most notable of which was that from the Thuringian mint for banknotes. In 1923 banknote-production was a booming industry throughout Germany thanks to inflation. A Bauhaus student, Herbert Bayer, was commissioned to design the one and two million and the one billion mark 110 notes. They were issued on 1 September 1923, by which time even higher denominations were necessary. It is a sobering thought that while the Bauhaus was *en fête* the German currency was collapsing. At the beginning of the exhibition a dollar was worth two million marks; by the time it ended, a dollar bought 160 million.

Bayer's designs were quite different from those for the rest of the inflation-money circulating at the time. They are models of

147

111 The Reichswehr, called in to quell civil unrest, parading in front of the town hall of Weimar in November 1923

simplicity and directness, virtues perhaps possible in banknote-design only when forgery is not worth the candle.

The inflation was not the only threat to the Bauhaus. The school began to flourish during a period of renewed political unrest. In 1923 there was a new national Government and a wave of demonstrations by both left and right throughout the country that threatened to bring the Government down. Troops were sent to 111 Weimar to keep the peace. Gropius, suspected of left-wing sympathies, was visited by military who searched his flat but found nothing. In December the Government fell. Early in 1924 the right gained the upper hand in the Thuringian parliament, and Gropius must have known then that the days of public financial support for the school were numbered.

The success brought by the exhibition was limited in any case. Before 1923 the Bauhaus workshops had sold products (above all

148

toys, furniture and fabrics) mainly to private individuals, either directly or at exhibitions staged by outside bodies. As a modest increase, by December 1923 some twenty German individuals and firms had placed orders with the workshops, as had a few foreign companies (including Dryad of Leicester). A small number of people in Germany had been granted a local franchise for Bauhaus products. The school took stands at various international trade fairs in Frankfurt and Leipzig in 1923 and 1924. During the same period only very few links with industry were established, and then only by the pottery and metal workshops. The celebrated chess set by Josef Hartwig which sold well was manufactured, not 112 by industry, but by a carpenter and joiner who had been sacked from his job in a piano factory – he had organized a strike. The chess set and other Bauhaus commissions enabled him to start his own firm. This, however, was scarcely the kind of co-operation with industry that Gropius was looking for.

112 Josef Hartwig, chess set, 1924. The design of each piece indicates its move

Although the atmosphere at the Bauhaus changed for the better after the 1923 exhibition, many of the painters sensed increasingly that they had become irrelevant to the school. Even Muche, whose design for the Haus am Horn had demonstrated a talent for architecture, later came to the conclusion that 'the thinking in norms had crippled the agility of my mind'. Muche remembered that:

It was the time when we at the Bauhaus began to think rationally after a period when our strengths were intuition and ignorance. We made life difficult for ourselves by, for example, trying to decide in committee meetings lasting for hours whether we should identify the workshop doors with letters or numbers, or letters and numbers or numbers and letters, in white or black or black and white or white and colours or colours and black.

Even though Feininger had seen the need for change, he also quickly regretted its results, as did Klee and Kandinsky who, like Feininger, preferred to remain at the school in the hope that they would provide a balance against the weight of rationalist thinking.

After the exhibition that weight became heavier still, as Gropius thought increasingly in scientific terms and peppered his lectures and articles with technical metaphors. In an article written in 1924 and published a year later he described the Bauhaus workshops as being 'essentially laboratories in which implements, capable of reproduction and typical of today, are carefully developed as models and continuously improved. In these laboratories the Bauhaus intends to train a new, previously non-existent type of collaborator for industry and craft who commands an equal knowledge of technique and form.'

The tensions within the Bauhaus were as nothing, however, when compared to the growing opposition from outside its walls. It soon threatened the school's very existence.

14 dessau

The 1923 exhibition had made the Bauhaus many friends. Few of them, alas, lived in Weimar. For the nationalists who won a majority in the Thuringian parliament in February 1924 the Bauhaus was too 'cosmopolitan'. Local craftsmen were more opposed to it than ever, now that it was preaching close links with industry, and the general public remained angry that their taxes were being spent on such a hare-brained institution. Mothers continued to warn unruly children that if their behaviour failed to improve they would be packed off to the Bauhaus.

Gropius spent much of his time parrying attacks from the right-wing press and doing his best to explain the school to bureaucrats and politicians. Sensing that he was fighting a losing battle, the director had been searching for alternative sources of funds for some time.

In September 1924 the Thuringian Ministry of Education informed Gropius that only half the necessary funds were available, and gave cautionary notice, effective from March 1925, to all Bauhaus staff. At the end of 1924 Ministry officials made a conducted tour of the school and announced that only teaching contracts valid for six months could now be offered. Three days later Gropius and the Council of Masters publicly announced that the Bauhaus would be closed at the end of March 1925. Since the school belonged not to the Masters but to the State and since all the Masters were under notice, what they did was illegal. Nevertheless, the Government eagerly approved the announcement and the school shut.

During the final confusing months Gropius and his staff considered ways of continuing the school elsewhere and, if need be, in a changed form. Other cities, among them Breslau and Darmstadt, expressed an interest in taking over some or all of the responsibilities Weimar had abandoned. The art school in Frankfurt am Main offered to employ all the painters on the staff and

STAATLICHES BAUHAUS WEIMAR

5

Bankkonten:
THÜRINGISCHE STAATSBANK
BANK FÜR THÜRINGEN
Postscheckkonto: ERFURT 22096
Fernsprecher 1135

WEIMAR, den 26.Dez.1924

An
 das thüringische Ministerium für Volksbildung

 W E I M A R

Auf Grund des Berichtes über die am 23.Dez. anlässlich
der Besichtigung des Bauhauses durch die Mitglieder des Staats-
ministeriums stattgehabten Besprechung mit Herrn Staatsminister
Leutheusser teilen wir dem Ministerium für Volksbildung mit,dass
wir von nun ab unsere Bereitwilligkeit zu Verhandlungen über die
Weiterführung des Bauhauses über den 1.April 1925 hinaus und
über die Gründung einer Bauhausgesellschaft zurückziehen.

 Wir sehen uns gleichzeitig gezwungen unsere Stellungnahme
durch Bekanntgabe der beifolgenden Erklärung in der Presse vor
der Öffentlichkeit zu rechtfertigen.

113 Letter to the Thuringian Ministry of Education from the Council of Masters
of the Bauhaus, breaking off negotiations about the future of the school

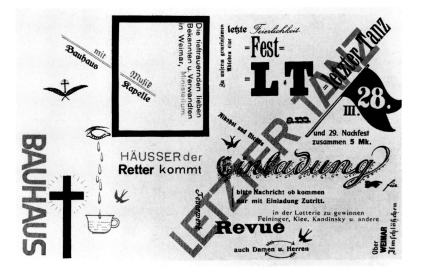

114 Herbert Bayer, invitation to the final Bauhaus party in Weimar, March 1925

some of them were tempted to accept. In the event Dessau made the most generous proposal.

This did not deter Frankfurt from reorganizing its school along Bauhaus lines, and it secured the services of some of the Workshop Masters: Christian Dell from the metal workshop, for example. Adolf Meyer also went to Frankfurt.

Meanwhile, with Gropius and his staff removed, the school in Weimar could be re-opened. Funds were restored, a new director was appointed and the name Bauhaus was even adopted for a few months.

Dessau was like Weimar in several ways. Until 1919 it had been the Residence of the Princes of Anhalt who, like the rulers of Weimar, preferred to spend their money patronizing the arts, not waging wars. Like Weimar, Anhalt and its capital had early established a reputation for liberalism, but, like Weimar, its cultural life had – with the exception of the theatre – been in stagnation for more than a hundred years.

Dessau was unlike Weimar in more important ways, however. It had a larger population (70,000), lay at the centre of an important coal-mining area and was consequently the site of a number of modern industries, the most significant of which was the Junkers

153

115 Dessau in 1924: the town hall with a Junkers aeroplane in the sky above

engineering and aircraft company. Twenty-five per cent of the
German chemical industry was also concentrated in the Dessau
area. The city was eager to expand still further.

Dessau had been governed by the Social Democrats for years,
and their majority seemed unassailable even during a period of
phenomenal growth for the nationalists. As Kurt Schwitters wrote
to Theo and Nelly van Doesburg, 'Dessau is the only German
province that has Socialist rule. It is therefore a Party matter that
the Bauhaus has been taken up there.' The final advantage offered
by Dessau was that it was much closer to Berlin. The train took
only two hours to get there, and it would not be long before a daily
air-service linked Dessau to the capital.

Most of the staff and students were delighted to move to Dessau. In spite of its industrialization every part of it was within walking distance of rivers and open fields, and the magnificent park at Wörlitz was not far away. As Klee's son Felix, by this time a Bauhaus student himself, remembered: 'In the midst of gloomy industrial sites (sugar, gas, Agfa, Junkers), this little capital city drowsed like some Sleeping Beauty.'

The person who achieved the school's move to Dessau was its mayor, Fritz Hesse, a liberal who ruled with SPD support. Hesse not only convinced influential industrialists of the advantages of having the Bauhaus in their midst, but also secured a budget for the school that would have been unthinkable in Weimar, even though the Bauhaus was funded by the state of Thuringia in Weimar and by the city alone in Dessau. The funds provided for new building and for accommodation for students and staff.

Gropius and almost all the staff quickly threw in their lot with 116
Hesse. Marcks preferred to go to another art school, and a few students and assistant teachers stayed on in Weimar.

Initially it was not clear whether funds would be available for a theatre department at the new school, but Mayor Hesse managed

116 The teachers at the Dessau Bauhaus, 1926. Left to right: Albers, Scheper, Muche, Moholy, Bayer, Schmidt, Gropius, Breuer, Kandinsky, Klee, Feininger, Stölzl, Schlemmer

to come to an arrangement with the Dessau theatre which put up most of the necessary money. For some years Schlemmer was theoretically employed not by the Bauhaus but the Dessau theatre, and was paid less than the other teachers. This led to resentment: Schlemmer believed that Gropius had let him down.

At first most of the teachers continued to live in Weimar and travelled to Dessau to teach for several days at a time. Kandinsky was one of the first to move. Klee, who had managed to arrange a convenient timetable, spent two weeks a month in Dessau where he rented a room in Kandinsky's flat.

Gropius was finally able to design a building to meet the school's needs, and went to work with a will. Before the new premises were ready, however, the Bauhaus moved into part of the Dessau school of arts and crafts, and took rented accommodation and some spaces in the city museum which were turned into temporary studios.

It was hoped that the Bauhaus would amalgamate with the Dessau school of arts and crafts. The director of the latter was persuaded to take early retirement on full pay to smooth Gropius' path. But, the optimism of the early Weimar years having evaporated, the hope was quickly abandoned. Indeed, in 1926 the Bauhaus took an additional name to distinguish it clearly from the other school. It became a 'Hochschule für Gestaltung', an 'Institute for Design'.

Other changes revealed how far the Bauhaus had moved from its original conception. Teachers at the Hochschule für Gestaltung were no longer known as 'masters' but as 'professors'. The dual system of Masters of Form and Workshop Masters was abandoned. Trained craftsmen were employed to assist with workshop teaching, but they were no longer treated as the equals of the professors. The apprenticeship scheme continued for some time, however, as did the division of students into journeymen and apprentices. At first students worked for qualifications validated by external bodies, but later for a single diploma awarded by the school itself. The democracy of the Weimar period was abandoned: decisions were now taken by the director alone.

One of the these changes had always been envisaged. The dual teaching system was a compromise enforced in Weimar by the lack of people equally gifted and trained in artistic theory and craft

practice. Gropius intended to abandon it as soon as enough sufficiently able students had graduated from the school. Such former students were now available, and were qualified to undertake the obligations of both Masters of Form and Workshop Masters. They were to train, not craftsmen, but, in Gropius' words, 'a new, previously unavailable type of *collaborator for industry, craft and building* who is the master equally of technique *and* form'.

Some workshops closed and others were amalgamated. Among the former were those for pottery (which continued independently at Dornburg) and stained glass (which was highly specialized and could not benefit from co-operation with industry). Craft implied the mastery of specific materials, so the Weimar workshops had been identified by the material – wood, stone, metal and so forth – used in each. This was unnecessarily inhibiting: it was in the cabinet-making and not the metal workshop that the first chairs were made from steel tubing, for example, and this demonstrated that function and not material more naturally defined the scope of each department. In 1928, therefore, the cabinet-making and metal workshops were combined to collaborate on the design of furniture and household equipment. Marcel Breuer was given charge of the enlarged department.

In Weimar the printing workshop had been devoted to the production of graphic art. In Dessau it concerned itself with layout, typography and advertising. It was run by Herbert Bayer. 125 Muche continued to have responsibility for weaving (assisted by Gunta Stölzl, a former student) and Schlemmer for the theatre 137 workshop. The mural-painting and sculpture workshops were run by Hinnerk Scheper and Joost Schmidt respectively. Moholy and 134, 136 Albers taught the *Vorkurs*, Kandinsky and Klee their basic seminars in form, which remained compulsory. Gropius, who had been Master of Form in the cabinet-making workshop in Weimar, now gave up teaching to concentrate on architectural commissions and administration.

Of all the changes at Dessau, the most important was the introduction of a department of architecture. Although it began work only in 1927, Gropius had made plans for it by the time the new building was opened in 1926. He even knew whom he wanted to run it: Hannes Meyer. 142

Other changes were also of consequence. In 1925, with capital provided by Adolf Sommerfeld, a Bauhaus limited company was founded to trade in patents and designs and assure the school of an 89 independent income. Plans were also made for a school journal. The first issue appeared in time for the opening of the new 86 building. A series of 'Bauhaus books' also began to appear.

In spite of all these changes, or perhaps because of them, not everything ran smoothly at first. A letter from Gropius to the Masters dated 21 January 1926 makes clear that several problems had moved with the Bauhaus from Weimar. Only one-sixth of the students at most ever seemed to be on the premises at one time, he observed, and 'What has become most important is not the work of the department or of the whole school, but the personal work of the individual. . . . I think it impossible to keep a department going if one concerns oneself with it for about an hour a day or less.'

Gropius then criticized the image of the school which had become too 'arty-crafty'. It is a letter which might just as easily have been written in Weimar in 1921.

In view of the size of the new Bauhaus building, the speed of its construction is surprising, testifying to one of the advantages of the new methods and materials Gropius employed. It was begun in 120 the summer of 1925 and was ready for use in October 1926. It was officially opened on 4 December 1926 in the presence of almost a thousand guests.

121 The new building consisted of teaching and workshop areas, a 122 theatre, canteen, a gymnasium and twenty-eight studio flats for students, above which was a roof-garden. The outstanding visual features of the main building were a vast glass curtain-wall on the workshop side (in Dessau the Bauhaus was known as 'the Aquarium'), and an enclosed two-storey bridge spanning a road, in which the administration and Gropius' private practice (later the architecture department) were housed.

The building, whose interior was designed and fitted by the Bauhaus workshops, bristled with special features. The kitchens, connected to the canteen by a serving-hatch, had a food-lift which could serve every floor of the studio flats and the roof-garden above. The stage separated the canteen from the main hall, and when folding screens were operated the stage, canteen and hall could be combined into a partial theatre-in-the-round with the

158

117 The director's house, designed by Gropius in the Bergkühnauer Allee, Dessau, 1926

audience seated on both sides of the stage. Students could reach every part of the school under cover. Xanti Schawinsky, one of the students, ascribed the 'wonderful community spirit' of the Dessau Bauhaus to Gropius' architecture: 'All you had to do to call a friend was to step out on to your balcony and whistle.'

Structurally the building was an experiment. The skeleton was of reinforced concrete, the floors were of hollow tiles resting on beams. The flat roofs were covered with a newly developed waterproofing material. This soon proved inadequate, however. Also inadequate were the funds provided by the Dessau council: Gropius greatly exceeded the generous budget, ensuring that the Bauhaus would become an election issue in 1927.

About ten minutes' walk away on the Bergkühnauer Allee, a pleasant street liberally planted with pine trees, Gropius built four houses for members of staff. He himself had a detached house and 117 there were three pairs of semi-detached houses. Each of them was severely functional. As Gropius explained: 'To build means to shape the activities of life. The organism of a house derives from the course of the activities which take place within it. ... The shape of a building is not there for its own sake ...'.

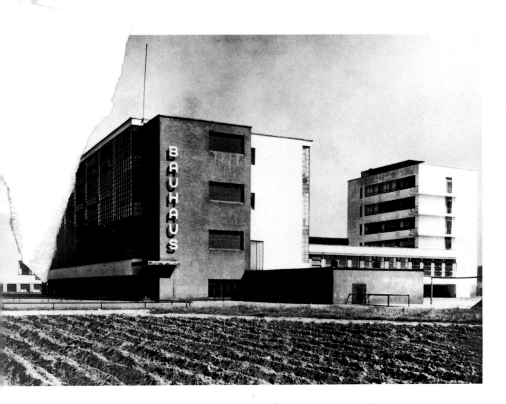

118–22 The Dessau Bauhaus. *Opposite, above* The vestibule on the first floor of the main block opening into the auditorium (*opposite, below*). The theatre's seats are by Breuer, lighting fixtures by Moholy. *Above* Exterior view, and plan showing (1) workshop wing, (2) auditorium, canteen, kitchens and gymnasium, (3) Studio apartments, (4) administration and Gropius' architectural practice (later the architectural department of the school), (5) School of Arts and Crafts. *Right* Balcony of student's apartment

Moholy and Feininger shared one of these houses, Muche and Schlemmer another, and Kandinsky and Klee the third. Not all of them were happy in their new surroundings. Kandinsky's wife recalled that:

There were weaknesses which did not make living very comfortable. For example, Gropius had given the entrance-hall a large transparent glass wall which gave everyone the chance to look into the houses from the street outside. That bothered Kandinsky. ... So he took it upon himself to paint the inside of the glass wall white.

Kandinsky's problems did not end with the lack of privacy:

Gropius was against coloured interior decoration in his houses. Kandinsky on the contrary appreciated living in a coloured environment. We therefore had our rooms painted, the dining room, for example, in black and white.

Marcel Breuer produced furniture for the dining rooms and bedrooms according to Kandinsky's instructions. Kandinsky who, according to his wife 'was going through a phase of circles ... wanted ... furniture with as many circular elements as possible'.

It is perhaps details of the more trivial aspects of life which help us more clearly to imagine the atmosphere at the Dessau Bauhaus. Kandinsky, middle-aged, always immaculately dressed, rode about on a racing bicycle. Klee, an accomplished violinist, played string quartets at home and duets with his wife in public at the Bauhaus, and occasionally elsewhere with members of the Dessau city orchestra. Aircraft from the Junkers factory droned daily overhead. In 1929, on Klee's fiftieth birthday, one of them dropped flowers and presents on to the flat roof of his house. If Felix Klee is to be believed, the roof collapsed under the weight of the gifts. Sport and rambling became popular free-time activities for staff and students. The young Prince of Anhalt was a frequent guest at Bauhaus parties.

The enthusiasm for sport reflected a general trend in Germany at the time. What was previously regarded as a pursuit of the leisured class was now seen not only as important for health but as a means of breaking down class-barriers and of making democratic Republicans out of authoritarian Germans. The team was the thing: in soccer as in workshop-production and architecture.

123 The Bauhaus Band. Formed in Weimar, it only played improvised music –
not all of it jazz

The Bauhaus parties (which had begun in Weimar) were regular
and spectacular. By the time of the move to Dessau the school jazz
band had become famous even in Berlin, and always provided
music for such occasions. The parties were regarded almost as
extensions of the school curriculum. Each had a theme, invitations
were designed and produced, costumes and masks were made. The
proceedings were stage-managed by Schlemmer and the theatre
workshop. It is not surprising that some former students remem-
bered more about the parties than the teaching.

A report in the *Anhalter Anzeiger* for 12 February 1929 described
the excitement of that year's Carnival party which had metal as its
theme:

Even the entrance to the party was original. It led to a slide which had been constructed in the walkway between the two Bauhaus buildings. Even the most dignified personalities could be seen sliding down into the main rooms . . . music, bells, tinkling noises were heard . . . wherever one went . . . every area of the populace was represented. Most of them in 'metallic' costumes . . . an amusing confusion of films alternated with a variety of acts presented by members of the Bauhaus.

The atmosphere at the Dessau Bauhaus was quite different from that at the Weimar school. The clean-lined, functional and assertively modern building served as a constant reminder that the school had come of age, not as a place where the old-fashioned crafts lived on in rejuvenated form, but where a new kind of industrial designer was being trained. The period of experimentation was over. What went on now was serious, practical and effective.

Many of the old faces remained, however, and the teachers who had transferred from Weimar continued their courses in virtually unchanged form. Klee and Kandinsky developed their instruction in basic design. Albers and Moholy ran the preliminary course much as they had done in Weimar. Muche remained in charge of the weaving workshop until 1926. Schlemmer made full use of the new facilities offered by the building and made the experimental theatre famous throughout the German theatrical world. Feininger was no longer a full member of staff. Having long since given up teaching, he received no salary but was permitted to live rent-free in one of the school's houses.

What made the teaching at Dessau obviously different from that at Weimar was not so much the work of the older staff as that of their younger colleagues, the 'Young Masters' who introduced new activities or taught in new ways.

124 The Bauhaus vestibule decorated for the 'Metallic Festival', mirrored in one of the reflective balls hanging from the ceiling, 1929. Photograph by the student W. Funkat

15 young masters

Of the twelve members of staff at the Dessau Bauhaus, no fewer than six had been students in Weimar. Their elevation realized one of Gropius' original aims.

One of the students, Albers, had already designed and given a preliminary course in Weimar, but circumstances prevented his appointment as a full teacher until the move to Dessau. He was joined on the staff by Herbert Bayer, Marcel Breuer, Hinnerk Scheper, Joost Schmidt and Gunta Stölzl.

Five of them, equally at home with fundamental theoretical problems and workshop techniques, were given full responsibility for their various departments. The sixth, Gunta Stölzl, was obliged to work under Muche in the weaving workshop until he resigned in 1927. Bayer took over the printing workshop, Breuer the carpentry and cabinet-making, Scheper mural-painting and Schmidt the sculpture workshop.

These teachers were not formally regarded as the equals of the old guard who had been Masters of Form in Weimar. For reasons that are not entirely clear, although almost certainly financial, they were given no official title, being known unofficially as 'Young Masters', and they were paid two-thirds of the full teaching salary. A promise that they would be elevated to professorships later on was not kept.

125 Of the Young Masters, Herbert Bayer (born 1900) was probably the most versatile. A painter and graphic artist as well as a photographer, designer and typographer, Bayer was an Austrian who had arrived at the Bauhaus as a student in 1921. From 1919 until then he had been working in Darmstadt for an architect who introduced him to the then completely new business of designing packages.

In charge of the school's printing department from 1925 until 1928, Bayer became interested in advertising techniques of all

kinds, in the design of exhibition stands, promotional literature, advertisements and the visual identity of a firm or product in general. He changed what in Weimar had been a workshop for the hand-printing of lithographs, woodcuts and other graphics into a modern enterprise which employed movable type and mechanical presses.

As a typographer Bayer was sufficiently gifted to carry out commissions while still a student, and in his use of simple typefaces, heavy rules and asymmetrical composition was much influenced 126 by Moholy and De Stijl. As a teacher of typography Bayer was exercised above all by the problem of simplicity and directness. He considered serifs redundant, as he did capital letters.

The boldness – some might say rashness – of Bayer's campaign against both serifs and upper case type is better understood if it is remembered that much German printing at this time employed 'Gothic' type-faces, and that German orthography demands the use of capital letters not merely for proper names and at the start of sentences but for the first letter of every noun.

125 Herbert Bayer

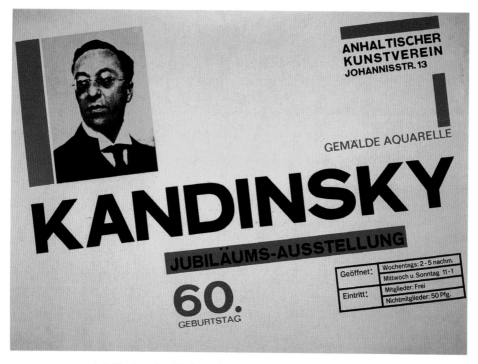

126–8 Designs by Herbert Bayer. *Above* Poster for Kandinsky's 60th birthday exhibition in Dessau (modern reprint). *Below* Research in the development of a universal type, 1927. *Right* Design for a newspaper kiosk, tempera, 1924

129 Marcel Breuer

Bayer argued that lower-case alone was more economical because it required one alphabet instead of two, and would give perfectly legible texts once readers had grown used to it.

Resistance to such typographical radicalism was as great then as it is now, and in any case Bayer continued to use capitals in many of his projects. He did forgo serifs in his display-work at least, however, and his use of simple, elegant type-faces in a limited number of weights and sizes, together with his judicious introduction of heavy rules, sometimes in a different colour, probably did more than anything else to give the Dessau Bauhaus a clear visual identity. Today the Bauhaus and sans-serif type seem inseparable.

Like Bayer and all the other Young Masters, Marcel Breuer (1902–81) produced work of great originality while still a student at the Weimar Bauhaus. Born in Hungary, he arrived at the school in 1920 and spent most of his time in the cabinet-making workshop. His earliest work demonstrates the hold on the Bauhaus at that time of Expressionism and the related interest in primitivism. One of his pieces was a chair made out of branches applied virtually direct from the tree. Then he came under the

130–2 The development of Breuer's chairs. *Left* The primitivistic 'African chair', 1921. *Above* The influence of Rietveld and De Stijl, wood, 1922. *Below* the 'Wassily' chair of 1925 of tubular steel and leather (originally canvas) named for Kandinsky

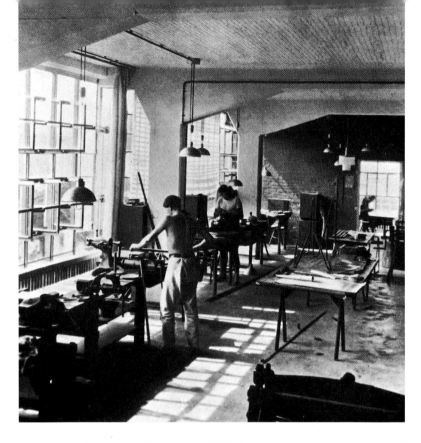

133 The metal workshop, Dessau, *c.* 1927

134–5 Hinnerk Scheper and (*far right*) his colour scheme for an interior, probably 1930

influence of Rietveld and De Stijl and tried to rethink the design of furniture, and especially of chairs. He produced a series of wooden chairs that were strikingly simple and aggressively geometric. They were also designed to be easily assembled from standard parts.

Although in charge of cabinet-making at the Dessau Bauhaus, Breuer produced his most celebrated designs for furniture, not in wood, but in metal and cloth or leather. His use of bent tubular steel in chairs (reportedly influenced by the chromed steel tubular handlebars on his Adler bicycle) was original and very influential. The leather or cloth supports for the body resulted in greater comfort than did the wood in his earlier designs.

A commercial company, Mannesmann Steel, made the bent-steel frames until special manufacturing equipment could be designed and imported for the Bauhaus. Breuer was the first designer to allow chrome to enter the home. It was a material dramatically alien to craft traditions.

Hinnerk Scheper (1897–1957), who took over the mural-painting workshop in Dessau, was one of the many Bauhaus students who had trained elsewhere before arriving in Weimar. He was twenty-two when he enrolled as one of the first students in 1919. Although Scheper specialized in mural painting the term is misleading. Whereas Kandinsky, in charge of the workshop in Weimar, saw interior decoration in terms of producing abstract

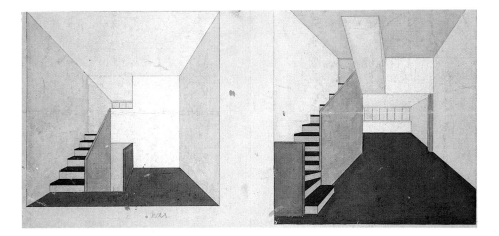

compositions on a large scale, Scheper was concerned with the use
135 of large areas of flat colour, varied from wall to wall and even from
floor to ceiling, to create a pleasant environment and to enhance
the spaces established by the basic architectural design.

Although influenced by De Stijl (who restricted themselves to
the primary colours, however), Scheper's use of colour in rooms
was original and influential. He also brought a fresh approach to
the design of wallpaper, one of the fields in which the Dessau
Bauhaus was conspicuously successful. In wallpaper design as in
his colour combinations Scheper favoured simple effects which
complemented the architecture.

Joost Schmidt (1892–1948) was a student of painting at the
Weimar art academy from 1910 until 1914. He was therefore

already qualified as an artist when he decided to begin his studies again at the Bauhaus in 1919. As a member of the sculpture workshop he collaborated on the Sommerfeld house in Berlin, he was Schlemmer's most able student, and later produced reliefs in the main Bauhaus building for the 1923 exhibition. He was also gifted as a typographer, and taught hand-lettering in the printing workshop under Bayer while running the sculpture department at the same time. When Bayer resigned in 1928, Schmidt succeeded him as head of the printing workshop, and remained with the Bauhaus until its final closure. 52 55 89, 98

As the only woman on the staff, Gunta Stölzl (born 1897) trained and later taught in the workshop devoted to what was conventionally considered to be women's work: weaving. Stölzl 138–9 arrived in Weimar in 1919 and left in January 1924, after she had qualified, to join Itten at Herrliberg. He had asked her to start and run a small workshop for weaving at the Mazdaznan headquarters. Stölzl returned to the Bauhaus in 1925 to assist Georg Muche, an arrangement which suited neither him nor her, and failed to satisfy the students. Between 1926 and 1931 she ran the workshop single-handed, and demonstrated that she was one of the finest weavers of her generation, capable not only of translating complex formal compositions into handwoven carpets, curtains and runners, but also of designing for machine-production.

136 *Opposite* Joost Schmidt, possibly the most versatile of all the Bauhaus students and teachers

137 Gunta Stölzl, one of the most original weavers of this century

138–9 Products of the weaving workshop. *Above* Ruth Hollos-Consemüller, gobelin, *c.*1926. *Opposite* Gunta Stölzl, gobelin, 1926–7

140 Gunta Stölzl, design for a runner, tempera, 1923

Stölzl also experimented successfully with new and surprising materials (cellophane, for example) and established important links with industry. Indeed, in terms of designs sold to outside businesses, her department was one of the most successful at the Bauhaus.

According to Stölzl, the workshop discipline in Dessau was stricter than in Weimar, and this was not necessarily a good thing. In Weimar any student could wander into the department, weave a carpet or rug and then wander out again. Such work was often better than that made by the regular students. In Dessau, on the other hand, only registered apprentices were permitted to work in the workshop, and their timetable was rigorously structured.

These Young Masters were different in many ways from their older colleagues. They were much less specialized, equally at home in the workshop and studio, dedicated to solving practical problems, devoted to artistic activities with an obviously public application, and determined to demonstrate that there is no essential difference between fine art and the crafts. A generation younger than the other teachers, they were also closer to the students and more anxious to teach by example, co-operating on projects with the students in the workshops. It was the Young Masters who did most to create the identity of the Bauhaus and its products during its early years in Dessau.

16 a new director

The Bauhaus, founded and directed by an architect who believed that 'the ultimate aim of all creative activity is the building', had been without an architectural department in Weimar, and continued to lack one for some time after its move to Dessau in 1925. Gropius remained convinced, at least initially, that students would be ready to approach architectural problems only after a thorough grounding in theory and craft- and design-skills.

Soon after the move to Dessau, however, Gropius changed his mind. In 1927 an architectural department was established, and was the equal of the workshops. After completing the preliminary course the student could opt to specialize in architecture, and was thus not obliged to acquire a craft-skill of any kind.

After Gropius had approached a reluctant Mart Stam, the man who accepted the post of professor of architecture was the Swiss Hannes Meyer (1889–1954). Meyer had a background which at 142 least in theory made him an ideal member of the Bauhaus. In Berlin from 1909 to 1912, he had become an anthroposophist and a member of various groups working for land-reform. In 1912 and 1913 he had travelled around Britain studying the English garden-city and co-operative movements. At the beginning of 1927 Meyer arrived in Dessau and moved into part of Schlemmer's house. Meyer brought Hans Wittwer with him as an assistant: Wittwer had collaborated with him on designs for the projected League of Nations building in Geneva.

It is not clear why Gropius proposed Meyer for the post, and even less clear why his proposal was accepted by the Bauhaus Council. For Meyer's approach to architecture was quite different from that of Gropius, and was informed by an uncompromisingly left-wing political philosophy which had replaced the belief in anthroposophy. Gropius must have known that he was courting disaster by appointing such a man to an institution whose survival depended on strict political neutrality.

179

Nor is it entirely clear why Meyer accepted the offer of a professorship at the Bauhaus. At first he could not make up his mind, for he was extremely critical of the work he had seen at the school. 'Much', he wrote to Gropius, 'immediately reminded me of "Dornach-Rudolf Steiner" – sectarian, therefore, and aesthetic . . .'. Three years later, he wrote scathingly about the Bauhaus that awaited him upon his arrival in Dessau. It was a school 'whose reputation greatly exceeded its ability to achieve anything'. It was 'an "Institute for Design" in which every tea-glass was turned into a problematical constructivisty shape. A "Cathedral of Socialism" in which a medieval cult was pursued by the revolutionaries of prewar art, assisted by a youth which squinted towards the left while simultaneously hoping to be sanctified, some time in the future, in the same temple!' Meyer continued:

Incestuous theories blocked every means of designing in a way that was right for life: the cube was trumps and its faces were yellow, red, blue, white, grey, black. This Bauhaus cube was given to the child as a toy and to the Bauhaus snob as a knick-knack. The square was red. The circle was blue. The triangle was yellow. One sat and slept on the coloured geometry of the furniture. One lived in the coloured sculpture of the houses. As carpets on their floors were laid the psychological complexes of young girls. Art strangled life everywhere.

Meyer fervently believed that it was the architect's job to improve society by designing functional buildings that would improve the lot of the common man. His philosophy can be understood with the aid of an article which he wrote for the fourth issue of the Bauhaus magazine in 1928:

All things on this earth are a product of the formula: (function times economy) . . . building is a biological process. Building is not an aesthetic process . . . architecture which produces effects introduced by the artist has no right to exist. Architecture which 'continues a tradition' is historicist . . . the new house is . . . a product of industry and as such is the work of specialists: economists, statisticians, hygienicists, climatologists, experts in . . . norms, heating techniques . . . the architect? He was an artist and is becoming a specialist in organization . . . building is only organization: social, technical, economic, mental organization.

Under Meyer the architecture department assisted Gropius with a number of commissions, the most important of which was an

141–2 Hannes Meyer, *right*, at the Bauhaus in 1928; *left*, caricatured as 'From the Bauhaus to Moscow' in 1930

experimental housing-project built in three stages in the Törten 143–6 district of Dessau (1926–28). Here an entire, rationally planned estate was to be constructed with standardized components, most of which, such as concrete walls, were to be manufactured on site. Standardization made for speed and economy of production, and on-site manufacture dramatically reduced transport costs. The initial construction of each house took only three days.

Although the first three stages of the estate were built and although important lessons were learned about on-site preparation, the project was not an unqualified success. By 1929 serious criticisms were being made of the speedy deterioration of the buildings. Cracks had appeared in the walls of no less than a third of the houses, damp had become a problem and the heating was inadequate. Nevertheless the houses (which were for sale as well as rent) were very cheap, and offered hundreds of families the realization of a dream: their own property with a garden. In the originality of their building methods they were rivalled only by Ernst May in Frankfurt am Main.

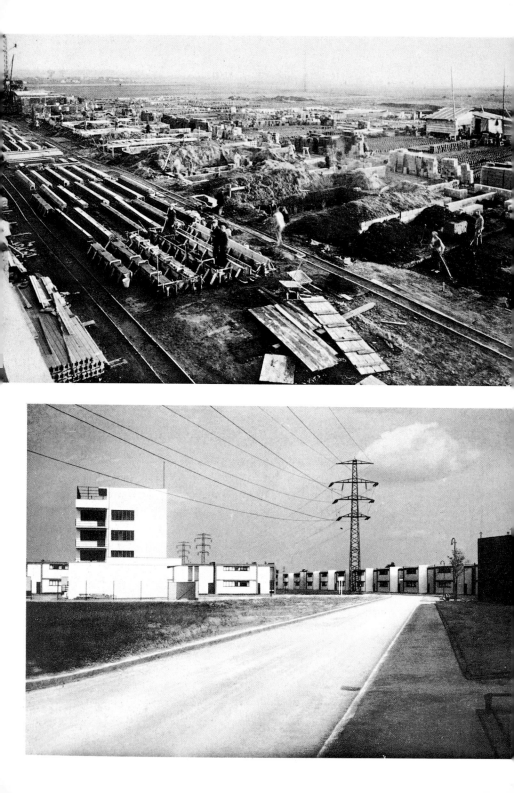

143–6 The estate at Dessau–Törten. *Opposite, above* Construction in 1927 showing the on-site manufacture of breeze blocks and beams. *Opposite, below* A general view soon after completion in 1928. Gropius' Konsum (co-operative shop) building is on the left. *Above* Gropius' Konsum building today with a row of shops and, at right, the apartment block. *Right* Terraced houses in their modern state

147 Experimental steel house on the Törten estate, 1926, by Georg Muche and Richard Paulick, modern photograph. The porch and rustic garden are later additions

145 The Törten estate also contained a block of flats with shops beneath designed by Gropius (the Konsum building), and a single dwelling by Georg Muche and Richard Paulick, an experimental construction made almost entirely from steel plates 3 mm thick. Steel houses were not new: three British companies had been producing them for some time, proudly advertising that they could be built from start to finish in from six to nine days. They, however, were finished to look like conventional brick-and-timber 147 constructions, while the Törten steel house made no attempt to disguise its material. It still stands, although rust around the base is causing problems.

Within the Bauhaus Meyer's presence quickly inspired resentment. He fell out with Moholy who, in spite of his belief in the importance of science and technology, insisted on the crucial role of artistic creativity; and he antagonized Klee and Kandinsky, who had experienced problems enough in coming to terms with Moholy. Muche, disillusioned even before Meyer's appointment, resigned in 1927. He had become convinced that he had lost his way at the Bauhaus. Significantly, he moved to Berlin where he joined the staff of the private art school run by Johannes Itten, now returned to education after his sojourn in Herrliberg.

In January 1928 Gropius himself decided to resign. His decision was sudden, surprising, and meant breaking his contract which had two more years to run. He had been director for nine years, had fought with wearying determination to establish the school and protect it from ceaseless attack. Now criticisms of the Bauhaus, echoing those of the school's Weimar years, were increasing monthly. On resigning, Gropius claimed 'that until now ninety per cent of my work has been devoted to the defence of the school'. He came to the conclusion that if he did not leave he would quickly be burned-out as an architect and as a man. The moment for his resignation seemed propitious: in spite of the criticisms in the press and the Dessau council the school enjoyed good relations with the funding authorities for the first time in its history. The new building was a great success. The facilities were excellent and contacts with industry were beginning to multiply.

Only haste caused by Gropius' anxiety to return to his architectural practice and his relief at freeing himself from the burden of administration can explain his choice of successor. For, after approaching Mies van der Rohe (who refused), Gropius named Hannes Meyer, who had been at the Bauhaus for a shorter time than any other professor, had already provoked the enmity of most of his colleagues, was left-wing and anti-art, and, if his later statements are to be believed, had a low opinion of the school.

The student-representatives feared what Meyer's directorship might bring. 'We have gone hungry for the sake of an idea, here in Dessau,' they told Gropius. 'You must not be allowed to stop now. . . . Hannes Meyer may be a splendid fellow. . . . But Hannes Meyer as director of the Bauhaus is a catastrophe.'

Moholy immediately resigned. Breuer and Bayer went soon after, and it is surprising that no-one else followed their example. Kandinsky remained and continued to act as deputy director, although subsequent events suggest that he did so only to undermine Meyer's position.

Those who left made their objections clear in a letter to the Bauhaus Council:

We are now in danger of becoming what we as revolutionaries opposed: a vocational training school which evaluates only the final achievement and overlooks the development of the whole man. . . . Community spirit is replaced by individual competition . . .

185

According to T. Lux Feininger:

Architecture became the principal field of study. . . . The new unity of art
and technology came to a standstill. . . . The dreams of a regeneration of
society hardened into specialization. Authority, structure, re-entered the
scene.

The architecture department was subdivided into two sections:
building in theory and practice, and interior design including the
manufacture of furniture and utensils. All the workshops with the
exception of the theatre, the newly formed advertising department
and the fine art classes were therefore brought into much closer
contact with, and made subordinate to, the business of building.

Although the architecture department was now clearly supreme,
some of Meyer's innovations as director must have taken staff and
students by surprise. For the first time Klee and Kandinsky were
allowed to offer painting classes as part of the curriculum, and

149–50 Schlemmer, whom a lack of money had prevented from becoming
a full member of staff in Dessau, was now made a professor and
asked to teach a new course. Called 'Man', it consisted of life-
drawing and lectures on human biology, philosophy and so forth.
Regular classes in gymnastics were introduced. Town-planning
was taught by Ludwig Hilbersheimer (1885–1967). A constant
stream of guest lecturers (among them Mart Stam) passed through
the Bauhaus bringing knowledge of sociology, Marxist political
theory, physics, engineering, psychology and economics.

148 A new photography workshop was established under Walter
Peterhans (1897–1960) who had trained as a mathematician,
became a Bauhaus professor in 1928, and taught the technical as
well as the aesthetic sides of photography. During a three-year
course students acquired knowledge of photo-journalism as well as
of advertising and other display work.

Meyer also did his best to persuade the various workshops to
think first of producing designs and goods for sale to industry, not
supplying the luxury market but making cheap, mass-produced
essential items like furniture. And he made his architectural
students concentrate not on individual dwellings but on the
problems of mass-housing.

Theory was taught as a reflection of practice. The students from
almost all the workshops were given practical problems to solve:

148 Student photograph made in one of Walter Peterhans' classes, *Detail of an Ashtray*, c.1932

on the final stage of the Törten estate and on a trade union school in Bernau, for example. Meyer was determined 'that the group of students participating should be spared nothing from the first letter ordering the necessary material to the auditing of the final account'.

The best example of how some of the workshops became profitable during Meyer's directorship is provided by the mural-painting department. Emil Rasch who had inherited a wallpaper factory at Bramsche near Osnabrück, and whose sister was a student at the Bauhaus, suggested to Meyer that the school might like to produce some designs for him. Although Rasch later revealed that 'my sister asked me never to mention at the Bauhaus that she was the daughter of a manufacturer – even worse, a manufacturer of wallpaper', his suggestion was enthusiastically received. Staff and students in the mural-painting department designed a series of textured and quietly patterned papers quite unlike anything commercially available at the time. They proved very popular and made more money for the school than anything else. In the first year alone four-and-a-half million rolls were sold. They are still available today and are produced by the same company, Emil Rasch of Bramsche.

149–50 Oskar Schlemmer, *Group on Stairs*, oil on canvas, 1931, a characteristic example of the artist's architectonic style in which simplified, doll-like figures are arranged in a clearly defined space. *Right* Sketch for a schematic survey for Schlemmer's course on 'Man', 1928, indicating the relationships of the figure to the environment and between one part of the body and another

At the same time the weaving and furniture workshops also proved capable of earning considerable funds for the school. A few of the commissions secured by the Bauhaus during the last quarter of 1928 demonstrate how successful the workshops had become. The metal workshop designed all the lighting in the Dessau swimming baths and for the Dresden museum of hygiene. The furniture workshop designed the fixtures and fittings for exhibitions in Dessau and Leipzig. The new advertising department won the contract to design all the newspaper advertisements for I-G Farben. The funds thus earned enabled the Bauhaus to establish scholarships and grants for some of the students, and even to think of becoming self-supporting for the first time.

Ironically, the school under the Marxist Meyer benefited enormously from the success of the capitalist system. By 1927 Germany had become a major economic power again. It exported more electrical goods than any other nation, and had turned the phrase 'Made in Germany' into a synonym for excellence and reliability. Money was now available for investment and experiment, and some of it came the way of the Bauhaus.

For the first time the school was achieving what it set out to do. At the same time, however, the school had changed almost beyond recognition, and it was inevitable that most of the staff whom Meyer inherited should have felt disaffected and threatened. Albers, Klee, Kandinsky and Schlemmer were quickly convinced that their presence was an irrelevance. Klee let it be known that he would be happy to be offered a congenial post elsewhere. Schlemmer moved to the Breslau Academy in the autumn of 1929. Meyer did not replace him, and closed the theatre workshop.

What the painters disliked most was the emphasis on building, advertising and, above all, the sociological approach to everything. In a letter written shortly before his departure, Schlemmer reported on the 'latest *cri de Meyer*, "The Sociological"'.

The pupils have to do something on their own, carry out a commission 'with the least possible intellectual prompting from above'; even if the work is unsatisfactory it has a sociological value ... (I am constantly reminded of the joke: Master I have finished making your trousers; shall I darn them now?) The aim: a Students' Republic (without teachers).

Meyer's belief in sociology was an extension of his political views, and since he believed that every human activity had political implications, politics were given an important place in the curriculum. Classes in political theory were held and political discussion was encouraged. A Communist cell was formed, and attracted fifteen members, about ten per cent of the students. Unlike Gropius, Meyer was not prepared to trim his sails to the wind in the interests of the school's survival.

Meyer's Marxism played into the hands of the school's opponents, who had been arguing ever since the Bauhaus had moved to Dessau that it was a nest of Bolsheviks. The students' singing of Russian revolutionary songs at the 1930 Carnival party had not been well received. The press circulated rumours, and Mayor Hesse was

accused of having used money from the city art gallery to buy paintings from Bauhaus teachers at inflated prices to decorate his own private rooms. It became clear to Hesse that if the school were to survive at all it would have to be with a new director.

Kandinsky was clearly implicated in a plot to have Meyer removed: it was his close friend, the art historian Ludwig Grote, who first informed Hesse that the Bauhaus was riddled with left-wing radicals encouraged by the director. Gropius, who continued to keep a benevolent eye on the school from afar, was also in favour of a speedy change, as were all the teachers with the exception of Stölzl and – surprisingly – Klee. In 1930 Meyer was forced to resign, ostensibly because he had donated money to striking miners in the name of the school. In a bitter open letter to the Mayor he reminded Dessau that under his directorship the school's earned income had almost doubled, and that the number of students had risen from 160 to 197. 'Only by introducing entrance qualifications', he wrote, 'were we able to keep the numbers down.' Meyer could not hide his anger. He had been 'stabbed in the back'.

Not only Meyer was forced out of the school. Communist students had to leave, too, and some of them joined a collective with Meyer which offered its skills to the Soviet Union. Meyer wrote at the time: 'I am going to the USSR in order to work where a truly proletarian culture is being forged, where socialism is coming into being, where that society already exists for which we here under capitalism have been fighting.' Meyer remained in Russia until 1936 when he returned to Switzerland.

The Bauhaus now had enemies on the left as well as the right. The Communist illustrated weekly *AIZ* (Workers' Illustrated Newspaper) spoke for many of the former when it wrote, soon after Meyer's resignation, that 'a revolutionary Bauhaus was an illusion in a capitalist state'. In becoming the target of radicals from both ends of the spectrum the school continued to mirror the predicament of the Weimar Republic, which was itself increasingly weakened by attacks from all quarters and which, thanks to Black Friday on Wall Street, was again experiencing economic chaos and entering its final phase.

In August 1930 Meyer was replaced by Mies van der Rohe. The last, depressing years of the Bauhaus had begun.

17 the bitter end

Mies van der Rohe (1886–1969) had long since established an international reputation as the designer of seemingly simple, elegant steel-and-glass buildings when, on Gropius' recommendation, he was appointed director of the Bauhaus in the summer of 1930. It is not clear why, having refused the directorship in 1928, he now accepted.

Mies' main task was clear. He had to restore the reputation of the school in the eyes of its opponents and that meant, above all, freeing it from the taint of politics. In order to achieve this he was forced to keep the more radical students under control, to introduce a degree of authoritarianism that was quite foreign to the original Bauhaus idea.

There was more than enough opposition to Mies among the left-wing students. Soon after he arrived they criticized him as a 'formalist', for preferring to design luxurious houses for rich patrons rather than cheap accommodation for the working class. They felt that they had been given no say in the appointment of a new director, and instructed Mies to exhibit his designs so that they might judge whether he was qualified to run the school. In place of Albers and Kandinsky they demanded teachers of sociology, economics and psychology. An application form for membership of the Communist Party was appended to one of their pamphlets. Noisy meetings were held in the school canteen and at least one of them threatened to degenerate into a riot. Chanting students dared the director to come out of his office and defend himself. The police were called in, the school was cleared and then closed.

After several weeks the Bauhaus re-opened its doors and the leaders of the near-riot were expelled. Mies then interviewed each

student individually in his office, telling all that they too would be expelled unless they promised to obey the rules. These rules included a ban on political activity of every kind.

Before the start of the first term in 1931 each student received at his home address a declaration which he had to sign before being readmitted. It read in part: 'With my signature I undertake to attend the courses regularly, to sit in the canteen no longer than the meal lasts, not to stay in the canteen in the evening, to avoid political discussions, and to take care not to make any noise in the town and to go out well dressed.' At least one student 'tore up the paper and sent it back to the Bauhaus without a stamp' before leaving the school.

The introduction of such petty regulations testifies to the precarious state of the Bauhaus on Meyer's departure and to Mies' determination to defend his school from its critics.

Like Gropius, Mies combined the directorship with work in his private practice; but Mies kept on his practice in Berlin and left the capital only for three days every week, living in Dessau in one of the staff houses. Mies thought that architectural training was central to the school's curriculum, and placed even more emphasis on it than Meyer had done. Indeed, under Mies the Bauhaus became even more like a traditional school of architecture. Theory now dominated everything. Practice was restricted to such an extent that the workshops began to stagnate, produced fewer and fewer goods, and then halted production completely. As Hannes Meyer wrote later:

The third phase of the Bauhaus, that under the direction of the architect Mies van der Rohe, is characterized by the return to the school of instruction. The influence of the students over the way life was lived at the Bauhaus was wiped out. All sociological subjects and opinions disappeared, particularly in the work of the workshops. Once again the children of the upper classes were admitted as students and in the workshops exclusive furniture was produced from exclusive materials. The first organized Nazis appeared among the students.

The dominance of architecture over the workshops was made plain when, in 1930, the furniture, metal and mural-painting workshops were combined into a single department for 'interior design'. From 1932 this was run by Lilly Reich (1885–1947), who was also given responsibility for the weaving department. Mies cut

151 The Berlin Bauhaus at Birkbuschstrasse in the suburb of Steglitz, 1932–3

the length of study from nine to seven semesters and divided the school into two main areas: exterior building and interior design.

As an architect and teacher Mies was markedly less functionalist than Meyer. Far from being scornful of the notion of architect as artist, he stressed formal qualities, demanded elegance and aesthetic 'rightness'. An anecdote told by one of his students nicely describes Mies' attitude to architectural design: 'If you meet twin sisters', Mies said, 'who are equally healthy, intelligent and wealthy, and both can bear children, but one is ugly, the other beautiful, which one would you marry?'

By now the original Bauhaus was unrecognizable in its Dessau form. Most of the personalities who had shaped the school until then had left. Only Klee and Kandinsky remained, and Klee resigned soon after Mies' arrival. He had been offered the congenial post for which he had been looking for so long: a professorship which involved but little teaching at the Düsseldorf academy.

Kandinsky had little to do, since the few fine art courses were now eliminated, and in 1932 he was still arguing with Mies about the cuts made to his teaching.

By 1931 the political developments outside the Bauhaus threatened the school once again. For several years the extreme right, now increasingly identified with the Nazi party, had been gaining strength throughout Germany. In 1931 the Nazis achieved control of the Dessau city parliament and the school's Weimar history looked like repeating itself.

194

152 Berlin police taking Bauhaus students to headquarters, April 1933

153 Mies van der Rohe

The criticisms of the school now emanating from the local parliament were virtually identical to those that had circulated in Weimar. The Bauhaus was cosmopolitan: instead of cultivating peculiarly German values and expressing them through architecture and design it pursued an anonymous style equally at home in North America, Holland and France. It was therefore anti-German, and since warped thinking had made all modernism synonymous with Communism, the Bauhaus was Bolshevik as well. According to thinking equally warped, most of the staff and students were Jews. The Jewishness of the Bauhaus was made plain by, among other things, Bauhaus architecture which insisted on the flat roof. (The flat roof did not belong in northern climes but had manifestly come from subtropical regions. It was therefore oriental and Jewish.)

It came as no surprise, therefore, when the Dessau parliament seized the first opportunity to rescind the grant to the Bauhaus and terminate all staff contracts. All pleas and protests were in vain. The school was closed on 30 September 1932. Soon after, the Nazis moved in, breaking the windows and throwing files, tools and fitments out on to the street below. They wanted to raze the site: only a vociferous international campaign dissuaded them.

The Bauhaus was still not dead. In one last desperate attempt to keep the school alive Mies rented a disused telephone factory in the Steglitz suburb of Berlin, and hastily had the space turned into teaching areas. Given the political and economic climate there was no chance whatever of a subsidy from public funds, so Mies

151

195

reopened the Bauhaus as an entirely private institution, hoping that student fees and the income from patents and patrons would enable it to survive. He had been shrewd enough to ensure that the rights to all the Bauhaus products remained with the school instead of being transferred to the city of Dessau.

Time was against him. Soon after the school reopened the Nazis gained national control and Hitler became Chancellor. Even though it would be some while before the major onslaught on artistic modernism began, before artists and writers were declared 'degenerate' and banned from all public activity, action was taken against the Bauhaus immediately. According to the Nazis the school was 'one of the most obvious refuges of the Jewish-Marxist conception of "art" . . . so far beyond all art that it can only be judged pathologically'.

Pius Pahl, a student at the Berlin Bauhaus, remembered how 'the end came on 11 April 1933 during the first days of the summer term. Early in the morning police arrived with trucks and closed the Bauhaus. Bauhaus members without proper identification (and who had this?) were loaded on the trucks and taken away.'

Pahl makes it clear, however, that neither Mies' thinking nor that of the Nazis was as straightforward as the events make them seem: 'Mies himself was very much against an emigration; he hoped, as all of us did, for a better understanding of cultural questions in the NSDAP, after the party came to power. And surely this hope had some justification, though a small one, because shortly afterwards it became known that the head of the Chamber of Arts and Culture announced in public that he expected Mies someday to build a palace of culture for Hitler.'

Indeed, four months after the school's closure the Nazis declared that the Bauhaus might begin work again on two conditions: that 'The architect Hilbersheimer is dismissed, because he is a member of the Social Democratic Party', and that 'Kandinsky is fired, because his ideas are a danger to us.'

Even if the conditions could have been accepted, the offer came too late. On 10 August 1933 Mies sent a leaflet to all Bauhaus students announcing that 'at its last meeting the faculty resolved to dissolve the Bauhaus'. He gave as the reason for the decision 'the difficult economic situation of the institute'. They were the school's last words.

18 judgments

National Socialist hostility to the Bauhaus was largely responsible for the speed with which the school's reputation now grew. By 1933 it was well known in interested circles in most of Europe; its forced closure and the subsequent emigration of many former students and staff then ensured that it would quickly become famous throughout the world. Without the Nazis fewer people would have heard of the Bauhaus today and it would almost certainly seem a little less important. It is a pleasant irony.

Attempts by former Bauhaus teachers and students to continue to revive Bauhaus ideas and methods after 1933 are beyond the scope of this book. They do demonstrate the strength and tenacity of the school's influence, however. The 'New Bauhaus', founded by Moholy-Nagy in Chicago in 1937, the activities of Gropius at Harvard, Albers at both Black Mountain College and Yale, the establishment in 1950 of a 'Hochschule für Gestaltung' in the West German city of Ulm (with a former Bauhaus student, Max Bill, as its first director) are merely the most visible results of that influence.

Less easy to demonstrate but no less important is the continuing influence of Bauhaus ideas in countless art schools from London to Tokyo. It takes the form of a faith in the efficacy of 'foundation courses' of one kind or another, and in carefully designed projects given as a spur to students' creativity. The continuing popularity of departments of fine art in which painting and sculpture are taught in isolation from the rest of the school suggest, however, that the Bauhaus influence is not as lasting in this area as is sometimes thought.

The history of the influence of the Bauhaus on art education (to say nothing of its effect on the course of architecture and design) is also beyond the scope of this book. More pertinent here is the way

attitudes towards the Bauhaus have developed and changed both during and after the life of the school, both in Germany and abroad.

Soon after it moved to Dessau the Bauhaus became known to the general public throughout Germany, and journalists ensured that its name became associated with a style: anything and everything geometric, seemingly functional, employing the primary colours and made in modern materials was 'Bauhaus style'.

This dismayed Gropius, who never ceased to deny the existence of a Bauhaus style in anything, and to stress that what the school sought to develop was not a uniform visual identity but an attitude towards creativity intended to result in variety.

It was a losing battle. The school had been so intimately associated in the popular imagination with everything that was modern and fashionable that journalists and tradesmen saw profit in the Bauhaus name. As Schlemmer noted in 1929:

The Bauhaus style which sneaked its way into the design of women's underwear; the Bauhaus style as 'modern decor', as rejection of yesterday's styles, as determination to be 'up-to-the-minute' at all costs – this style can be found everywhere but at the Bauhaus.

The confusion continues. Bauhaus design is still widely identified with almost everything 'modern', functional and clean-lined, just as all experimentation in art education is still thought in some way to have originated with the Bauhaus even though it was but one of several contemporary schools in which new ideas were developed and applied.

It was during the Dessau period that the Bauhaus became well known, and it is the school's Dessau image that has lodged in the imagination. What the Bauhaus advocated and practised during its early years in Weimar has come to be seen as an aberration, as an unfortunate mistake made by a pioneering institution before it found its true mission. Nikolaus Pevsner's bewilderment ('It is all very weird – . . . the Gropius of Fagus [starting] an Expressionist guild') was later shared by Reyner Banham who was unable to understand how Gropius 'grounded in the Werkbund and the office of Behrens . . . should be capable at this time of making no reference whatever to machinery and should take his stand solely on the Morrisian standpoint of inspired craftsmanship'.

During the last decade or so, however, more attention has been given to the school's early history in Weimar, and it is now widely seen not as an aberration but as a necessary preparation for what was to follow. Recent scholarship, especially in the USA and East Germany, has concentrated on the Weimar years.

In West Germany after 1945 the Bauhaus was seen as one of the great glories of modernism, largely for no better reason than that it had been suppressed by the Nazis. The international, cosmopolitan character of the Bauhaus was stressed, and the school was frequently used as the clearest example of the vitality of Weimar culture in spite of the economic chaos and political unrest. For the West Germans the Bauhaus demonstrated that Germany had played a crucial role in the development of modernism before her culture was isolated by the Nazis.

Although Weimar and Dessau were now situated in the Soviet Zone it was the West Germans who took the lead in cultivating the Bauhaus legacy. In 1960 a Bauhaus archive was established in Darmstadt on the initiative of the art historian Hans M. Wingler, who in 1962 published the massive volume of documents and photographs which remains the major published source for Bauhaus scholars. Wingler continues to be the director of the archive, now situated in West Berlin in buildings designed for it by Gropius. The largest Bauhaus exhibition so far mounted originated in Stuttgart in 1967 and included much material from the archive.

In East Germany after the war the name of the Bauhaus was anathema. It was regarded as a school which, in the words of a guidebook to Weimar published in 1954, 'led directly to the destruction of architecture'. This was because the school's curriculum was designed for a capitalist economy and taught by artists whose work was 'formalist'.

Then official attitudes changed. Towards the end of the 1960s a new and subtle interpretation of the Bauhaus appeared in the German Democratic Republic. According to the new line the school had attempted to realize a set of socialist ideals but was doomed to failure because the capitalist society in which it found itself made its life impossible. At the same time the Bauhaus was presented as the German equivalent of those revolutionary attempts to reform art education in the Soviet Union, like INKhUK.

As a consequence of the new interpretation, scholarship in the German Democratic Republic flourished and the early Weimar years of the Bauhaus with their emphasis on social renewal and community were brought into even sharper focus. The several excellent East German studies of the Bauhaus have tended to stress the political and sociological aspects of their subject at the expense of attention to the actual products. There is also a tendency to regard the period of Meyer's directorship more highly than have most scholars in the West.

The results of the change of official attitude to the Bauhaus in East Germany were not restricted to a string of outstanding books and articles. As important are the organization of the Bauhaus papers in the Weimar State Archive, the development of the Bauhaus collection (especially of graphics) in the Weimar Castle Museum, and the restoration of the Dessau Bauhaus itself which, for more than thirty years, had remained in the bricked-up and dismal state in which the Nazis had left it. Now it is returned to its former glory. Even the fixtures and fitting have been faithfully restored.

While the Bauhaus enjoyed something of a renaissance in the East, attitudes to it in the West became complex and ambiguous. Praise of the school's achievements has become muted as the tenets of modernism in general have been questioned. 'Modern' architecture, according to some, has let society down, and the arrogance of too many architects who put dogma above utility and believe they know better than their clients how their clients should live, derives at least in part from attitudes which originated at the Bauhaus.

Functionalism, which is falsely thought to have been another Bauhaus invention, has also come into question: 'functional' form is now seen as being as much of a separate aesthetic as any other consciously imposed style. An emphasis on simplicity and on a lack of decoration at all costs has become equally suspect: individualism and even whimsy is increasingly prized, in architecture as well as design.

Whatever the changing attitudes to the Bauhaus its place in the history of virtually every visual creative activity is secure. The look of the modern environment is unthinkable without it. It left an indelible mark on activities as various as photography, architec-

ture and newspaper design. As this book has tried to show, the Bauhaus idea derived from two quite different approaches to architecture and design: that of the Werkbund before the First World War and the romantic medievalism of William Morris that was reinforced by Expressionism. The disputes within the Weimar Bauhaus showed how contradictory these approaches were, but it was paradoxically because of such contradictions that the school achieved a language of architecture and design liberated from the historicism of the previous hundred years. That liberation was the school's main achievement.

154 Former Bauhaus students in front of the restored Dessau building in 1976, fifty years after the opening of the Bauhaus in Dessau

documents

Walter Gropius, Manifesto of the Bauhaus, April 1919. The Manifesto precedes the 'Programme' of the Bauhaus in a four-page leaflet published by the school.

The ultimate aim of all creative activity is the building! The decoration of buildings was once the noblest function of the fine arts, and the fine arts were indispensable to great architecture. Today they exist in complacent isolation, and can only be rescued from it by the conscious co-operation and collaboration of all craftsmen. Architects, painters and sculptors must once again come to know and comprehend the composite character of a building both as an entity and in terms of its various parts. Then their work will be filled with that true architectonic spirit which, as 'salon art', it has lost.

The old art schools were unable to produce this unity; and how, indeed, should they have done so, since art cannot be taught? Schools must be absorbed by the *workshop* again. The world of the pattern-designer and applied artist, consisting only of drawing and painting, must at last and again become a world in which things are *built*. If the young person who takes joy in creative activity begins his career now, as he formerly did, by learning a craft, then the unproductive 'artist' will no longer be condemned to inadequate artistry, for his skills will be preserved for the crafts in which he can achieve great things.

Architects, painters, sculptors, we must all return to crafts! For there is *no such thing* as 'professional art'. There is no essential difference between the artist and the craftsman. *The artist is an exalted craftsman.* By the grace of Heaven and in rare moments of inspiration which transcend the will, art may unconsciously blossom from the labour of his hand, *but a foundation of handicraft is essential for every artist.* It is there that the primary source of creativity lies.

Let us therefore create a *new guild of craftsmen* without the class-distinctions that raise an arrogant barrier between craftsman and artist! Let us together desire, conceive and create the new building of the future, which will combine everything – architecture *and* sculpture *and* painting – in a *single form* which will one day rise towards the heavens from the hands of a million workers as the crystalline symbol of a new and coming faith.

Walter Gropius, from a speech to the students given during the first exhibition of their work in July 1919 [STAW 132].

We are in the midst of a monstrous catastrophe in the history of the world, of a transformation of all of life and of the *entire* inner being . . . Those who experienced [the war] out there have come back *completely changed*; they see that *things cannot*

continue in the old way ... Our impoverished State has scarcely any funds for cultural purposes any more, and is unable to take care of those who only want to occupy themselves by indulging some minor talent ... I foresee that a whole group of you will unfortunately soon be forced by necessity to take up jobs to earn money, and the only ones who will remain faithful to art *will be those prepared to go hungry* for it ... while material opportunities are being reduced, intellectual possibilities have already enormously multiplied. Before the war we put the cart before the horse and wanted to bring art to the general public backwards, by means of organization. We created artistic ashtrays and beer tankards, and wanted to move upwards towards the large building gradually. Everything by means of cool-headed organization. That was a presumption on which we came to grief, and now it will be done the other way about. What will develop are not large, intellectual organizations but small, secret, closed associations, lodges, guilds, cabals which preserve ... a secret core of belief until a general, great, productive, intellectual and religious idea emerges from the individual groupings, an idea which must ultimately find its expression crystallized in a great, total work of art. And this ... cathedral of the future will illuminate the smallest things of everyday life with floods of light ... *We* shall not experience it, but we are ... the precursors and first instruments of just such a new world philosophy ... I dream of an attempt to create a small community here out of the isolation of individuals ... The coming years will demonstrate that craft will be the salvation of us artists. We will no longer exist *alongside* the crafts but shall be *part* of them since we are obliged to earn money. For great art this historical ... inevitable development is a necessity. All the great artistic achievements of the past, the Indian, the Gothic miracles, arose out of a total mastery of craft.

Oskar Schlemmer, extract from a letter to Otto Meyer, Weimar, 7 December 1921.

There's a crisis at the Bauhaus ... Itten has introduced Mazdaznan teaching ... the kitchen [students' canteen] has been converted to Mazdaznan cooking ... the meat-eaters have to manage without the canteen and there are those who say they need meat ... furthermore: Itten has allegedly introduced Mazdaznan into his teaching ... a special group has formed which has split the Bauhaus into two camps ... Itten has managed to make his courses obligatory – no others are – has control of the essential workshops and aims ... to leave his mark on the Bauhaus. ... Gropius is an outstanding diplomat, a businessman and practitioner; he runs a large private practice from inside the Bauhaus, and the commissions are villas for Berliners. Berlin and its business, from which the commissions come ... are not the best foundations for Bauhaus activities. Itten is right to criticize this, and to want to preserve quiet working conditions for the students. But Gropius says that we must not shut ourselves off from life and reality, a danger (if it is one) that arises from Itten's methods, in which, for example, meditation and ritual are more important for the workshop-students than work. ... Itten wants the kind of talent that is formed in quietude, Gropius desires the kind of character forged in the hurly-burly of the world (and the talent with it). ... On the one hand the incursion of oriental culture ... on the other Americanism, the miracle of technology, invention, the big city ...

Oskar Schlemmer, extract from a letter to Otto Meyer, Weimar, end of March 1922.

One of the most energetic critics here is van Doesburg, the Dutchman, whose conception of architecture is so radical that painting – in so far as it does not merely reflect the glory of architecture – does not exist for him. He fights very adroitly for his ideas, so he has influenced the Bauhaus students, especially those concerned with building above all else and who desire the focal point which, in their opinion, the Bauhaus lacks . . . [Van Doesburg] rejects the crafts (the heart of the Bauhaus) in favour of modern methods: the machine. He believes that with the exclusive, consistent use of the horizontal and vertical in art he is creating the style which rejects the individual in favour of collectivism . . .

Minutes of a meeting of the Bauhaus Council, 22 October 1923 [STAW 184].

Gropius refers to the common aims of all the workshops and the aim of each individual workshop; to the activities of the workshops from the point of view of building; to the special difficulties in the case of mural and decorative painting, stone-sculpture and woodcarving. The craftsmen here earn nothing, since nothing is sold. The sculptors and carvers are in a specially difficult position. What has been achieved here so far is small. The workshop is not a playground for truanting students.

Muche is of the opinion that neither of these workshops can be justified. They should be reorganized as workshops for three-dimensional studies, or as places where architectural projects can be tested (Gropius's suggestion).

Gropius agrees with Muche, is for laboratory work – no craft – no systematic training . . .

Moholy asks: is the Bauhaus, are the workshops in tune with the times? As workshops for the crafts they are not so, and can be regarded as moribund.

Gropius agrees with this, but speaks of a practical difficulty: there is a lack of the right kind of people. The critical failure is the lack of production. Only free sculpture is being produced, and it has little to do with craft.

Schmidt is for restricting entry to the workshops . . . to those who have already completed another course of training.

Schlemmer reports the large demand for three-dimensional studies. Students want to model the figure again, the reaction against formalism is obvious . . .

Gropius says that the Bauhaus is not only a school but also a place geared to production, and asks: should apprenticeship indentures be issued or not?

Kandinsky asks: why train apprentices?

Gropius replies that the basic idea is to prevent the appearance of dilettantism, to train apprentices and journeymen.

Hartwig stresses that the only decisive thing is results. The trouble is, that there is no pure craft involved in the making of sculpture . . .

Walter Gropius, memorandum to the Masters, 13 February 1923 [STAW 13; first publication].

The artistic presumption which we wished to suppress is more rampant than ever. The free, speculative work [which the students produce] during the first half-year and the large doses of intellectual fare [they are offered] are obviously overloading their minds and are leading these people – for the most part still too young and not yet independent – into arrogance, and a misunderstanding of who and what they are. The corrective provided by working with their hands is almost entirely

absent, since workshop training (the study of materials) is left up to each individual. ... The advantage gained from having each newly arrived student confronted by Itten's powerful personality, so that he came to know himself, was lost, because the students, still not independent, were left in their own work too much to their own devices. I have the impression that they need to be led more firmly and specifically during the early part of the course, so that they are occupied all the time they are on the premises, and during the first period acquire the basis of a later expertise in both craft and art in a truly systematic fashion.

Announcement by the 'Association for the Protection of German Culture in Thuringia' in the Weimarische Zeitung, *6 July 1924* [Hüter, Doc. 93, extract].

We protest at the continuing existence of the State Bauhaus. We protest against State support for an institution under the direction of Herr Gropius with the collaboration of the teachers and Masters at present there. . . . According to information from the director, the State Bauhaus wants to be an institute which 'unites fields which have recently been moving together: art (above all architecture, painting and sculpture), science (mathematics, physics, chemistry, physiology, etc.) and technology'. . . . In spite of claims to the contrary by the Bauhaus Masters, art cannot be comprehended scientifically, but is the most deeply inward experience, a feeling rooted in the subconscious, in human instinct. Our healthy instinct tells us that truly authentic art cannot consist of colour-composition alone, or of the filling-in of flat areas, or technical construction, or any other kind of one-sided approach. All the mechanical games, the arrangements of materials, the colour effects, each distorted idiot's head and bizarre human body, all the schizoid scribblings and experiments in embarrassment which we find in exhibitions and publications of the State Bauhaus in Weimar are decadent values, theatrically inflated into art by the director and the Masters of the Bauhaus, and lacking artistic creativity. They have nothing to do with genuine art. . . . It is arrogance to contend that the State is neglecting to preserve and encourage its culture if it refuses to support this institution. Such a bloodless, diseased artistic instinct . . . as that . . . at the Bauhaus . . . is assisting the collapse of our culture. We expect of the present government that it will refuse every form of State support for this 'cultural institute'.

Oskar Schlemmer, from a letter to Otto Meyer, Weimar, 20 May 1924.

The decision will be made in the coming days – weeks? – whether the Bauhaus shall live – with or without Gropius, with or without the present Masters. The right-wing Thuringian government, the bourgeoisie, the skilled craftsmen, the local artists 'with their backs to the wall', are in uproar with their various slogans. The flood of pamphlets for and against rushes on; Gropius publishes a collection of press notices, a counterblast appears, a pamphlet – a newspaper campaign – posters for the Bauhaus produced by the students.

Walter Gropius, from 'Dessau Bauhaus – principles of Bauhaus production', sheet published by the Bauhaus in March 1926.

The Bauhaus intends to contribute to the development of housing – from the simplest appliance to the complete dwelling – in a way which is in harmony with the spirit of the age.

Convinced that household appliances and furnishings must relate to each other rationally, the Bauhaus seeks – by means of systematic theoretical and practical research into formal, technical and economic fields – to derive the form of an object from its natural functions and limitations.

Modern man, who wears modern not historical dress, also requires a modern dwelling which is in harmony with himself and with the times in which he lives, and is equipped with all the modern objects in daily use.

The nature of an object is determined by what it does. Before a container, a chair or a house can function properly its nature must first be studied, for it must perfectly serve its purpose; in other words it must function practically, must be cheap, durable and 'beautiful'. Research into the nature of objects leads one to conclude that forms emerge from a determined consideration of all the modern methods of production and construction and of modern materials. These forms diverge from existing models and often seem unfamiliar and surprising (see, for example, the changes in the design of heating and lighting fixtures).

Only by constant contact with advanced technology, with the diversity of new materials and with new methods of construction, is the creative individual able to bring objects into a vital relationship with the past, and to develop from that a new attitude to design, namely:

Determined acceptance of the living environment of machines and vehicles.

Organic design of objects in terms of their own laws and determined by their contemporaneity, without Romantic beautification and whimsy.

Exclusive use of primary forms and colours comprehensible to everyone.

Simplicity in multiplicity, economical use of space, material, time and money.

The creation of standard types for all objects in daily use is a social necessity.

For most people the necessities of life are the same. The home, its furnishings and equipment are required by everybody, and their design is more a matter of reason than of passion. The machine, which creates standard types, is an effective means of liberating the individual from physical labour through mechanical aids – steam and electricity – and giving him mass-produced products cheaper and better than those made by hand. There is no danger that standardization will deprive the individual of choice, since competition automatically results in so many alternatives that the individual can make a personal choice of the model which suits him best.

The Bauhaus workshops are essentially laboratories in which prototypes suitable for mass production and typical of their time are developed with care and constantly improved. In these laboratories the Bauhaus intends to train an entirely new kind of collaborator for industry and the crafts who has an equal command of technology and design.

To make prototypes which fulfil all economic and formal demands requires the most rigorous selection of the best, the most comprehensively trained minds, schooled in basic working methods and the precise knowledge of formal and mechanical design-elements and the laws of their construction.

The Bauhaus believes that the difference between industry and the crafts consists less in the tools each uses than in the division of labour in industry and the unity of labour in the crafts. But the crafts and industry are constantly moving closer. Traditional crafts have changed; the crafts of the future will have a unity of labour in which they will be the medium of experimental work for industrial production. Experiments in laboratory-workshops will result in models – prototypes for factory production.

Definitive models will be reproduced by outside industries in contact with the workshops.

206

Bauhaus production is therefore not in competition with industry and crafts-men; it rather provides them with new opportunities for growth . . .

Rolf Rössger, writing about the work in the Bauhaus metal workshop. From the catalogue Bauhaus Werkstattarbeiten, Dessau 1978. *[Rössger was at the Bauhaus in Weimar and Dessau from 1923 to 1929.]*

Production generally began with a workshop discussion which was always led by Moholy-Nagy . . . Together, we contributed information about the function of the object to be produced. If, for example, we were to make a tea or coffee service, then we discussed in detail the methods used in each part of the world for preparing coffee or tea.

While in Weimar we were chiefly concerned with making parts of a service, such as pots, sugar bowls, cream jugs, sauce boats, tea infusers, etc., as well as light fittings, in Dessau we changed to intensive production. . . . We made almost all the lights for the Dessau Bauhaus in our own workshop. We gathered detailed information before carrying out this project, too. We visited the laboratory of what was then the Osram company in Berlin and the firm of Kandem in Leipzig.

Max Bill, from 'Teaching in and out of the Bauhaus', in Form und Zweck, Fachzeitschrift für industrielle Gestaltung, *3–1979, 11th year, p.66. [Max Bill, the Swiss architect, painter, sculptor and designer, studied at the Dessau Bauhaus from 1927 to 1929. In 1950 he planned the Hochschule für Gestaltung at Ulm and directed it until 1956.]*

The principle behind the Bauhaus teaching, above all behind the basic preliminary course taught by Josef Albers, was to a large extent that everything known should be questioned, and the answer further questioned. Especially in Albers', and later on in Moholy's classes, everyone tried to produce something that was not like anything that already existed, and which had to be explained and discussed in the group. The discussion of things with no obvious purpose made demands on the wits of everyone. . . . The basic classes and exercises in form given by Wassily Kandinsky and then Paul Klee were in addition to these experiments. Later, depending on the department, there were technical subjects and, for everyone, lectures and discussions with guests like Lu Märten, El Lissitzsky, Naum Gabo, Mart Stam. A seminar on colour given by Wilhelm Ostwald sparked off a kind of religious war between the disciples of his scientifically based theory, and those who opposed it as physiologically false.

Dr W.A.K., leading article from the Anhalter Anzeiger, 7 May 1930. *[This attack on Communism at the Bauhaus appeared in a newspaper which supported the Bauhaus when it moved to Dessau but later led the campaign against it.]*

Had you visited Weimar, the ancient city of Goethe, at the beginning of the second decade of this celebrated century wishing to derive strength and spiritual sustenance from the classic sites of German art and German intellectual greatness, you would have met, increasingly often, youths, mostly in gangs, with flowing black hair and legs like gooseberries, who introduced a Russian element into the civilised quiet of the old aristocratic city. . . . It was the period when a thousand notions of salvation were clothed in as many different religious, aesthetic or social garbs, most of them, like those who wore them, linked closely with the red star of Bolshevikia. Had you asked what the aims of these youths were, you would

mostly have received the answer: 'They're students at the Bauhaus – you know what I mean!' . . . Those who warned that pure Bolshevik ideas were being disseminated under the cover of a school were ignored, and it has remained so almost until the present . . .

Oskar Schlemmer, diary entry for 9 April 1927.

'The cathedral of Socialism'. The original sentence reads: 'The State Bauhaus, founded after the catastrophe of war, in the chaos of the revolution and at a time when an emotionally charged, explosive kind of art had reached a high-point, will initially become the place where those people gather who, believing in the future and beating at the gates of heaven, wish to build the cathedral of Socialism.'

The sentence, taken from a manifesto written for a Bauhaus exhibition in 1923, referred to an earlier period and was intended to describe the stages of development of the Bauhaus. The word 'initially' makes this clear enough. It is therefore nonsensical and michievous to take the sentence out of context and to turn it into the Bauhaus manifesto. The following sentences adequately demonstrate that this stage was very quickly superseded and replaced by other aims, just as the political face of the Bauhaus – if there ever was such a thing – was also very soon changed: there were as many right-wing as left-wing students, or, at the most, a religious wave followed a political one.

It need not be denied that . . . the Bauhaus mirrors an historical epoch. Did not the majority of Germans wish to build the cathedral of Socialism in 1918? Did not the revolution and subsequent constitution acknowledge a desire for a People's State? And what is a People's State, if not socialism? Moreover: is not socialism the same as a social democratic or a communist party? Is not socialism an idea, an ethical concept, which stands above all parties?

Hannes Meyer, from 'Experiences of a Polytechnic Education', first published in Edificacion, Mexico City, 5 (1940), 34, July–September, pp. 13–28.

The Bauhaus was obviously the offspring of the German Republic with which it shares its dates of birth and death. Equally obviously, it was from the beginning a European, even international cultural centre . . . a typical product of the emotionally vehement Expressionism of that period. For, although from the start it was a place where many kinds of polytechnic skills were taught, seven abstract painters and two architects were on the staff. . . . The scientist was completely absent. Most of the students were disciples of every kind of 'life-reforming' movement. . . . At the Dessau Bauhaus . . . the early freshness and powerful design invention became increasingly lost in empty prescription which – as 'Bauhaus fashion' – turned the heads of the Formalists. . . . The directorship of the architect Hannes Meyer was characterized by an emphasis on the social mission of the Bauhaus, an increase in the number of exact sciences taught, by the co-operative extension of the workshops, the growth of teaching on the job with the aid of commissions for real projects, by the diminution of the influence of the artists, by the development of prototypes to meet the needs of the people, by a proletarization of the student body, and by closer co-operation with the labour movement and trades unions. . . . Under the direction of the architect Mies van der Rohe . . . the influence of the students over life at the Bauhaus was stamped out. All sociological subjects and attitudes . . . disappeared. . . .

At the heart of all the polytechnic teaching at the Bauhaus (under Meyer) lay work itself, and not imaginary projects in an invented context for the purposes of

'study'. No invented house, therefore, no imaginary site; but work to be carried out and used directly, real projects in real environments. . . . The single piece of furniture for some snob enthusiastic about the 'modern' was produced no longer; rather, standardized furniture for the use of the people . . .

The individual workshops . . . had increasingly to become self-sufficient economic and collective working-groups. For, if the individual student had previously been provided with the tools and the professional advice he needed for his specialized training, and if he was proud of his own personal and individual achievements, now increasingly . . . 'vertical' working brigades were formed which dealt with a shared, real task. In the 'vertical brigade' students of different years worked together, and the older student helped the younger to develop under the professional guidance of the Master . . .

Oskar Schlemmer, letter to Otto Meyer, Dessau, 17 April 1927.

One of [Meyer's] mottos, referring to architecture, is 'organization of needs'. But this is 'needs' in the broadest sense, and does not exclude spiritual needs. He said that paintings (mine and Moholy's) made the strongest impression here. . . . Klee did not interest him; he thinks that he must always be in a state of trance; Feininger didn't interest him. Kandinsky did, for the theories. By nature he is perhaps closest to Moholy. . . . Muche's new steel house didn't interest him since steel accounts only for the smallest part of it. Gropius can be happy to have got this honest fellow as a new feather in his cap.

Oskar Schlemmer, letter to Willy Baumeister, Dessau, 6 March 1929.

All in all, it seems that my time at the Bauhaus has ended! I want to leave. People – the students, me, too – are dissatisfied with Hannes [Meyer] because of his rough manner and lack of tact. The atmosphere in the school is not good. Bad enough that the entire Bauhaus question will soon be debated in the State parliament.

Annelise Fleischmann, 'Economic Living', first published in Neue Frauenkleidung und Frauenkultur *(supplement), Karlsruhe, 1924.* [Annelise [Anni] Albers, née Fleischmann, studied at the Bauhaus from 1922 to 1930 and was one of the most gifted weavers there. In 1925 she married Josef Albers.]

Economy is demanded today throughout the business world. Economy of living (not its restriction) is but little considered. To gain four hours of freedom by means of economic house design implies a significant change in the pattern of modern life.

Economy of living must first be economy of labour. Every door-handle must require a minimum of energy to operate it. The traditional style of living is an exhausted machine which enslaves the woman to the house. The bad arrangement of rooms and their furnishings (padded chairs, curtains) rob her of freedom, restrict her development and make her uneasy. Today the woman is the victim of a false style of living. It is obvious that a complete change is urgently required.

New objects (the car, aeroplane, telephone) are designed above all for ease of use and maximum efficiency. Today they perform their function well. Other objects in use for centuries (the house, table, chair) were once good, but now no longer fully do their job. In order to make them meet *our* needs we must design them unencumbered by the weight of history.

It is not enough to improve old forms (such as water pipes, central heating, electric light). That is merely to give an old dress a new hem.

Compare our dress: it meets the demands of modern travel, hygiene and economics (you can't travel by rail in a crinoline) . . .

The Bauhaus attempts to find the functional form for the house, as well as for the simplest utensil. It wants things clearly constructed, it wants functional materials, it wants this new beauty.

This new beauty is not a style which matches one object with another aesthetically by using similar external forms (façade, motif, ornament). Today, something is beautiful if its form serves its function, if it is well made of well-chosen material. A good chair will then 'match' a good table.

The good object can offer only one unambiguous solution: the type. (We all have the same telephone without longing for an individual design. We wear similar clothes and are satisfied with a small degree of difference within this restriction.)

The optimal form demands mass production. Mechanization also means economy.

The Bauhaus attempts to produce the elements of the house with this economy in mind – therefore to find the single solution that is best for our times. It applies itself to this task in experimental workshops, it designs prototypes for the whole house as well as the teapot, and it works to improve our entire way of life by means of economic production which is only possible with the aid of the prototype.

Selman Selmanagic, from a conversation recorded in 1979 in Form und Zweck, Fachzeitschrift für industrielle Gestaltung, *3–1979, 11th year, pp. 67–8.* [Selmanagic studied at the Bauhaus from 1929 to 1933.]

While I was in the life class one day someone who could draw the model's every eyelash was sitting next to me; he had been to the academy. I looked at the model and then at his drawing, and thought: you could never do that. Then Paul Klee came up and said something to my neighbour. . . . Klee praised me, said that my neighbour should learn how to draw from me. Then I thought: what kind of school is this – I can't draw and he should learn drawing from me? . . .

After the preliminary course the most important thing I learned was to design for present needs, for people, for the masses. For example, I had to make a cupboard. Master Arndt asked: what is going into the cupboard? If you are making a cupboard you have to know what and how much the people have, you must work from the whole thing to the detail, you must always begin with the entire object, the proportions will then be different . . .

Later I had to investigate the needs of the people earning between around 150 to 250 marks a month – the masses . . . we had to think economically, we had to investigate the social conditions of the people . . .

bibliography

The following is a guide to the sources on which this book is based and also to selected further reading.

The major public collections of Bauhaus documents are preserved in the Bauhaus Archive, West Berlin (which also contains copies of some material held elsewhere; it is abbreviated here as BA), the Busch-Reisinger Museum of Germanic Culture at Harvard University and the Thuringian State Archive in Weimar (which is limited to the Weimar period; it is abbreviated here as STAW). Many of the most important documents in these and other archives are published in HANS M. WINGLER's massive *Das Bauhaus* [Bramsche and Cologne 1969 and subsequent editions] which appears in English as *The Bauhaus* [Cambridge, Mass., and London 1969 and subsequent editions]. Wingler contains the fullest bibliography available, in the latest English edition brought up to 1975. Readers are also referred to the collection of contemporary newspapers in the Dessau City Archive, to the MIES VAN DER ROHE papers in the Library of Congress, Washington, DC, and the GROPIUS papers at Harvard University.

Key documents in STAW and other archives appear as an appendix to KARL-HEINZ HÜTER's *Das Bauhaus in Weimar* [East Berlin 1976], perhaps the best book on the school's early period and its social and political background.

Often as enlightening as official papers are published diaries, letters and reminiscences. Of these, the most consistently fascinating are SCHLEMMER's diaries and letters, edited by his wife Tut Schlemmer [Munich 1958, translated into English, Middletown, Conn., 1972]. FEININGER's letters, some of which are collected by June L. Ness in *Lyonel Feininger* [New York 1974], also provide glimpses into life at the Bauhaus. Two teachers published books which include memories of their time at the school, but neither GEORG MUCHE's *Blickpunkt* [Tübingen, 2nd ed. 1965], nor LOTHAR SCHREYER's *Erinnerungen an Sturm und Bauhaus* [paperback ed., Munich 1966] is entirely reliable: a pity, since both are full of memorable anecdotes. Only slightly more reliable

are NINA KANDINSKY's memoirs *Kandinsky und ich* [Munich 1976]. HANNES MEYER's *Bauen und Gesellschaft*, edited by Lena Meyer-Bergner [Dresden 1980], includes letters and articles written by Meyer about his experiences at the Bauhaus and his philosophy as teacher and architect. The memoirs of the then mayor of Dessau, FRITZ HESSE, *Von der Residenz zur Bauhaus-Stadt* [privately published, Bad Pyrmont 1963], include some interesting material; and HENRY VAN DE VELDE's autobiography, *Geschichte meines Lebens* [Munich 1962] is enlightening on the pre-history of the Bauhaus and the ideas and circumstances which gave it shape.

The reminiscences of former students, published for the most part as articles, are an invaluable source of information about teaching methods and daily life at the school. Those I have found most useful are: HELMUT VON ERFFA, 'The Bauhaus before 1922' in *College Art Journal*, vol. 3, Nov. 1943, pp. 14–20, and 'Bauhaus: First Phase' in *Architectural Review*, vol. 132, August 1957, pp. 103–5; GEORGE ADAMS, 'Memories of a Bauhaus student' in *Architectural Review*, vol. 144, Sept. 1968, pp. 192–4; BRUNO ADLER, 'The Bauhaus 1919–33' in *The Listener*, vol. 41, 24 March 1949, pp. 485–6; PETRA PETITPIERRE, *Aus der Malklasse von Paul Klee*, Bern 1957. A splendid anthology of reminiscences can be found in ECKHARD NEUMANN's *Bauhaus and Bauhaus People*, [New York 1970], a translation of *Bauhaus und Bauhäusler, Bekenntnisse und Erinnerungen* [Bern and Stuttgart 1971]. Still more reminiscences are published in the catalogue of the Bauhaus collection of the Busch-Reisinger Museum, Harvard University: 'Concepts of the Bauhaus', 1971. Books by former students include: LUDWIG HIRSCHFELD-MACK, *The Bauhaus* [Victoria 1963; not a memoir but an introductory survey]; THEODOR BOGLER, *Ein Mönch erzählt* [Honnef 1959]; PAUL CITROEN, *Introvertissimento* [The Hague 1956] and, by an artist but briefly at the Bauhaus, HEINRICH BASEDOW, *Meine Lebenserinnerung* [Hamburg 1973].

Among numerous accounts of the Weimar Bauhaus, the following are especially rec-

ommended: MARCEL FRANCISCONO, *Walter Gropius and the Creation of the Bauhaus in Weimar* [Urbana 1971]; WALTHER SCHEIDIG, *Crafts of the Weimar Bauhaus* [London 1967; the English version of *Bauhaus Weimar 1919–1924, Werkstattarbeiten*, Leipzig and Munich 1966]: not as specific as its title makes it sound, this is a first-class introduction; CHRISTIAN SCHÄDLICH, *Bauhaus Weimar 1919–1925* in the series 'Weimar Tradition und Gegenwart', vol. 35 [Weimar 1979]; LOTHAR LANG, *Das Bauhaus 1919–1933, Idee und Wirklichkeit* [East Berlin 1965]. Concise but informative surveys are provided by DIETHER SCHMIDT, *bauhaus* [Dresden 1966] and GILLIAN NAYLOR, *The Bauhaus* [London and New York 1968].

ADALBERT BEHR's *Das Bauhaus Dessau* [Leipzig, 2nd ed. 1980] is the only book to deal exclusively with the Dessau period, although a special issue of the East German periodical *Form und Zweck* [vol. 8, no. 6, 1976] marks the 50th anniversary of the school's removal to Dessau with an anthology of excellent articles and reminiscences. A later issue of the same journal [vol. 11, no. 3, 1979] prints documents and memoirs from every period of the school's life. A further invaluable collection of papers given at the Bauhaus colloqium in Weimar in 1979 is published in the *Wissenschaftliche Zeitschrift der Hochschule für Architektur und Bauwesen Weimar*, vol. 26, 1979, nos. 4 and 5. This also includes an exhaustive bibliography of publications about the Bauhaus in the GDR between 1977 and 1979.

Among the studies of particular aspects of the Bauhaus that can be recommended are: GIULIO CARLO ARGAN, *Gropius und das Bauhaus* [Reinbek 1962]; EBERHARD ROTERS, *Maler am Bauhaus* [West Berlin 1965; English edition *Painters of the Bauhaus*, London and New York 1969]; and the very thorough examination of the school's teaching methods, RAINER WICK, *Bauhauspädagogik* [Cologne 1982].

Catalogues of exhibitions and permanent collections provide an incomparable source of illustrations and information about all aspects of the school. The BA published its *Sammlungs-Katalog* in 1981 and there is also a fine, brief and well-illustrated introduction to the archive in the 'Museum' series, published by Westermann in Brunswick in 1979 [2nd ed. 1982]. The Schlossmuseum Weimar published its catalogue *Bauhaus 1919–25, Werkstattarbeiten* in 1979. The Busch-Reisinger *Concepts of the*

Bauhaus is referred to above. The catalogue of the to-date largest Bauhaus exhibition *50 Years Bauhaus*, Royal Academy of Arts, London 1968, is an essential tool [German edition *50 Jahre Bauhaus*, Württembergischer Kunstverein, Stuttgart 1968].

There are so many articles on every aspect of the Bauhaus that the following lists only those that I have found especially stimulating: WOLF VON ECKARDT, 'The Bauhaus' in *Horizon* 11, 1961, pp. 58–75; WULF HERZOGENRATH, 'Die fünf Phasen des Bauhauses' in *Paris–Berlin, colloque de l'office francoallemand pour la jeunesse*, Centre Georges Pompidou, Paris, 1978, pp. 1–13; NIKOLAUS PEVSNER 'Post-war tendencies in German art schools' in *Journal of the Royal Society of Arts*, 17, 1936, pp. 248–56; ULLA MACHLITT and HANS HARKSEN, 'Vor 50 Jahren kam das Bauhaus nach Dessau' in *Dessauer Kalender*, 1975, pp. 19–28, and 'Aus der Arbeit der Bauhaus-Werkstätten in Dessau' in *Dessauer Kalender*, 1977, pp. 76–102.

The cultural and political background to the Bauhaus is described in: GORDON A. CRAIG, *Germany 1866–1945* [Oxford 1978]; HELMUT HEIBER, *Die Republik von Weimar* [Munich 1966]; JOST HERMAND and FRANK TROMMLER, *Die Kultur der Weimarer Republik* [Munich 1978]; PETER GAY, *Weimar Culture* [London 1968]; Gay's essay on Gropius in his *Art and Act* [New York 1976] is also to be recommended; WALTER LAQUEUR, *Weimar – a cultural history 1918–22* [London 1974]; JOHN WILLETT, *The New Sobriety* [London 1978]; ALEX DE JONGE, *The Weimar Chronicle* [London 1978]; BARBARA MILLER LANE, *Architecture and Politics in Germany, 1918–1945* [Cambridge, Mass., 1968]; *Tendenzen der 20er Jahre*, catalogue of the series of exhibitions organized by the Council of Europe, Berlin 1977; H. M. WINGLER (ed.), *Kunstschulreform 1900–1933* [Berlin 1977]; REYNER BANHAM, *Theory and Design in the First Machine Age* [London 1960 and subsequent editions]; JULIUS POSENER, *From Schinkel to the Bauhaus* [London 1972]. The articles collected and edited by UWE M. SCHNEEDE, *Die Zwanziger Jahre* [Cologne 1979] are a useful selection of contemporary essays and theoretical statements of the period, including some of direct relevance to the Bauhaus.

I have not included the books published by the Bauhaus itself and the newly edited reprints, nor articles from the Bauhaus journal. Monographs on the various teachers and students are listed in the standard bibliographies and especially Wingler.

sources of quotations

The sources of quotations, where they are not given in the text, are listed here by chapter and page number. STAW refers to the Thuringian State Archive in Weimar, the number following to the file in which the particular document can be found. BA refers to the Bauhaus Archive in West Berlin.

CHAPTER ONE

9 Oskar Schlemmer in Christian Geelhaar, *Paul Klee and the Bauhaus*, Bath 1973, p. 12.
10 Wolf von Eckardt, 'The Bauhaus' in *Horizon*, November 1961, IV, 2, p. 58.
11–12 *Manifesto and Programme of the State Bauhaus at Weimar*, see section 'documents'.

CHAPTER TWO

16 John Ruskin, 'Stones of Venice' in Marcel Franciscono, *Walter Gropius and the Creation of the Bauhaus in Weimar*, Urbana 1971, p. 26. William Morris in Rainer Wick, *Bauhaus Pädagogik*, Cologne 1982, p. 18.
20 Adolf Loos, 'Ornament und Verbrechen' in Janet Malcom, 'Wolfe in Wolfe's Clothing', *New York Review of Books*, 17 November 1981, p. 16. Hermann Muthesius in Wick, op. cit., p. 23.
22 Peter Behrens in Christian Schädlich, 'Kunstschulreform' in *Wissenschaftliche Zeitschrift der Hochschule für Architektur und Bauwesen*, Weimar 1979, 4/5, p. 299.
23 Henry van de Velde in Franciscono, op. cit., p. 35. Walter Gropius in Wick, op. cit., p. 15.
25 Henry van de Velde, *Geschichte meines Lebens*, Munich 1962, pp. 210–11.

CHAPTER FOUR

31 Alma Mahler in von Eckardt, op. cit., p. 61.
36 Walter Gropius in Karl-Heinz Hüter, *Das Bauhaus in Weimar*, Berlin (East) 1976, p. 202.
37 Walter Gropius, letter of 31 January 1919 in Christian Schädlich, *Bauhaus*

Weimar 1919–1925, Weimar 1979, p. 8. Gropius, letter to Ernst Hardt of 14 April 1919 in Jochen Meyer (ed.), *Briefe an Ernst Hardt*, Marbach 1975, p. 109. Gropius in Hüter, op. cit., pp. 57, 58–9. Gropius in Franciscono, op. cit., p. 22.
37–8 Bruno Taut in Hüter, op. cit., p. 57.
38 Walter Gropius in Schädlich, op. cit., p. 17. Gropius, letter to Adolf Behne in Peter Gay, *Art and Act*, New York 1976, p. 129. Alma Mahler, *Mein Leben*, Frankfurt (paperback ed.) 1963, p. 122.
40 Walter Gropius in Franciscono, op. cit., p. 15.

CHAPTER FIVE

44 Walter Gropius, letter to Ministry of Culture, 31 March 1920, in Hüter, op. cit., p. 31. Gropius, letter to Freiin von Freitag Loringhoven, 31 December 1919, STAW 10.
44–5 Max Thedy, letter of 9 January 1920, STAW 7.
46 Ré Soupault in Nina Kandinsky, *Kandinsky und ich*, Munich 1976, p. 98.
49–50 Oskar Schlemmer, letter to Otto Meyer-Amden, December 1920, in Tut Schlemmer (ed.), *Oskar Schlemmer; Briefe und Tagebücher*, Stuttgart (paperback ed.) 1977, p. 96.

CHAPTER SIX

51 Lothar Schreyer, *Erinnerungen an Sturm und Bauhaus*, Munich (paperback ed.) 1966, p. 142.
54 Helmut von Erffa in Walther Scheidig, *Crafts of the Weimar Bauhaus*, London 1967, p. 18. Alma Mahler in Janet Malcom, op. cit., p. 16.
55 Alfred Arndt, 'Wie ich an das Bauhaus in Weimar kam' in exhibition catalogue *Bauhaus-Idee-Form-Zweck-Zeit*, Göppinger Galerie, Frankfurt, 1964, p. 39.
62 Lyonel Feininger in 'Concepts of the Bauhaus', catalogue of the Busch-Reisinger Museum, Harvard University, 1971, p. 50. Hans M. Wingler, *The Bauhaus*, Cambridge, Mass., 1978, p. 4.

CHAPTER SEVEN

68 Heinrich Basedow, *Meine Lebenserinnerung*, Hamburg 1973, pp. 60–1.
69 Ludwig Hirschfeld, letter of 1 January 1923, BA 7/6. Lis Abegs in Gunta Stadler-Stölzl, 'Die Entwicklung der Bauhaus-weberei' in *Werk*, vol. 55, 1968, p. 746.

CHAPTER EIGHT

73 Gropius' speech, typescript, STAW 132.

CHAPTER NINE

80 Schlemmer in Scheidig, op. cit., p. 22. Schlemmer, diary for 23 June 1921 in Tut Schlemmer, op. cit., p. 52.
89 Schlemmer, diary for June 1922 in Tut Schlemmer, op. cit., p. 59. Schlemmer in Hüter, op. cit., p. 142.
91 Klee, letter of 1919 to Alfred Kubin in Wick, op. cit., p. 217. Schlemmer in Wick, op. cit., p. 216. Klee in Geelhaar, op. cit., p. 18.
92 Klee in Werner Haftmann, *The Mind and Work of Paul Klee*, London 1954, p. 115. Klee in Geelhaar, op. cit., p. 55.
94 Klee in Wick, op. cit., p. 226. Klee in Geelhaar, op. cit., p. 98.
95 Kandinsky, article of 1919 in Troels Andersen, 'Some unpublished letters by Kandinsky' in *Artes*, II, 1966, p. 101. Gropius, memorandum of 19 June 1922, STAW 13.
98 Kandinsky in Nina Kandinsky, op. cit., p. 110. Kandinsky in Schreyer, op. cit., p. 120.
98–9 Bayer in Nina Kandinsky, op. cit., p. 109. Jean Leppien quoted, ibid., p. 134.
99–100 Ibid.
100 Anonymous student in Wick, op. cit., p. 190.

CHAPTER TEN

106 Itten in Wick, op. cit., p. 83.
106–7 Johannes Itten, *Die Farbkugel; aud Kunst der Farbe*, Ravensburg 1961, p. 114.
107 Itten in Wick, op. cit., p. 98.
110–11 Kandinsky, ibid., pp. 191–2, p. 193.
114 Klee in Wick, op. cit., p. 233.

213

115 Klee in Wick, op. cit., p. 235.

CHAPTER ELEVEN

116 Vilmos Huszar in Wick, op. cit., p. 35.
116–17 Feininger in Wick, op. cit., p. 35.
117 Quoted by Ré Soupault in exhibition catalogue 'Karl Peter Röhl', Kunsthalle zu Kiel, 1979, p. 11. Ré Soupault in Nina Kandinsky, op. cit., p. 104.
120–1 Gropius' memorandum, STAW 3.

CHAPTER TWELVE

127 Moholy in exhibition catalogue 'Tendenzen der 20er Jahre', Berlin 1977, 1/92. Circular of 14 March 1923, STAW 13. Moholy in Schreyer, p. 138. Citroen in Sibyl Moholy-Nagy, *Moholy-Nagy*; *experiment in totality*, New York 1950, p. 35. Idem, p. 39.
128 Anonymous student in Busch-Reisinger catalogue, p. 50. Moholy in Sybil Moholy-Nagy, p. 19.
132 T. Lux Feininger in Eckhard Neumann (ed.), *Bauhaus and Bauhaus People*, New York 1970, pp. 180–1. Klee in Geelhaar, p. 66.
132–3 Feininger in exhibition catalogue '50 Years Bauhaus', Royal Academy, London 1968, p. 75.
134–5 Hannes Beckmann in Busch-Reisinger catalogue, p. 30.

CHAPTER THIRTEEN

136 *Rheinisch-Westfälische Zeitung*, clipping in STAW 5.
138 Gropius memorandum of 25 March 1922, STAW 14.
143 Gropius, letter of 9 March 1923 to Döblin, STAW 40.

144 Heinrich König in Neumann, op. cit., p. 121.
146 Behne in Christian Schädlich, 'Kunstschulreform' in *Wissenschaftliche Zeitschrift der Hochschule für Architektur und Bauwesen*, Weimar 1979, vol. 26, 4/5, p. 302. Paul Westheim in Wingler, op. cit., p. 69.
146–7 Paul Westheim in Claude Schnaidt, 'Frankreich und das Bauhaus: eine unmögliche Begegnung' in *Wissenschaftliche Zeitschrift der Hochschule für Architektur und Bauwesen*, p. 329.
150 Georg Muche, *Blickpunkt*, Tübingen 1965, p. 153. Gropius draft for Bauhaus constitution, typescript in BA 8/1.

CHAPTER FOURTEEN

154 Schwitters, letter of 23 March 1925 in Kurt Schwitters, *Wir spielen, bis uns der Tod abholt; Briefe aus fünf Jahrzehnten*, Frankfurt 1975, p. 93.
155 Felix Klee in *Paul Klee*; *Diaries 1898–1918*, London 1965, p. 416.
157 Gropius in Christian Schädlich, 'Das Bauhaus in Dessau' in *Form und Zweck*, 1976, no. 6, p. 4.
158 Gropius, letter of 21 January 1926 to the Masters, BA 8/2.
159 Xanti Schawinsky in von Eckardt, op. cit., p. 73. Gropius in catalogue of the Bauhaus Archiv, Berlin 1981, p. 184.
162 Nina Kandinsky, op. cit., p. 118.
163 *Anhalter Anzeiger* bound volume in Dessau City Archive.

CHAPTER FIFTEEN

180 Hannes Meyer, letter to Gropius of 3 January 1927 in Hannes Meyer, *Bauen und Gesellschaft. Schriften, Briefe, Projekte*, Dresden 1980. p. 42. Meyer in Claude Schnaidt, 'Hannes Meyer und das Bauhaus' in *Form und Zweck*,

1976, p. 36. Meyer in Diether Schmidt, *Bauhaus*, Dresden 1966, p. 47.
185 Gropius in Schnaidt, op. cit., p. 35. Undated minutes of meeting between Gropius and the students, BA 8/3.
185 Letter from the resigning Masters to the Council, 13 January 1928, in Sibyl Moholy-Nagy, op. cit., p. 46.
186 T. Lux Feininger in Busch-Reisinger catalogue, p. 30.
187 Meyer in Schädlich in *Form und Zweck*, 1976, p. 5. Emil Rasch in Neumann, op. cit., p. 210.
190 Schlemmer to Otto Meyer, letter of 8 September 1929 in Tut Schlemmer, op. cit., p. 113.
191 Meyer to Mayor Hesse in Meyer, op. cit., p. 69. Meyer in Schmidt, op. cit., p. 51. AIZ 1930 in Jost Hermand and Frank Trommler, *Die Kultur der Weimarer Republik*, Munich 1978, p. 414.

CHAPTER SIXTEEN

193 Jean Leppien in Nina Kandinsky, op. cit., p. 144. Meyer in Meyer, op. cit., p. 79.
194 Mies in Neumann, op. cit., p. 229.
196 in Schmidt, op. cit., p. 7. Pius E. Pahl in Neumann, op. cit., p. 229. In Nina Kandinsky, op. cit., p. 150. Mies, BA 17/3.

CHAPTER SEVENTEEN

198 Schlemmer, diary entry of February 1929, Tut Schlemmer, op. cit., p. 109. Nikolaus Pevsner, 'Gropius and van de Velde', *Architectural Review*, March 1963, p. 167. Reyner Banham, *Theory and Design in the First Machine Age*, London 1960, pp. 277–8.
199 *Stadtführer Weimar*, Berlin 1954, p. 44.

acknowledgments

AEG-TELEFUNKEN: 9, 10; Bauhaus-Archiv/Museum für Gestaltung, Berlin: 1, 11, 16, 27, 30, 31, 32, 33, 35, 36, 38, 42, 45, 46, 50, 51, 52, 53, 55, 56, 57, 58, 59, 60, 63, 66, 67, 70, 72, 74, 75, 76, 77, 80, 82, 84, 86, 88, 89, 90, 91, 92, 95, 96, 97, 98, 99, 102, 103, 113, 114, 116, 120, 122, 123, 124, 125, 126, 128, 129, 133, 134, 135, 136, 137, 138, 139, 140, 148, 150, 151, 153; Busch-Reisinger Museum, Harvard University: 17, 93, 110, 112, 127; Museum Folkwang, Essen: 39; Fotoatelier Louis Held: 12, 15, 22, 23, 24, 25, 111; Archiv Hochschule für

Architektur und Bauwesen, Weimar: 28, 29, 40, 41, 49, 61, 62, 68, 100, 101, 130; Marlborough Gallery, London: 87; Kunstsammlung Nordrhein-Westfalen, Düsseldorf: 149; Lucia Moholy: 85; Museum of Modern Art, New York: 83; National Film Archive, London: 105; North Hertfordshire District Council: 6; Benno Keysselitz: 8; PGH 'Die Camera', Dessau: 117, 118, 119, 121; Roger Rössing: 47, 48, 73, 94, 131, 132; Staatsgalerie moderner Kunst, Munich: 54; Ernst Steinkopf: 154; Dr Franz Stoedtner: 13, 19, 20; Tate Gallery, London: 65; Thurin-

gian State Archive, Weimar: 43, 71, 81, 104; Ullstein: 115; Frank Whitford: 145, 146, 147; William Morris Gallery, Walthamstow: 4.

OTHER SOURCES
Chicago Sunday Tribune, 1906: 37; *Illustrated London News*, 1851: 3; K. Junghammms, *Bruno Taut*, 1970: 14; W. Kandinsky, *Point and Line to Plane*: 69; *Official Descriptive and Illustrated Catalogue of the Great Exhibition, London*, 1851: 5; R. Wick, *Bauhaus Pädagogik*, 1982: 78, 79.

index

215